Art-as-Politics
The Abstract Expressionist
Avant-Garde and Society

Studies in the Fine Arts
The Avant-Garde, No. 26

Stephen C. Foster, Series Editor

Associate Professor of Art History
University of Iowa

Other Titles in This Series

Art-as-Politics

The Abstract Expressionist Avant-Garde and Society

by
Annette Cox

UMI RESEARCH PRESS
Ann Arbor, Michigan

Produced and distributed by
UMI Research Press
an imprint of
University Microfilms International
Ann Arbor, Michigan 48106

Library of Congress Cataloging in Publication Data

Cox, Annette.
 Art-as-politics.

 (Studies in fine arts. The avant-garde ; no. 26)
 A revision of the author's thesis (Ph.D.)–University of
North Carolina at Chapel Hill, 1977.
 Bibliography: p.
 Includes index.
 1. Abstract expressionism–United States. 2. Avant-
garde (Aesthetics)–United States–History–20th century.
3. Painting, Modern–20th century–United States.
4. Politics in art–United States. I. Title. II. Series: Studies
in the fine arts. Avant-garde ; no. 26.

ND212.5.A25C69 1982 759.13 82-4760
ISBN 0-8357-1318-0 AACR2

For my family

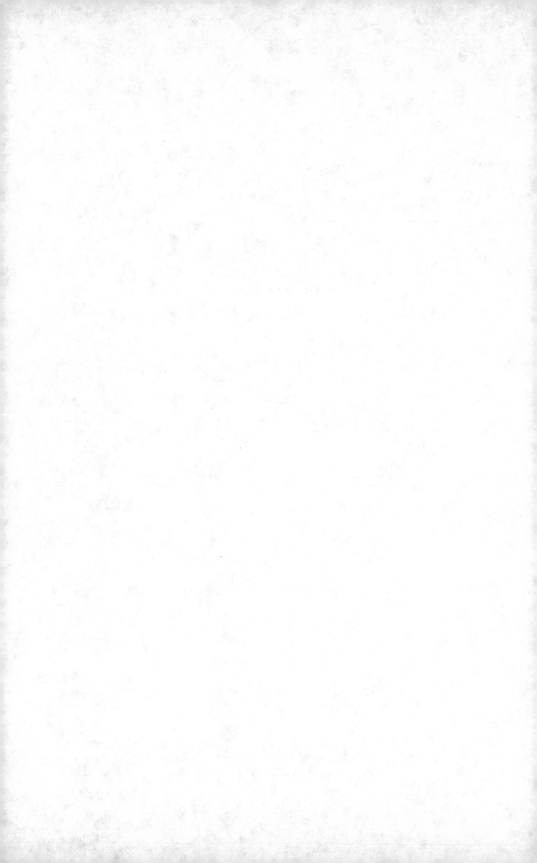

Contents

List of Illustrations

Following chapter 4

18. Barnett Newman. *Vir Heroicus Sublimis.* 1950–51.
19. Barnett Newman. *Abraham.* 1949.
20. Barnett Newman. *Gea.* 1944–45.

Following chapter 5

21. Jackson Pollock. *Autumn Rhythm.* 1950.
22. Thomas Hart Benton. *The Ballad of the Jealous Lover of Lone Green Valley.* 1934.
23. Jackson Pollock. *Going West.* ca. 1934–35.
24. Jackson Pollock. *Cotton Pickers.* ca. 1935.
25. Jackson Pollock. *The She-Wolf.* 1943.
26. Jackson Pollock. Photograph by Arnold Newman. 1949.
27. Jackson Pollock. Photograph by Hans Namuth. 1950.
28. Jackson Pollock. Photograph by Martha Holmes. 1949.
29. Jackson Pollock. Photograph by Hans Namuth. 1950.

Following chapter 6

30. Ad Reinhardt. *Untitled.* 1938.
31. Ad Reinhardt. *Number 18.* 1948–49.
32. Ad Reinhardt. *Abstract Painting, Number 33.* 1963.
33. Ad Reinhardt. "Returned, No Thanks." *New Masses,* 1939.
34. Ad Reinhardt. "The Unhappy Warriors." *New Masses,* 1939.
35. Ad Reinhardt. "Millennium." *New Masses,* 1940.
36. Ad Reinhardt. "How to Look at a Cubist Painting." 1946.
37. Ad Reinhardt. "How to Look at Looking." 1946.
38. Ad Reinhardt. "FOUNDINGFATHERSFOLLYDAY." 1954.
39. Ad Reinhardt. "How to Look at Art and Industry." 1946.

1

Abstract Expressionism:
The Unwanted Title

Painter Willem de Kooning once warned his fellow Abstract Expressionists against naming themselves. He gave that advice in April 1950 at a conference for avant-garde artists held at the Manhattan art school, Studio 35. During the discussion, other artists also seemed reluctant to label or classify their art. For example, when Alfred H. Barr, Jr., an official at the Museum of Modern Art, suggested three possible names for the new American modernist painting—"Abstract-Expressionist," "Abstract-Symbolist," and "intra-subjectionist"—the artists showed no interest in any of these ideas. Barr went on to urge them to be the first group of artists to name themselves. Sculptor David Smith appeared to agree with Barr when he reminded his listeners that "names are usually given to groups by people who don't understand them or don't like them." Yet Smith himself concluded that he and his friends could never reach a decision on a name.

Three artists then offered their own ideas for a name—"direct," "concrete," and "self-evident." Even if these alternatives had pleased any of the others, they demonstrated that these artists did not want to leave critics and historians any specific clues about the meaning of Abstract Expressionist painting. De Kooning ended the discussion by declaring: "It is disastrous to name ourselves."[1]

Not only did these artists refuse to name themselves, they also never felt that it was necessary to write a manifesto explaining their intentions. Even though many other avant-garde artists relied on formal statements to defend their art, the Abstract Expressionists never composed a manifesto that could be interpreted as a common position on aesthetic questions. One Abstract Expressionist, Clyfford Still, even claimed that he wanted to eliminate all criticism and interpretation of art. He loathed what he called the "totalitarian hegemony" of art history. Still and many other Abstract Expressionists also stopped titling their works in the late 1940s and thereby made it more difficult for viewers to understand the subject matter of their paintings.[2]

Two of these painters, however, did write a number of essays and catalog introductions that dealt with the purposes of the Abstract Expressionists. Barnett Newman, for one, published numerous pieces about his work and that of his friends, but none of those texts constituted a formal group manifesto. A second painter, Ad Reinhardt, also wrote extensively about the contemporary art scene, but his perspective was that of an outsider disdainful of the intentions of his fellow artists.[3]

In 1950 a group of Abstract Expressionists signed a letter attacking the exhibition policies of the Metropolitan Museum of Art, but it contained no mention of aesthetic questions. In conjunction with that protest, the artists posed for a group photograph for *Life* that the magazine's editors called a portrait of the "Irascibles." Yet no one ever used that name again because it reflected an antagonism to the official art world rather than the substance of their paintings. During the 1950s the artists staged additional panel discussions on the nature of their art, but again found that they could form no consensus about their subject matter.[4]

Even though the Abstract Expressionists refused to name themselves or to draw up a common aesthetic manifesto, they were, in fact, a small, closely knit group of avant-garde artists. Most of them lived in New York City as art students during the Depression, worked on the New Deal's Federal Art Project, and became involved in the leftist art organizations of the era. During the 1940s, many of them exhibited works at Art of This Century, Peggy Guggenheim's Manhattan gallery for modernist painting and sculpture. After Guggenheim returned to Europe in 1947, these artists continued to show their works together through dealers such as Betty Parsons, Samuel Kootz, Charles Egan, and Sidney Janis. Artists Barnett Newman and Robert Motherwell also organized shows of Abstract Expressionist painting that reflected their conviction that this art constituted a movement. In 1949 the artists also started The Club, a group that met on Eighth Street in Greenwich Village on Friday nights for panel discussions, guest speakers, and parties.[5]

Abstract Expressionist painting also displayed common interests and influences. Most of these artists, during the late 1930s and early 1940s, drew on European Surrealist painting as an alternative to American realism. From the Surrealists they borrowed automatic drawing, biomorphic forms, and mythic themes. After experimenting with these concepts, two Americans, Jackson Pollock and Clyfford Still, developed techniques and imagery that shaped the work of the rest of the avant-garde. By the late 1940s, Pollock's spontaneous and expressive linear webs and Still's large irregular fields of color established the broad patterns of postwar abstract painting. These two branches of Abstract Expressionism are now called gesture and color-field painting.[6]

Although the Abstract Expressionists issued no manifesto, their individual statements on the subject matter of their paintings were strikingly similar. To a great extent they agreed that their art portrayed the spiritual malaise of modern society. They also concluded that abstract art was the appropriate style for the age since they believed that realism lacked the means to address the crisis of the contemporary world. For example, in 1947, Adolph Gottlieb asserted that his abstract paintings were "the realism of our time" because they contained "obsessive, subterranean and pictographic images that are the expression of the neurosis which is our reality." Barnett Newman claimed in 1948 that he and other American painters sought to find through art "the sources of the tragic emotion." Mark Rothko defended his paintings by explaining that he chose abstract forms not to deny content but to depict mythic dramas that served as "an anecdote of the spirit." Still also dismissed representational elements from his art by calling them "crutches for illustrators." He characterized his themes as grand and tragic ones that addressed sublime philosophical questions. And Pollock, just before his death in 1956, acknowledged the influence of Sigmund Freud and Carl Jung on his art. In other interviews, he had also pointed out his dissatisfaction with conventional American realism and his interest in imagery from the unconscious.[7]

Art critics first noticed the emergence of Abstract Expressionism in the mid-1940s. In 1944, for instance, the critic for the *New Yorker,* Robert Coates, noted a new tendency in the American paintings shown at Art of This Century Gallery: painters seemed to be using elements of abstract, Surrealist, and Expressionist art without committing themselves exclusively to any one style. Puzzled, Coates found this new painting to be "pretty free-swinging in a spattery fashion, with only vague hints at subject matter." Even sympathetic observers admitted that Rothko's art was difficult to classify because it occupied a "middle ground" between abstraction and Surrealism.

More certain about the direction of the new American painting, Clement Greenberg wrote in 1945 that it represented the synthesis of two divergent tendencies in art: "the flattening-out, abstracting, 'purifying' process of cubism," and the "look of organic substances" and a "violent and extravagant temperament." In 1944, collector and dealer Sidney Janis also called attention to the inclination of this group of young painters to develop "interchanging ideas" between abstract and Surrealist art.[8]

This synthetic impulse among American painters eventually made the term "Abstract Expressionism" seem to be the most appropriate name for the new art. *New Yorker* critic Coates first applied this name to American painting in 1946, but he did not invent the term himself. He had seen it in the catalogs written by Alfred Barr for the Museum of Modern Art. In

these publications Barr treated modernist painting historically by describing how each artist depended on and transformed the art of the past for his own purposes. Barr first used the term "Abstract Expressionism" in a 1929 catalog for a show of Post-Impressionist painting, asserting that the Russian Wassily Kandinsky was the first "'abstract' Expressionist" because he drew on the Expressionist style of Paul Gauguin while eliminating its representational aspects. The term appeared again in Barr's most important catalog, *Cubism and Abstract Art* (1936), as part of a schematic diagram of the history of modernist painting (see figure 1). The critics and historians who used "Abstract Expressionism" to describe the new American painting of the 1940s chose that term because it demonstrated that this art combined the emotional resonance of Expressionist techniques with the treatments of form, line, and space developed by Cubist and abstract artists.[9]

Other art critics also saw Abstract Expressionism as a cohesive body of art, but unlike Barr they focused on its subject matter. In the essay "The American Action Painters" (1952), Harold Rosenberg first compared the creation of this art with the themes of existential philosophy. Because some of the Abstract Expressionists could no longer accept traditional ways of making art, Rosenberg argued, they set out to paint alone and away from the formulas dictated by politicians and critics. They could only undertake this difficult task outside the public arena and in the privacy of their own studios. Like the protagonists in literary existentialism, Rosenberg's Action Painters created their works in an atmosphere of isolation, anguish, and struggle.[10]

The influential art historian Barbara Rose also contended that these artists shared basic assumptions about their art and its meaning. During the postwar period, artists seemed so intent on investing their painting with tragic, metaphysical content that, according to Rose, the art world became a *Götterdämmerung* where "trumpets blared with such an apocalyptic and Wagnerian intensity that each moment was a crisis and each 'act' a climax." Subsequent artists grew so tired of the self-indulgence of the Abstract Expressionists that, in Rose's opinion, they turned to anonymous and impersonal themes. In the same vein, critic Max Kozloff wrote of the "violence and exalted, tragic spirit" of Abstract Expressionism. He charged that these painters believed themselves to have "a total moral monopoly" through their pursuit of the sublime and the absolute in art.[11]

Europeans also acknowledged the existence of a cohesive group of American painters in the postwar period. At the request of a number of foreign museums, the Museum of Modern Art sent a selection of these works in 1958–59 to major European cities in an exhibit called *The New American Painting*. Through this show the Museum also asserted the inter-

national importance of Abstract Expressionism and certified it as the first American painting to rank with the European art of the twentieth century.[12]

By the 1960s, then, Abstract Expressionist painting had been named, classified, and interpreted as if it had been a consciously unified body of art. Critics and historians agreed that these artists demonstrated remarkably similar styles and purposes. Despite the artists' resistance to this process, the art establishment had assimilated and accepted their art. As Renato Poggioli pointed out, avant-garde art, no matter how scandalous and controversial, ultimately loses its revolutionary identity to become part of official culture.[13]

Throughout history, artists have often resented the efforts of critics and historians to interpret their works. But in the case of the Abstract Expressionists, this desire to remain free from labels, names, and interpretations grew out of the political and artistic climate of the 1930s and 1940s. During this period, two of the most important forces in intellectual life, Stalinism and Surrealism, made these artists wary of any ideologies used to shape and measure art.

As young artists in New York during the Depression, the Abstract Expressionists sympathized with and supported various radical groups in the art world. However, the Communists they met through the Federal Art Project demanded that artists focus on themes derived from Marxian class analysis.

After the Party adopted a more tolerant culture policy during its Popular Front period, it still expected its adherents to support every twist and turn in Soviet foreign policy. Most of the Abstract Expressionists found these authoritarian aspects of the Party distasteful, and, after the Nazi-Soviet Pact of 1939, rejected any suggestion that the Soviet Union represented the ideal classless society.

The Surrealists, too, required that their followers demonstrate unquestioning loyalty to their principles. In search of a political and spiritual revolution, these European writers and painters permitted no deviation from a program that sought the overthrow of the bourgeoisie through a Freudian-inspired literature and painting. While these Surrealist premises supplied the underlying visual vocabulary of Abstract Expressionism, Americans insisted on remaining independent from the formal movement. They eagerly borrowed techniques and ideas from the Europeans, but wanted neither to join the Surrealist group nor to form their own rival organization.

This aversion to the more dogmatic aspects of Depression radicalism and European Surrealism did not mean that these painters abandoned the fundamental political viewpoint of these two groups: like the Communists

and the Surrealists, the Abstract Expressionists believed that art should reveal the barren and oppressive nature of modern capitalist society. But, though they agreed with these radicals about the condition of the modern world, they remained determined to retain their autonomy. They had become distrustful of those that demanded a direct relationship between art and political or aesthetic ideology. To these artists, the events of the 1930s and 1940s seemed too horrible and too complex to be expressed with simplistic adaptations of Marxist or Freudian concepts. Abstract Expressionist painting was meant to transcend if not subvert these ideologies. Growing out of Depression radicalism and European Surrealism, Abstract Expressionism took sustenance from these impulses and then transformed them into an art that was political but also much more than that.

The relationship of the Abstract Expressionist painters to the society around them can be better understood through an examination of the history of the avant-garde. Though some of these painters eventually became wealthy and famous, it is important to remember that they perceived themselves to be a part of the avant-garde tradition. While avant-garde art has sometimes been apolitical, at other times it has relied on leftist political themes. During the 1930s, most avant-garde artists in Europe and America had again turned to Marxist political ideas. Though the Abstract Expressionists found some aspects of this Depression radicalism unsavory, they still saw themselves and their art as critically opposed to the established social and political order.

Before the nineteenth century, there was no expectation that artists be alienated from the world around them or that they possess any special ability to reshape that world. Artists accepted the notion of tradition and the authority of the past. Standards for artists were static and classic, and the artists' task was to emulate the masters of antiquity. The Romantic movement changed that assumption by endowing artists with genius. Models from the past no longer mattered as much as this new capacity of the artist to address the crisis of the moment and to create the utopias for the future.

In the 1830s, French artists, critics, and reformers began for the first time to link art with radical political change. In this new role, the artist was to challenge the rule of the bourgeoisie by creating a novel and disturbing art. Using the French military term "avant-garde" to describe this fusion of art and politics, utopian socialist Henri de Saint-Simon argued that painters and writers could exercise a positive power over society. These socialists believed that the artist through his art could affect the destiny of the human race. As an outsider tied to no social class, the artist could be a visionary and a revolutionary. In early nineteenth-century France, the role of the avant-garde artist came to include the overthrow of the privileged

classes as a prelude to the formation of a genuine democratic and socialist state.[14]

The nineteenth-century painter who best represented this convergence of artistic and political radicalism was Gustave Courbet. He seemed to be one artist dedicated to destroying the prevailing political system while also defying the conventional artistic standards of his time. One of his major works, *Studio of the Painter* (1854–55), illustrated the role that the avant-garde artist envisioned for himself (see figure 2). According to the art historian Linda Nochlin, this painting constituted "a concrete emblem of what the making of art and the nature of society are to the realist artist." In this work, Courbet places himself at the center seated at an easel absorbed in the painting of a landscape. Surrounding him in the studio are the central characters in the artist's world. A woman and a child stand next to Courbet, watching him work and personifying respectively the traditional muse and the next generation of artists that Courbet hoped to inspire. The entire right-hand side of the studio is filled with the avant-garde friends with whom he shared this new interpretation of art and politics. Absent are the traditional patrons from the court and the church. In their place Courbet showed his concern for the masses by including figures that symbolize the workers and peasants of France. Courbet also played an active part in nineteenth-century French radical politics. A friend of Pierre Joseph Proudhon, he was a republican and an anarchist and participated in the Paris Commune of 1871.[15]

After the defeat of the Commune, political radicalism seemed less promising to French intellectuals. "Avant-garde," once a term reserved for an art in which political goals were paramount, became less and less charged with social meaning. After 1880, it tended to be more closely associated with an aesthetic radicalism with little concern for the external world. It also came to describe the efforts of artists to forego representational or mimetic techniques in favor of stranger and more difficult forms of art. This desire to dispense with traditional literary and artistic devices like narrative, melody, and perspective arose from attitudes of iconoclasm and nihilism as well as from what Poggioli called "a quasi-religious aspiration toward an absolute emotional and mental freedom."[16]

In this new spirit, the avant-garde shaped the literary and artistic movement known as modernism. It rested on the creation of forms independent of reason and rationality and without concern for public accessibility. Yet many modernists still claimed that their art was grounded in social reality and was the only appropriate art for the industrial and urban age. In this unreasonable and constantly changing world, art itself, according to many modernists, could not be as clear and direct as it had once been. Using Friedrich Nietzsche as a primary point of reference, modernists

concluded that through the destruction of past art and the old, outmoded gods of religion and politics, they could create completely new forms for a new world.

For example, in *The Banquet Years* Roger Shattuck describes why modernists like Alfred Jarry, Henri Rousseau, Erik Satie, and Guillaume Apollinaire rejected the traditional themes and standards expected in literature, music, and painting. Instead of conventional narrative, melody, and perspective, these artists introduced absurdity, disassociation, and obscurity into their art. What seemed unintelligible on its surface, however, was actually consistent with the environment that the modernists saw around them. Their art rested on an interpretation of the social order as fragmented and dislocated and dealt then with themes based on the fusion of opposites and contraries or, as Pablo Picasso put it, on "a sum of destructions."[17]

After the First World War, modernist art again took on explicit political meanings. As a reaction to what seemed to be the senseless destruction of that war, artists and writers again incorporated radical political change into their credos. For the Dadaists, political and artistic agitation were closely intertwined. Both the aesthetic and the social establishment became the target of ridicule and humiliation. Marcel Duchamp, for example, developed the readymade art object to demonstrate the superfluous nature of the canons of skill and taste in art. Other Dadaists like John Heartfield and George Grosz used modernist techniques to attack postwar German society and politics. In France, where the Dada movement settled after the war, a number of these artists attempted to introduce more coherence into the revolutionary art spirit by organizing literary experiments around Freudian concepts. Calling themselves the Surrealists, this group also adopted Marxist principles and for a short time belonged to the French Communist Party.

The Surrealists also remained modernists. Drawing on the writings of absurdists like Jarry, they invented an artistic vocabulary based on the placement of objects in unusual, unexpected settings. Using the writings of the French nineteenth-century poet Lautréamont (Isidore Ducasse), the Surrealists asserted that art is the product of the joining of a sewing machine and an umbrella on a dissection table. It was through this disturbing new imagery that the Surrealists hoped to bring about radical political change. Within Surrealism there was also a strain of rationalism. These painters argued that their seemingly incomprehensible themes and images actually represented those found in the Freudian interpretation of dreams and the unconscious. To the Surrealists, Freudian concepts were not based solely on cases of individual maladjustment but, rather, possessed broad social implications. At its core, Surrealist painting conformed to Freud's rational analysis of the collective human personality.[18]

The Abstract Expressionists matured as artists during the Depression, when Surrealism reigned as the epitome of international modernism. Its revitalization of the connection between art and leftist politics impressed the American painters. However, they never found its more programmatic Freudian and Marxian aspects congenial. For these artists, the link between art and an external interpretation would be problematic. What the Surrealists made obvious with the application of Freudian and Marxian concepts, the Americans preferred to leave unstated and latent. Simple formulas for meaning and interpretation seemed reprehensible to artists who had lived in a world of depression and war that could not be explained or rectified through Marxian and Freudian thought alone.

Though the Abstract Expressionists avoided the ideological formulations that they found inappropriate for their time, they wanted their art to be relevant to society. Having rejected the rigid demands on art presented by the Stalinists and the Surrealists, they did not simply retreat to their studios or into a mindless subjectivity. The key to understanding their art and their writings lies in an appreciation of their desire to remain free of Stalinist and Surrealist dogma without losing the expressive qualities that those two movements gave to art. They solved this problem in different ways. Some of the painters simply tried to avoid giving assistance to critics who wanted to interpret their art or apply those external standards. Others, like Barnett Newman, elevated interpretation to a cosmic and transcendental level beyond the more concrete worlds of Marx and Freud. But whatever strategy they chose to deal with the public, they hoped it would protect the radical meaning of their paintings.

The next two chapters will explore further the relationship between these artists and Stalinism and Surrealism, and serve as an introduction to Abstract Expressionist art and to the lives of the artists. These chapters analyze the attraction of Marxian and Freudian ideas, describe why these ideologies failed the Abstract Expressionists, and reveal a considerable amount about the social history of the American artist during the 1930s and 1940s. Education, training, and community life appear in the context of their relationship to larger political and aesthetic questions. Because this group of artists lived in near poverty with limited public recognition during the 1930s and 1940s, issues of fame, wealth, and patronage emerge with less urgency and are dealt with less frequently in this study. Only when this painting achieved substantial critical and public attention during the 1950s did the questions of fame and wealth become important. At this time Abstract Expressionism became a conservative and authoritarian tradition against which other artists had to revolt. The continuing demand for innovation in avant-garde art made it inevitable that Abstract Expressionism would lose its relevancy for many subsequent artists.

After an exploration of the relationship between these artists and Stalinism and Surrealism, this study turns to the artists themselves to examine the political dimensions of the work and writings of Barnett Newman, Jackson Pollock, and Ad Reinhardt. Newman served as a spokesman and polemicist for the other artists and tried to establish a connection between Abstract Expressionism and primitive art, metaphysical concepts, and political anarchism. Through this strategy, he hoped to make this painting mythic and portentous. Newman's writings and art represent the best example of how the Abstract Expressionists resisted political and aesthetic dogmas while trying to protect and expand the meaning of their canvases. In Newman's case, this effort produced a body of writing so inflated in its intentions that it seems to claim too much for his art.

Pollock protected and expanded the meaning of his paintings in an entirely different way. By allowing photographers to enter his studio to photograph him while he painted, he left a record that shaped the ways in which critics and other artists would interpret the content and implications of his paintings. The photographic images helped restore the visionary, apocalyptic qualities characteristic of Pollock's works, and served as a visual record of Pollock's extraction of imagery from his unconscious. As a result, these photographs shifted the discussion of Pollock's art away from its imagery to the issues of process and personality. In contrast to Courbet's crowded atelier, Pollock stood alone in his barn, immersed in his unconscious and in his automatic technique.

In an attempt to keep art relevant to the world around it, Ad Reinhardt provided the most radical solution for the Abstract Expressionists. After working in a style similar to that of the color-field painters during the 1940s, he departed from their Expressionist vocabulary to develop a more geometrical abstraction. In his writings Reinhardt grew even more estranged from the other artists. Because he was neglected by the official art world until the 1960s, he was left in a perfect position to point out the inconsistencies in the lives and art of his former friends. He argued that their attempts to invest their paintings with philosophical, even metaphysical, content never succeeded and that these efforts to defend abstract art somehow corrupted it. He also grew suspicious of the fame and wealth that his friends attained. He came to believe that the only way for modernists to remain ethical and keep their art vital and pertinent was to avoid explaining and interpreting it. Only by denying specific meaning, by making only "art-as-art," could the artist, according to Reinhardt, keep his work radical and free.

In a way Reinhardt's art-as-art dogma represents the logical extension of the modernist sensibility. Estranged from the establishment, the modernist artist, in Reinhardt's opinion, cannot even trust that revolutionary

politics or quasi-religious mysticism will protect his works from their assimilation into the official art world. Reinhardt's conclusions about art and its place in the world served as the basis for a growing feeling in the 1960s among artists and writers that too much damage had been done by interpretation. Susan Sontag explored this attitude in her work *Against Interpretation*. Other critics have labeled this phenomenon "postmodernism" and have identified Reinhardt as its key proponent in the art world.[19]

The writings of the two critics most closely associated with Abstract Expressionism, Harold Rosenberg and Clement Greenberg, demonstrate how much the political environment of the 1930s and 1940s shaped critical perceptions of this new painting. Each of these critics concluded that Abstract Expressionism reflected the cultural and political crisis of the Depression and the Second World War. From the left, Harold Rosenberg named these artists "Action Painters." Though Rosenberg remained an independent socialist in the postwar period, he did not mean to link painting with political "action." He felt that the militant revolutionary fervor of artists during the Depression was no longer possible after the war. To Rosenberg, the only conceivable "action" for the artist was in the studio and in the exploration of individual identity. His criticism was the first attempt to link Abstract Expressionism with the basic concepts of existentialism. As part of that search for self-knowledge, the American painter had discovered, according to Rosenberg, the importance of his national identity. Rosenberg took pride in the Abstract Expressionists, not as political radicals or existential heroes, but as Americans who could challenge and master the European cultural tradition.

In contrast, Clement Greenberg championed Abstract Expressionism from the right. His admiration for American painters like Pollock rested not on their themes but on their approach to the more concrete artistic problems of space, line, and color. To Greenberg, these artists excelled in dealing with the tangible visual aspects of painting. His interpretation of why these painters turned to the formal and immediate problems of painting bore some resemblance to the conservative interpretations of American culture and politics by Daniel Boorstin. As a result, Greenberg's Abstract Expressionists became typical postwar American intellectuals who were more concerned with the straightforward, practical problems of culture than with its revolutionary or utopian aspects. Sensitive as he was to the visual properties of Abstract Expressionism, Greenberg misrepresented the political implications of the art. Because he ignored the pervasive Surrealist influence on the new American painting, he failed to account for the Freudian framework in which it was created.

Despite the political and aesthetic differences between Rosenberg and Greenberg, they both agreed that Abstract Expressionism represented a

triumph for American culture. As former Trotskyists, neither critic admired traditional nationalistic themes in art, but they did point with satisfaction to the vitality and freshness of American painting in the 1940s and 1950s. Like many other *Partisan Review* critics, they believed that Europeans could no longer claim superiority for their cultural achievements.

Only one of the painters, Barnett Newman, wrote of the American qualities found in Abstract Expressionist art. He claimed that he and his artist friends, Gottlieb, Rothko, and Still, had moved beyond the depiction of the physical objects found in nature that had so captivated European artists. In rhetoric worthy of Whitman, Newman proclaimed that American painting had surpassed the European because Americans created works in the realm of "pure ideas, in the *meanings* of abstract concepts." Yet the American painter was not totally removed from the physical world because he was able, in Newman's opinion, to render "the epistemological implications of abstract concepts with sufficient conviction and understanding to give them body and expression." In another essay, Newman again characterized European art as only a search for beauty, while Americans possessed a "natural desire for the exalted, for...our relationship to the absolute emotions," what Newman called the pursuit of the sublime.[20]

When Newman turned to an explanation for the Americans' ability to surpass European modernists, he argued that Americans could transcend the pursuit of beauty because they were free of "the impediments of memory, association, nostalgia, legend, myth, or what have you, that have been the devices of Western European painting." Because Americans lacked the sophisticated cultural tradition of Europe, they were able, Newman believed, to avoid making "*cathedrals* out of Christ, man or 'life.'" Instead, he proclaimed, "we are making it out of ourselves, out of our own feelings."[21] Though Newman was determined to define the differences between European and American painting, the rest of the avant-garde showed no interest in adopting a national identity. To these painters, national labels remained as unwanted as other titles.

The underlying assumption of this study of American painters and critics is that they lived and worked in a milieu where many voices demanded that art be part of some kind of national or political program. It is also assumed that each of these intellectuals shaped his art or his criticism as a response to those political imperatives. What makes these figures so intriguing is the way in which many of them tried to elude these interpretations, especially political ones, without sacrificing the expressive qualities in their art. For in Stalinism and Surrealism, these artists had encountered two of the most aggressive interpretations of culture and human behavior, all-embracing systems that could explain every aspect of culture, politics, and society. Avoiding being trapped by Marx and Freud

meant adopting a variety of strategies to deal with the meaning and interpretation of art. The purpose of this work is to examine and explore those strategies.

In preparing this study, I wish to thank the staffs of the Archives of American Art in New York and Washington, the libraries of the Museum of Modern Art, the Library of Congress, Duke University, and the University of North Carolina. I also want to express my appreciation to various friends who through the years have encouraged me to pursue this problem. I also want to thank George Mowry, Jane Mathews, Donald Kuspit, Peter Filene, and John Kasson for their comments on the manuscript. The essays of Edward Shils have also been crucial for the ideas and perspective developed in this study.

Figure 1. *The Development of Abstract Art.* 1936. Chart
 prepared for the Museum of Modern Art, New York,
 by Alfred H. Barr, Jr. Appeared on jacket of *Cubism
 and Abstract Art* by Barr (New York: Museum of
 Modern Art, 1936).

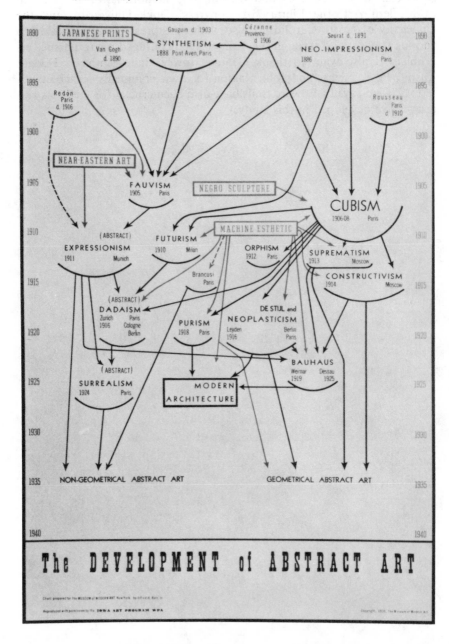

Figure 2. Gustave Courbet, *The Studio of the Painter*. 1854–55.
Oil on canvas. 359 × 598 cm. Paris, Louvre.

2

The Abstract Expressionists and Depression Radicalism

There are two photographs of Jackson Pollock that seem to illustrate the fate of the left in the American art world (see figures 3 and 4). The first shows Pollock helping to assemble a float for a May Day celebration in 1936. When this photograph was taken, the artist and his brother worked in an experimental studio run by the radical Mexican painter David Alfaro Siqueiros. In this workshop Siqueiros supervised the creation of "art for the people" in the form of floats and large posters for Communist Party rallies, parades, and conventions. The float that Pollock worked on in the photograph portrayed the destruction of Wall Street by an angry working class. To symbolize the capitalist financiers, Pollock and the other artists constructed a large figure decorated with a swastika and holding captive in his hands the emblems of the Republican and Democratic parties. A gigantic hammer representing the power of the people periodically smashed a ticker-tape machine sending paper flying over the float.[1]

Fourteen years later, in 1950, Pollock was photographed again. This time a young German photographer, Hans Namuth, found the artist inside a barn on Long Island, New York. Taken while Pollock painted, these stills reveal that the artist's imagery had become completely abstract webs of line produced by pouring paint off sticks onto a canvas lying on the floor. Fascinated by the speed and intensity with which Pollock worked, the photographer focused on him as he moved and gestured, almost dancing, around his canvas. Pollock's unorthodox method of painting was based on the automatic drawing techniques developed by the Surrealists, who, following the ideas of Sigmund Freud, believed that spontaneous movements of the hand drew out images from the unconscious.[2]

These two portraits of Pollock dramatically demonstrate the transformation in American intellectual life that took place after the Great Depression. From a commitment to an art to be taken into the streets to advance the fight for social justice, Pollock appeared to have retreated to

an isolated atelier where he could explore his unconscious. Like other artists and intellectuals of the postwar era, Pollock rejected the direct and concrete political content demanded by the Communist Party and adopted ideas and images with few discernible political references. The other Abstract Expressionist painters followed a similar path. By the late 1940s many of them had also abandoned recognizable forms and titles, leaving the uninformed public few clues to the meaning of their works.

Because the Abstract Expressionists were part of the "red decade" and then joined in what Daniel Bell calls "the end of ideology" in the postwar era, these artists offer the historian an opportunity to examine the general interpretations of American intellectual life during and after the Depression.[3] Upon exploration, it is evident that their experience fits no simple scheme for understanding the history of the period. While it is true that most of these painters identified themselves with the left during the Depression, at the same time they also considered themselves modernists. To this avant-garde, these two interests did not seem antithetical. From John Graham, the Surrealists, and the Trotskyists, the Abstract Expressionists learned that it was possible to fuse modernist art and radical politics. During the Depression, they believed that these two elements were closely linked. This preoccupation also explains why the Abstract Expressionists, even in works that were totally abstract, still sought to create an art with compelling expressionist qualities and a profound commitment to intense audience response.

Pollock's participation in a Communist workshop in 1936 demonstrates the substantial sympathy for the left and for social reform among painters during the Depression. This interest in radical politics represented a departure from the past experience of American painters. Before the twentieth century, the American art world had been particularly conservative. For the most part, nineteenth-century American painters, their patrons, and their audience considered the fine arts to be a reflection of traditional social and religious values and a force for civilizing a barbaric nation. It was only in the years just before World War I that American painters, led by Robert Henri, discovered that art could play a role in bringing about social justice for the people. Pollock and the other Abstract Expressionists matured as artists in a community dominated by Henri's teachings.

According to Neil Harris, a prosperous, self-confident artistic community developed in the United States only after 1840. It appeared in the major cities of the Northeast where artists found the studios, supply stores, and art schools that were necessary for the creation of a knowledgeable and thriving profession. Unlike their contemporaries in Europe, who were

exploring the leftist implications of Romanticism, these Americans turned to the views of conservative ministers of the gospel for guidance on the proper social role for artists. As Barbara Novak has shown, nineteenth-century American painters created their works out of a conviction that painting landscape and other natural subjects would reflect the hand of God in the creation of the world. Even those painters who chose their subjects from the lives of the common people did so to affirm rather than attack the prevailing political system. Almost all nineteenth-century American painters remained uninterested in French utopian notions about the avant-garde.[4]

The American clergy had discovered art in the nineteenth century after traveling in Europe and learning that it was not as sinful as their Puritan forefathers had warned. Once their suspicions were allayed, these pastors realized that the fine arts could have great influence over men's souls and, more importantly, over social behavior. Impressed with the order and civility they observed in the museums and parks of Europe, they argued that the fine arts would foster civilization in the seemingly chaotic world of antebellum America. In sermons and essays these ministers praised museum attendance as one way to refine and moderate public behavior.[5]

After the Civil War, the arts continued to be used as a tool by conservative social reformers. Through the building of museums and parks, they sought to temper the disorder of the emerging urban and industrial environment around them. Art collecting also became a social symbol in the late nineteenth century. The newly affluent business class began to buy European paintings as both an amusement and a certification of their social standing and cultural refinement. A group of Old Masters hanging in the drawing room offered visitors a ready indication of wealth and taste. Like museum trustees and collectors, late nineteenth-century American painters remained oblivious to European concepts about the revolutionary political aspects of experimental painting. When these painters rebelled, it was against the provincialism in style and taste found in American academies and museums.[6]

It was only in the early years of the twentieth century that some American painters began to claim that art should be closely connected to life and to the pursuit of social justice, ideas similar to those set forth by Gustave Courbet in nineteenth-century France. This new crusading spirit in American painting was led by Robert Henri. Although critics and historians regard Thomas Eakins and Winslow Homer as more significant realistic painters than Henri, he served as a model for a whole generation of American artists. It was Henri who inspired American painters to come out of their studios to search ghetto streets, subway cars, and wrestling arenas for their subjects. Because they chose these mundane urban topics, Henri's

followers became known as "the Ash Can School." In meetings at his studio first in Philadelphia and later in New York, Henri attracted the attention of a group of newspaper illustrators eager to become serious artists. This group included William Glackens, John Sloan, George Luks, and Everett Shinn.

Henri earned the admiration of these painters because he was one of the first American artists to suggest that there could be a clear connection between art and social reform. Like Whitman, Henri had faith in the goodness of the common man and in the ideal of a brotherhood of free individuals. After hearing an impassioned speech by Emma Goldman, he converted that faith into philosophical anarchism. An advocate of libertarian educational reform, Henri accepted an invitation in 1911 to teach evening art classes at the Modern School of the Ferrer Center, an anarchist institution that included Goldman among its founders. Among his students at the Ferrer Center was Leon Trotsky, who studied art for a brief period while in exile in New York.

Though Henri expressed support for anarchism, his radicalism grew more out of his literary interests. He had became sympathetic to individualism and self-reliance after reading Emerson and Whitman. These American authors apparently shaped his thinking on art and politics more than any knowledge he had of European writers or artists. He had lived in Paris during the late nineteenth century and had come to admire the paintings of Courbet, but he never read any of the French tracts on art and politics. While studying in Paris, Henri had almost no personal contact with the European avant-garde or with radical social reformers.

Henri's views on art and life represented a straightforward romantic realism. As he put it, the proper goal for a painter should be to extol "the dignity of life, the humor, the humanity, and the kindness" of the common people.[7] This could be accomplished, he believed, through a realistic style modeled after that of Eakins (see figure 5).

Because Henri had spent considerable time in Europe during the last years of the nineteenth century, he had seen the modernist experiments then taking place there. He incorporated elements from Impressionism and Post-Impressionism into his own art and taught his American students to do the same. However, Henri always denounced "art for art's sake" and characterized technique as "merely a language."[8] Artists might emulate Impressionist brushwork, but it was more important for them to portray the nobility of human beings whatever their social class, race, or nationality.

Because Henri's temperament was a contentious one, he became the natural leader for those artists eager to protest the conservative and genteel tastes of the official American art world. To circumvent reactionary juries, Henri helped organize exhibits for artists who shared his predilection for

unorthodox and unrefined subjects. For example, discouraged with the rigid standards of the National Academy of Design, Henri helped assemble the show The Eight at the Macbeth Gallery in 1908 and the Exhibition of Independent Artists in 1910. The rebellion that Henri led among American painters also extended to an interest in the newest European art and to the staging of its first major presentation in New York at the 1913 Armory Show. Some of Henri's socialist friends also approved of modernist canvases. In the atmosphere of bohemian iconoclasm of the Progressive era, modernist art symbolized one further revolt against bourgeois taste. Before the First World War, Ash Can painters and abstract artists found a common ground in their opposition to the establishment.

Henri and the Ash Can painters shared their radical vision with other intellectuals of their generation. In Greenwich Village before the First World War, painters and other intellectuals belonged to a bohemian community that valued both aesthetic and political radicalism. Mabel Dodge's salon was at the heart of this new interest in art and politics. In the Village, painters like John Sloan drew cartoons for the socialist magazine *The Masses*. At parties they debated questions of politics and art with feminists, socialists, labor organizers, and anarchists. Most of the time, these intellectuals drew optimistic conclusions about the future and foresaw the day when art itself would help bring about a socialist revolution and a classless society.

Historians have characterized Henri and the other radical intellectuals of his era as particularly "innocent." Before the emergence of the international Communist Party and before the revelation of Stalinist excesses, these intellectuals found it a simple and uncomplicated matter to fuse socialism and experimental art. By the late 1930s, however, such "innocence" was no longer possible. For the Abstract Expressionists, optimistic and easy formulas for social change through art had lost their appeal.[9]

Henri's influence persisted well after World War I. Because he taught at the Art Students League until 1928, his views on art and politics spread to the next generation of realistic artists—Edward Hopper, Reginald Marsh, George Bellows, and others. Even though these artists chose to work with little explicit political content, they did focus on the subject matter of the city, its streets, and its people. Like the Ash Can School, they portrayed both the excitement and the alienation of urban life. Henri also served as a model for the Social Realist painters, Ben Shahn, Raphael and Moses Soyer, and Philip Evergood, who identified themselves as leftists. The most famous example of Social Realism, *The Passion of Sacco and Vanzetti* (1931–32), was part of a series by Ben Shahn that depicted scenes from the trial of the Italian immigrants whose execution prompted some of the most important radical demonstrations of the era.

At the beginning of the 1930s, the Communist Party attempted to shape a more politicized art by calling on writers and artists to develop proletarian themes. The Party also tried to organize them for that task through groups like the John Reed Clubs and the Artists Union. These efforts thrived in part because they drew their membership from writers and artists employed by New Deal relief agencies like the Federal Writers' Project and the Federal Art Project. Although the Communist cultural program did foster some class-conscious writing and painting, the major artists of the period, like Shahn, the Soyers, and Hopper, avoided the Party's standards to favor the broader, humanistic approach taught by Henri. For example, advocates of proletarian art painted heroic workers while these American realists presented a much more somber working class. The common people in much of American realistic painting of the 1930s seem almost overcome by their circumstances (see figure 6). Even to the more militant Social Realists, the ultimate victory of the proletariat as prophesied by Marx was not readily apparent.[10]

The urban realism created by Henri and his followers was challenged after World War I by another, more conservative group of realists. These Regionalist painters drew on rural life for their subject matter and claimed that their art was free of European influences. Especially after the beginning of the Depression, these painters felt it was important to reject foreign ideas in order to reaffirm American themes and values. The leaders of this movement, critic Thomas Craven and painter Thomas Hart Benton, condemned modernism as alien to the American character and urged artists to pursue themes drawn from "American life as known and felt by ordinary Americans." Although Benton was a socialist and advocated a close relationship with the people, his murals and easel paintings reflected little of the economic suffering of the Depression. For subjects, Benton and the other Regionalists turned to rural America, particularly the Midwest, where they found a stereotypic, sentimental content that proved to be popular with the public. Even though Benton and the other Regionalists, Grant Wood and John Steuart Curry, believed that their "American" works were free from the "taint" of Europe, their styles were heavily indebted to German and Italian art. For example, Wood's portraits bore some resemblance to the German realism of the 1920s, *Neue Sachlichkeit,* and Benton himself borrowed extensively from Italian Renaissance painting.[11]

During the Depression tension grew among these realists. Benton resented the power of museums and galleries in urban areas like New York and deserted that city in 1935 to live in Kansas City. Urban radical intellectuals also aroused Benton's anger for he considered them a snobbish

elite that knew little about the common people. In a mural he once labeled them "the Literary Playboys League of Social Consciousness" (see figure 7). The Social Realists and the modernists were equally repulsed by Benton's themes and style. In *Art Front,* the magazine published by the Artists Union, the radicals accused the Regionalists of "vicious and windy chauvinistic ballyhoo" that lowered art to "the plane of a Rotarian luncheon." Benton responded by labeling leftist art "inauthentic" and "inhuman."[12]

The bitterness between these two groups can be explained in part by their divergent backgrounds. Many Social Realists and artists drawn to proletarian themes were first- or second-generation immigrants who had been raised in urban ghettos far from Benton's mythic rural scenes. Those who were Jews suspected that the nationalistic tone of Regionalist rhetoric was also anti-Semitic. Craven substantiated those fears in 1934 when in one of his books he called Alfred Stieglitz "a Hoboken Jew."[13] After 1935 German expansion in Europe drew attention to the similarities between Regionalism and Nazi cultural programs. For liberals and leftists, Regionalism came to represent a native fascist art that appealed to racist and nationalistic sentiment. After Stalin declared a Popular Front against fascism in 1935, the American Communists called for an alliance against such isolationistic attitudes. For example, at the first meeting of the Popular Front's American Artists' Congress in February 1936, speakers charged that Regionalism was a manifestation of American fascism.[14]

During the Depression, young Abstract Expressionists like Pollock tended to join the radicals in their denunciations of nationalism in art. Like the Social Realists, a number of them were Jews and had grown up in urban, immigrant communities where they experienced little that would have disposed them toward the tenets of Regionalism.[15] Only Pollock had a direct tie with Benton, through classes he took from him at the Art Students League. However, Pollock quickly disassociated himself from Benton by supporting groups allied with the international left.

Some of the Abstract Expressionists also had close connections with the Henri tradition. Adolph Gottlieb, for example, left high school in 1920 in order to enroll at the Art Students League in classes taught by Henri and Sloan. Newman also studied at the League with Sloan. In 1935 Gottlieb and Rothko helped form an exhibition group called The Ten that wanted to preserve the social tradition of the Ash Can School while it explored the possibilities of formal experimentation offered by European Fauvism and Expressionism. The critic for *Art Front* praised The Ten's effort to combine what he called "a social consciousness with an abstract, expressionist heritage, thus saving art from being mere propaganda on the one hand, or mere formalism on the other."[16] Rothko's paintings of the 1930s represent the closest any of the Abstract Expressionists came to adopting the themes

of the Ash Can School. His works of those years include a number of sub-way scenes with the urban flavor of the Ash Can School, and frozen, despairing figures like those found in the works of the Social Realists.

The Abstract Expressionists also found Benton's nationalism distasteful. Pollock in 1944 wrote that Benton's influence was only important to him as something to reject. Gottlieb and Rothko also demonstrated their disdain for Regionalist subject matter when they wrote to the *New York Times* in 1943 that their work served as an insult to the "Corn Belt Academy." At the beginning of the war, Newman wrote a piece that associated Regionalism with isolationism and Fascism. He charged that Regionalism resembled Nazi ideology because they both used "the 'great lie,' the intensified nationalism, false patriotism, the appeal to race, [and] the re-emphasis of the home and homey sentiment."[17]

Like many other artists of the era, the Abstract Expressionists found an alternative to nationalism in the program of the international left. Ironically, their contact with the left first took place through the New Deal's Federal Art Project, usually regarded as a manifestation of cultural nationalism. One of the purposes of that agency was to stimulate the creation of a national art that was authentically American and easily accessible to the masses. Although Project administrators used this nationalistic rhetoric to win approval for their programs in Washington, they actually hired artists on the basis of need rather than style or politics. Official Project ideology therefore was of little interest or little concern to the Abstract Expressionists.[18]

The importance of the Project to these artists lay elsewhere. Sculptor David Smith, a veteran of the Project, later claimed that it fostered "unity," "friendship," and "a collective defensiveness" among artists on its rolls. Ad Reinhardt praised the Project for the independence it gave the artist. With a government stipend the artist of the 1930s, according to Reinhardt, was freed from the demands of fashion and the dictates of the official art world.[19] The Project provided the Abstract Expressionists with economic support at a time when they especially needed it. Like most modernists, they were from middle-class or lower middle-class backgrounds; but on leaving home to become artists, they found it necessary to support themselves. At a time of economic hardship, pursuit of a career in painting was made possible by the Project.

It was through the Project that these artists first met Communist Party organizers like Alexander Trachtenberg and V. J. Jerome, whose arguments proved to be persuasive to many. Among artists later identified with Abstract Expressionism, a significant number demonstrated their sympathy for the Party by joining the Artists Union or writing for its magazine *Art Front*. John Opper served for a time as the magazine's busi-

ness manager while Harold Rosenberg was one of its editors. Pollock and his wife Lee Krasner first met at a loft party sponsored by the Union. Later she was arrested during a Union demonstration for higher wages for Project workers. Although Arshile Gorky and Willem de Kooning were particularly hostile to most organized artistic and political activity, they also helped build May Day floats for the Party during the Depression. David Smith always professed strong support for socialism and for unions. During the 1930s he wrote for *Art Front* and in 1935 signed the "Call for American Artists' Congress." In the Congress' first exhibition in April 1937, Opper and Smith and two other modernists, John Graham and Adolph Gottlieb, contributed works.

Ad Reinhardt proved to be more loyal to the left than any of the other Abstract Expressionists. A lifelong socialist, he joined the Artists Union immediately after college, and drew cartoons and designed covers for the *New Masses* and *P.M.* long after other modernists had abandoned the left. During the 1940s he continued to support leftist art groups like the United American Artists and the Artists League of America.[20]

Artists sympathetic to modernism participated in the Union and wrote for its magazine because the political aspects of art seemed to be the central issue of the era. But once attached to the Communist Party, these modernists found themselves the subjects of Party control. The Party may have welcomed support from modernists in order to build united cultural fronts, but it also tried to discipline them. In magazines like *Art Front,* Party loyalists sought to keep editorial policy in line with Party pronouncements on culture. Editorial meetings, as a result, became bitter exchanges between those determined to defend the Party line and those more interested in purely aesthetic issues. Both Rosenberg and Rothko became embroiled in such disputes. Gorky in particular wanted the Union to be an organization for artists rather than a political instrument for the Party. Another Union member remembered that Gorky would try to turn meetings to artistic topics by gaining "the floor on the most inauspicious occasions [to] declaim about the contours of Ingres.... [He] seemed to give the impression that Ingres might at any moment lend his support to the cause."[21]

After the Party adopted the Popular Front strategy in 1935, cultural diversity in magazines like *Art Front* became official policy. For example, in 1936 *Art Front* editors asked experimental theater director Frederick Kiesler to review Gorky's Newark airport mural knowing that he would write an enthusiastic piece. In 1937 Jacob Kainen, another critic, writing in *Art Front,* praised the works of Rothko and Gottlieb as "highly charged pictures" that portrayed "vast social passions and portents of doom and regeneration." Smith also earned the admiration of leftist art critics for a series of bronze pieces in which he attacked social injustice and fascism.

The *New Masses* continued to defend Smith as his work grew more abstract because, as one critic put it, his new style gave viewers "a stern pleasure in unraveling his thousand devices, and at last a great fresh shock."[22]

The artists themselves also developed explanations for the revolutionary nature of modernist art. One of the most influential expositions on the relationship between political radicalism and modernist art appeared in John Graham's *System and Dialectics of Art* (1937). A Russian émigré painter and collector with an extensive knowledge of contemporary art, Graham befriended a number of young American painters and introduced them to modernist concepts. Among the Abstract Expressionists, Graham knew and helped Smith, Gottlieb, and Gorky. Historians also agree that he "discovered" Pollock when he put one of his works in a 1942 exhibition of European and American art.

Writing in 1937, Graham compiled a series of questions and answers about the meaning of modernist art and how that art fulfilled a revolutionary role in society. The artist, according to Graham, "is an enemy to the bourgeois society" because he possesses the "ideals of a prophet." Society will not tolerate the true artist since, Graham believed, it cannot tolerate its prophets. Graham also defended modernist art by claiming that the masses could come to like and enjoy it. He even asserted that they wanted to be challenged by difficult art forms. Revolutionaries should also prefer modernist art over realism because, according to Graham:

> Academico-impressionist art methods...only lull the masses gently to sleep, precisely the aim of the capitalist state. Abstract art with its revolutionary methods stirs their imagination...to thinking and consequently to action.[23]

Horrified by the Stalinist purges and the Second World War, Graham retreated from political activism during the 1940s. He also lost the admiration of the Abstract Expressionists when he renounced the influence of Pablo Picasso and spent the last years of his life exploring occult themes in art.

Like Graham and other intellectuals of the late 1930s, the Abstract Expressionists grew progressively more disenchanted with the Communist Party. A series of devastating revelations about Stalinist policies, beginning with the Moscow trials of 1936–38 and ending with the Nazi-Soviet pact of 1939 and the Soviet invasion of Finland in the winter of 1939–40, led to the disintegration of the artistic left. At first artists and writers deserted Stalinist-dominated cultural front organizations to support groups that were still radical yet free from the inconsistencies of Soviet policy. One of the first of these, the League for Cultural Freedom and Socialism, was formed by the Trotskyist intellectuals who wrote for *Partisan Review*. A close

relationship between Leon Trotsky and that magazine's editors began in 1938 when the American journal printed the manifesto of Trotsky's International Federation of Revolutionary Writers and Artists. Signed by the French Surrealist poet André Breton and the Mexican muralist Diego Rivera but written by Trotsky and Breton, the Federation's manifesto called for an end of totalitarian control of art in favor of its complete independence. More sympathetic to the visionary and imaginative aspects of modernist art than any other Communist leader, Trotsky welcomed the support of intellectuals and artists and defended their right to an absolute freedom to experiment with form. Writing to his supporters in 1939, Trotsky attacked Stalin for ordering his "ignorant and insolent bureaucracy" to censor art and "to run amok with arbitrary power." He also argued that "a genuine revolutionary party cannot and will not wish to 'guide' art," because "art can be the revolution's great ally only in so far as it remains true to itself."[24]

During the late 1930s, the editors of *Partisan Review* tried to rally disaffected radicals around Trotsky by creating a home for them in the League for Cultural Freedom and Socialism. The League closely resembled the Federation in its cultural tolerance and its anti-Stalinist stance. Determined to remain truly radical, the League refused to support the war in 1939 since it was a conflict between capitalism and fascism. The League's supporters denounced Roosevelt for leading the world to a war that would not only mean the certain end of free culture but that would also contribute to the continued enslavement of the working class. For example, the League's manifesto called on all American artists, writers, and professional people "to join us in this state of implacable opposition to this dance of war with which Wall Street joins forces with the Roosevelt administration." Socialist revolution remained the goal of the League because it would encourage freedom of the arts. According to the League's manifesto, "the liberation of culture is inseparable from the liberation of the working classes and of all humanity."[25] None of the Abstract Expressionists signed the League's manifesto, but the two critics closely associated with them, Clement Greenberg and Harold Rosenberg, wrote frequently for *Partisan Review* and joined its Trotskyist crusade.

The Surrealists also endorsed Trotskyism in the late 1930s and furnished the American avant-garde with an additional reason to depart from orthodox radicalism. After the Surrealists had tried for years to form an alliance with the French Communist Party, their leader Breton visited Mexico in 1938 to announce his support for the exiled Soviet leader. Beginning as an avant-garde movement devoted to applying Freudian ideas to literary creation, the Surrealists added Communism to their program in 1925 when a revolt broke out in Morocco against French colonial rule.

Breton then became convinced that the destruction of imperialism and capitalism had to precede the revolution of the spirit that he had envisioned as the goal of Surrealism. Describing Surrealist art as revolutionary in its destructiveness, Breton claimed that it went hand in hand with Communist political activity. Its Freudian aspects created havoc and confusion among the bourgeoisie, Breton believed. After an initial enthusiasm for extremism and agitation, the Surrealists grew bored with prosaic Party functions, and the Communists themselves grew suspicious of the artists' sincerity. The final break between the Surrealists and the Stalinists took place in 1935 when Breton slapped a leading Communist literary figure and then was barred from speaking at an international cultural conference sponsored by the Party.[26] Joining the rival Trotskyist camp, Breton set an example for other modernists to follow.

Stalin's invasion of Finland in December 1939 provided disillusioned American artists with a reason to break completely with the Party. After the attack on Finland, the respected art historian Meyer Schapiro, then a prominent Trotskyist and member of the League for Cultural Freedom and Socialism, led a group of dissident painters out of the American Artists' Congress. Because the executive board of the Congress was dominated by loyal Party members, it had issued no statement on the Finnish invasion and had ignored a request for relief aid for Finnish refugees. The Congress had also recently praised a fascist-sponsored art show in Venice and a conference attended by Soviet and Nazi art officials. Meeting to protest these actions, Schapiro and his supporters decided to petition for an open meeting to discuss Stalinist control of the Congress. Among those who signed the petition were Gottlieb and Graham. At a meeting with Schapiro's group in April 1940, the board ignored these complaints and presented a report justifying the Soviet pact with Germany, the invasion of Finland, and the refusal to aid the refugees. The board also pleaded for American neutrality in the war. Characterizing the report as material for a column in the *Daily Worker,* Schapiro and his friends called on all artists to resign from the Congress.[27]

Shortly after leaving the Congress, Rothko and Gottlieb helped start an alternative organization, the Federation of Modern Painters and Sculptors, through which the artists intended to continue their campaign against the Stalinists. Its first statement of aims in 1940 condemned all threats to culture from nationalistic and reactionary political movements, but the Federation reserved its strongest language for Communist and fascist governments that they believed to be the primary threat to freedom of expression. No longer Party loyalists, Rothko and Gottlieb described the Soviet and Nazi regimes as two examples of "totalitarianism of thought and action." Such governments, the statement continued, valued the artist "only as a

craftsman who may be exploited."[28] Unlike the Trotskyists before them, the Federation members abandoned revolutionary socialism and all leftist affiliations.

In ensuing months, the Federation became an active agent for anti-Communism in the art world. It sought to expose Party influence in such organizations as Artists for Victory and Artists' Equity. Its Abstract Expressionist members, Rothko and Gottlieb, led these efforts to destroy the Communist presence in the art world. Their dedication to that cause was so strong that when the Federation voted to cease its political activities in 1953, Rothko, Gottlieb, and sculptor Herbert Ferber all resigned. In a debate over the group's original charter, these Abstract Expressionists urged that the passages in the constitution that condemned the Soviet Union remain intact. When other members voted to delete the reference to the totalitarian nature of the Soviet regime, these three artists protested by leaving the organization. The Federation continued to hold annual exhibits after 1953, but following the departure of these Abstract Expressionists it seldom ventured into political matters.[29]

The outbreak of World War II in 1939 forced Rothko, Gottlieb, and other intellectuals to reexamine their attitudes toward the Soviet Union as the representative society of the future, and to compare its policies more frequently with those of the Nazis. When the United States itself entered the war in 1941, the revolutionary ardor of American intellectuals faded even more and in many cases vanished completely. These writers and painters then translated what had been a distaste for Party censorship during the 1930s into a wholesale repudiation of socialism and Communism. These artists were not alone, for the exigencies of war turned many Americans to the right during the 1940s and seriously weakened what had been fairly widespread support for domestic reform during the Depression. Among artists, Soviet and Nazi manipulation of culture further discredited political art, created a strong distaste for government involvement in the arts, and made modernism seem all the more necessary.

"Red-baiting" compounded the problems for leftist artists and alienated them even more from the radicals. For example, Pollock was particularly vulnerable to this tactic because he was destitute during the 1930s and depended almost exclusively on his wages from the Federal Art Project. When its administrators began firing artists who had signed a petition to allow the Communist Party on the ballot, Pollock and his brother Sanford feared for their jobs. The Pollocks felt disillusioned with their radical friends; Sanford Pollock wrote to another brother in 1940 that he and Jackson felt like "fools" and "suckers" for signing the petition because the real Party people they knew had protected their jobs by refusing to sign. The panic created by "red-baiting" among artists with marginal economic

resources was considerable, especially when they imagined that their punishment would mean induction into the military. Sanford Pollock, for example, wrote to his brother Charles, "when they get us in the Army with the notion that we are Reds you can bet they will burn our hides."[30] By 1943 such fears so permeated the artistic community in New York that a leading radical, Herman Baron of the ACA Gallery, wrote to a friend that these tactics had destroyed the cooperative spirit among artists.[31]

The anti-Communist fervor intensified after the war when conservatives in Congress frequently attacked government-sponsored art shows that contained works by radical artists. One congressman, George Dondero of Michigan, even mounted a campaign against the nature of modernist art itself. In 1949 Dondero complained that the United States had been "invaded by a horde of foreign art manglers, who were...selling to our young men and women a subversive doctrine of 'isms,' Communist-inspired and Communist-connected." Not content merely to point out the radical political ties of some abstract painters, Dondero also detected danger from within abstract art itself. As he explained, "Cubism aims to destroy by designed disorder," and he added, somewhat enigmatically, "abstract art aims to destroy by the creation of brainstorms."[32] These anti-Communist campaigns ended federal support for the arts until the 1960s and closed down programs that had become focal points for the discussion of art and politics.

Ambition also eroded the commitment of these painters to social change. During the Depression artistic life had been unrewarding for the Abstract Expressionists and what recognition they received came through employment on the Federal Art Project and the approval of their fellow artists. When the war began in Europe in 1939, their relatively provincial, isolated lives were transformed by the presence of refugee artists and art collectors. Among the prominent Europeans who sought refuge in New York were André Breton, André Masson, Joan Miró, Piet Mondrian, and Max Ernst.

American painters could now extend their horizons beyond the Federal Art Project and compete for exhibition space and patronage with these masters of modernist art. Exhibition opportunities for American modernists also expanded when Peggy Guggenheim, the heiress then married to Max Ernst, opened the Art of This Century Gallery in 1942. Because the Abstract Expressionists demonstrated an affinity with the tenets of Surrealism, she gave one-man shows to Pollock, Motherwell, Baziotes, Rothko, and Still. These were the first major occasions for these artists to be seen by the public, critics, collectors, and museum officials. Guggenheim herself was so impressed by Pollock's work that after he lost his job on the Project in 1943, she offered him an income of $150 each month in exchange for paintings.

Recognition by the powers of the art world, however, did not mean that the financial situation of these artists changed drastically. Even though Pollock gained a modest degree of economic independence in 1943, other Abstract Expressionists like Rothko, Newman, Still, and de Kooning lacked such security until the 1950s. To the American artists of the 1940s it was not readily apparent that following the modernist path would lead to great wealth.

The final years of the Depression and the long months of the world war marked the end of what historians have described as the Old Left. Clearly the radical movement in the art world disintegrated after the collapse of the American Artists' Congress in 1940 and the demise of the Federal Art Project in 1943. As the war proceeded, observers of the New York art scene frequently commented on the decline of political themes in painting. For example, when art historian Milton Brown returned from military service in 1946, he was astounded by the decline of realism and the popularity of abstract art, which he had once considered the "darkhorse" of American art.[33]

To conclude that political activism and commitment declined during the late 1930s does not mean that there was a truly unified leftist art movement earlier in the Depression. The Communist Party had attracted support from artists as well as from writers and composers, but American painters remained loyal to tastes they acquired outside the Party. First of all, within the art world the ideas taught by Robert Henri persisted and were nourished in classes run by his disciples at the Art Students League. The realistic works created in the Henri spirit never really fit any Party definition of genuine proletarian art. The Communists confronted another obstacle when they discovered that the artists most likely to be radical, like the young Abstract Expressionists, were also drawn to modernist art. Any Communist cultural organization therefore had to demonstrate some level of tolerance for modernism if it were to retain the loyalty of painters like Pollock, Rothko, and Gottlieb. As a result, Communist influence in the art world remained limited and blunted by an older tradition of American realism and by the experimental cultural tastes of the younger artists.

Another cliché associated with intellectual life of this period, "the end of ideology," was coined by Daniel Bell, a principal spokesman for postwar conservatism, to describe the decline of Marxism. Bell concluded that it collapsed when intellectuals realized that the practical nature of the American political and economic system made it a superior one. Critic Clement Greenberg applied ideas similar to those in the "the end of ideology" argument by pointing to the absorption of the Abstract Expressionists in transforming Cubist space and structure, a certain sign to Greenberg that they had forsaken utopian elements in their art.

Curiously, leftist critics have also borrowed Bell's framework for their interpretation of Abstract Expressionism. For example, in 1952 *Masses and Mainstream,* a Communist monthly, attacked Jackson Pollock for his use of "thick layers of paint, either dropped on or spread in aimless convolutions and scribblings." Pollock, according to the magazine, had retreated from radicalism and wanted "to wipe out the real world from painting."[34]

To be sure, these painters consciously chose a course that departed from orthodox radicalism. Later, they also earned great critical acclaim and substantial economic rewards. Their themes and their imagery seemed increasingly introspective, but to characterize their experience as an "end of ideology" is a mistake. If anything they became more ideological after 1940, when they immersed themselves in Surrealist concepts and techniques. Even before 1940, they had found these to be more appropriate artistic concepts than those expounded by Marxists committed to realistic depictions of the class struggle.

One myth about art and politics—the tendency to view leftist political attitudes and modernist painting as mutually exclusive categories—often confuses an understanding of artists like the Abstract Expressionists. From this exploration of Communist cultural programs, Trotskyist dissent, and the example of the Surrealists and John Graham, it becomes clear that the Abstract Expressionists were more likely to interpret modernism as a genuinely revolutionary art form. When subsequent observers put art and leftist politics in separate categories, they distort the sense of possible unity that the Abstract Expressionists saw during the 1930s.

The political implications of Abstract Expressionism derive from the general assumptions about the role of the artist that lie at the heart of modernism. From its beginnings in the nineteenth century, modernism was based on the perception of a severe disjunction between human nature and the political and economic systems of the industrial age. Because the modern world presented these disturbing new situations, artists concluded that traditional art forms had to be discarded and replaced by those more appropriate and meaningful for the new era. Modernist artists assumed that the society around them was hostile and would make this search for new artistic forms an arduous one.

As an adjunct to this aesthetic dissatisfaction, some modernists readily endorsed socialism or communism. For example, Russian modernists greeted the revolution of 1917 with the hope that the new regime would foster new art forms. Other modernists looked not to a socialist future but to a pastoral past and to the restoration of an organic society that suffered none of the disruptions of the industrial, urban order. T. S. Eliot's political views best represent this conservative direction. But common to both the Russian modernists and conservatives like Eliot was a distaste for the course of modern world history.

Like other modernists before them, the Abstract Expressionists agreed with the notion that they created art in the midst of the unfriendly, if not inimical, culture and that their art stood in opposition to it. When they assumed the role of outsiders and critics of the system, they conformed to the model that Henri had established for the American artist, but as modernists, they could not follow Henri's version of romantic realism. Turning from what they believed to be an old-fashioned tradition of American realism, they chose the European modernist vocabulary of forms.

In modernism the Abstract Expressionists discovered an art that possessed a capacity for transforming the consciousness of its audience and for undermining the established order. The abstract nature of their painting, then, did not deter them from attributing political implications to their art; in the eyes of the Abstract Expressionists, modernism was a necessary choice for a culture whose traditional subjects and forms had been exhausted. Believing that it contained the only suitable patterns and possibilities for meaning and significance in the contemporary world, the Abstract Expressionists attempted a fusion of art and politics. They sought to create a modernist art that echoed the radical commitment most of them had shared during the Depression.

Figure 3. Jackson Pollock, lower right, in the Siqueiros
 workshop, 1936. Archives of Laurance Hurlburt.

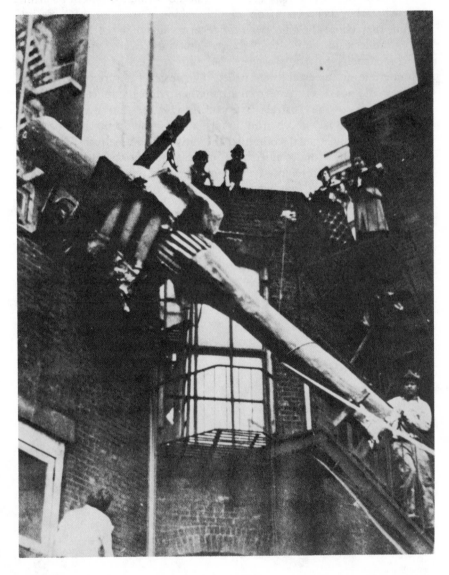

Figure 4. Jackson Pollock in his studio, 1950. Photograph by
 Hans Namuth.

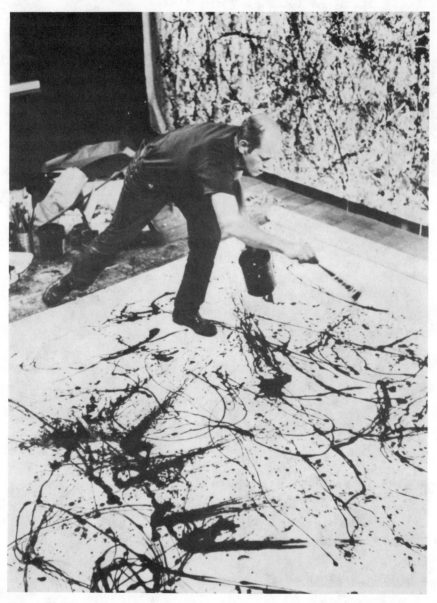

Photo: Hans Namuth

Figure 5. Robert Henri. *Laughing Child*. 1907. Oil on canvas.
24 × 20 inches. Collection of Whitney Museum of
American Art, New York. Lawrence H. Bloedel
Bequest.

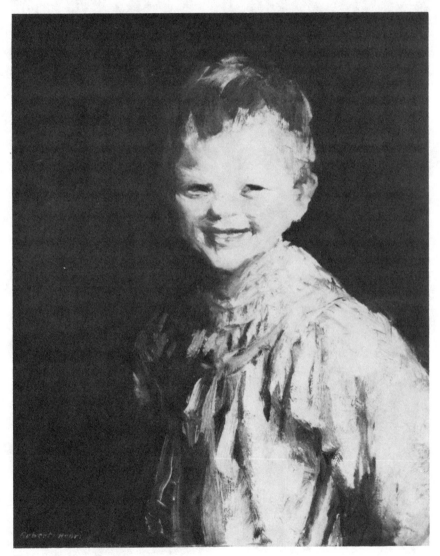

Photo: Geoffrey Clements

Figure 6. Isaac Soyer. *Employment Agency*. 1937. Oil on
 canvas. 34¼ × 45″. Collection of Whitney Museum of
 American Art, New York.

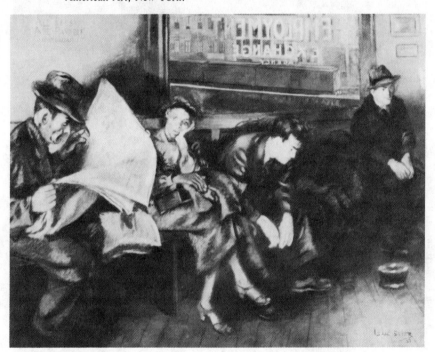

Photo: Geoffrey Clements

Figure 7. Thomas Hart Benton. *Political Business and Intellectual Ballyhoo.* 1932. Tempera with oil glaze on linen mounted on panel. 56½ × 9'5". Collection of the New Britain Museum of American Art, New Britain, Connecticut. Alix W. Stanley Foundation Fund.

Photo: Irving Blomstrann

3

Myth and the Unconscious: The Emergence of a New American Painting

The arrival of refugee artists from Europe in the late 1930s and early 1940s brought an excitement and sophistication previously missing in the American art world. For example, painter William Baziotes abandoned the traditional drawing techniques he had learned in art school after he met several European Surrealist painters in the late 1930s. Before the outbreak of war in 1939, such direct exposure to European artists and art would have entailed a trip to Paris. Unlike previous generations of American painters, Baziotes and many of the other Abstract Expressionists had not studied in Europe. They had limited financial resources during the Depression and preferred to remain in New York where they could work for the Federal Art Project.[1]

One substitute for foreign travel proved to be the exhibits at the Museum of Modern Art, which gave young American artists a systematic and thorough introduction to European modernism. Baziotes, for example, was deeply moved by the Picasso retrospective the Museum mounted in 1939. The show covered all phases of Picasso's career, but it is clear from Baziotes' reaction that the Surrealist works affected him more than any of the others (see figure 8). He later described his intense response to Picasso's Surrealist themes:

> Well, I looked at Picasso until I could smell his armpits and the cigarette smoke on his breath. Finally, in front of one picture—a bone figure on a beach—I got it. I saw that the figure was not his real subject. The plasticity wasn't either—although the plasticity was great. No. Picasso had uncovered a feverishness in himself and is painting it—a feverishness of death and beauty.[2]

Baziotes and other American painters learned principles of composition and space from Picasso's Cubist works, but it was the poetic and expressive content of Surrealism that mattered more to them during the latter years of the Depression.

This Surrealist vision lies at the heart of Abstract Expressionism. Contact with Surrealist images, ideas, and methods during the late 1930s and early 1940s freed American painters like Baziotes from a native cultural tradition dominated by realism and leftist politics. Surrealism, however, did not represent a withdrawal from the public world. On the contrary, as an art movement that grew out of Romanticism and Symbolism, it reflected the modernist assumption that twentieth century man lived at a time of unprecedented catastrophe. According to the Surrealists, it was necessary for the artist to explore this desolation and disarray. In that role the Surrealist artist fabricated new myths to replace the classical and Christian themes no longer meaningful in the modern world. This new mythology rested on Sigmund Freud's interpretation of the human personality and its instinctual and primal elements. Using Freud's analysis of dreams and the unconscious, the Surrealists then recast ancient mythology in a form appropriate for the twentieth century.

The experience of Baziotes illustrates the crucial role that Surrealism played in helping young American artists break with the past and learn new themes and techniques. After Baziotes rejected traditional realism for Surrealist imagery and methods, he remained devoted to these new modernist ideas for the rest of his career. Using automatic drawing to generate primitive organic shapes from the unconscious, he placed his imagery in a dreamlike setting lighted with dim colors. These mysterious atmospheres evoked the undersea world where life first began. They could also be interpreted as Baziotes' vision of the realm of the unconscious. Unlike other Abstract Expressionists, Baziotes never ventured beyond this limited biomorphic Surrealist vocabulary. Less ambitious than his friends, Baziotes proved to be only a minor American painter.[3] His importance lies elsewhere. He embodied the sense of crisis among American painters at the end of the Depression; and he introduced his fellow American artists to Surrealist poetic and visual ideas.

Baziotes discovered Surrealism after considerable traditional training in painting and drawing. The son of Greek immigrants, he left his hometown of Reading, Pennsylvania, in 1933 to go to New York to study at the National Academy of Design. During his four years at the Academy, he learned the standard lessons of his craft from the examples of Rembrandt and Leonardo. Dissatisfied with this conservative schooling, Baziotes tried to incorporate a more contemporary tone of melancholy into his art. To create this more somber modernist feeling, he borrowed drawing techniques from the figural work of Modigliani and from the paintings of Picasso's Blue Period. He also drew on the writings of the modernist French poets Baudelaire, Verlaine, and Rimbaud for inspiration. After art school he worked as a teacher for the Federal Art Project, but he remained as

discouraged about its political and nationalistic milieu as he had been with the conventional drawing lessons at the Academy.

From the European Surrealists that Baziotes met in the late 1930s, he learned that the technique of automatic drawing would produce an elemental and primal imagery more compelling than that found in American realism. The Surrealists had begun using automatism in the 1920s to uncover the forces within the unconscious. According to André Breton, "pure psychic automatism" probed the *"unfathomable* depths" of the mind where there dwelled "a total absence of contradiction" and "a release from the emotional fetters caused by repression." Among the Surrealist painters, André Masson was one of the first to introduce free association into drawing in order to generate forms and then entangle those shapes in a swirling veil of line. The Frenchman never abandoned recognizable figures but found that automatism transformed the meaning of shapes. Because automatic drawing created ambiguity and multiple associations, Masson's forms easily changed identity; they could either be birds, leaves, or vaginal openings (see figure 9).

Another important model for the Americans was Joan Miró who began his paintings by allowing his brush to wander haphazardly over the canvas. He then based his finished work on these automatic ideas. Miró also pasted random bits of paper to his canvas to serve as starting points for his compositions. At times when food and money were scarce, he also drew on hunger-induced hallucinations for images.[4]

Baziotes, already discontent with the mundane and sentimental aspects of American realism and searching for a more poetic content, seized on this new method. Later he recalled the circumstances that led him and other American painters to experiment with the automatic techniques of the Surrealists:

> Got depressed. Couldn't paint. Keep working until almost kill yourself. Then stopped. Suffered a little bit. Then, suddenly one night, usually made five or six gouaches a night, three hundred that night. Flat, Persian miniatures, very distorted, extremely Freudian.... Completely unexpected. Quite a big thing for me.... Kurt Seligmann, famous Surrealist, saw me, wanted me to exhibit.[5]

With this method, Baziotes created works like *Accordian of Flesh* (1942), that echoed the themes found in the writings of Freud and the forms in Surrealist painting (see figure 10). On this canvas Baziotes' forms changed freely from faces to torsos or insects and were surrounded by flowing, intertwined lines. He created a setting that was indistinct and blurred in order to establish an eerie mood typical of Surrealist landscapes. His intention, like that of the Surrealists, was to paint Freud's netherworld of the unconscious.

Baziotes also played a central role in introducing other young American painters to Surrealist techniques. Since he and Robert Motherwell knew the Surrealists well enough to appear in their first major New York show, *The First Papers of Surrealism* (1942), they served as mentors to other, more isolated Americans. Gerome Kamrowski, for example, remembered that it was Baziotes who first showed him and Jackson Pollock how a Surrealist employed automatic techniques in painting:

> Baziotes...did bring Pollock over to the place I was working at Sullivan Street at that time [1941]. Baziotes was enthusiastically talking about the new freedoms and techniques of painting and noticing the quart cans of lacquer asked if he could use some to show Pollock how the paint could be spun around. He asked for something to work on and a canvas that I had been pouring paint on and was not going well was handy. Bill then began to throw and drip the white paint on the canvas. He handed the palette [sic] knife to Jackson and Jackson with his intense concentration, was flipping the paint with abandon... Baziotes had obviously made his point. Jackson was puzzling the thing out and was more or less relaxed about it so we just stopped.[6]

That experimentation with materials and methods proved to be fundamental to Pollock's famous poured, all-over canvases of the late 1940s.

Even though Pollock usually avoided group activity, he was so intrigued by the Freudian games that the Surrealists had invented that he played them with Baziotes and other friends. Together the artists wrote automatic poetry and produced automatic drawings. In the automatic writing game, which the Surrealists called *exquisite corps,* one painter would write a phrase, fold over the paper to conceal what he had written, and pass it on to the next person, who would write another phrase. The process continued around the room to all present; then the completed poem would be read aloud. They also would all write down answers to such questions as "What is a fox?" The answers would then be read aloud as a poem. The drawing games were played in a similar manner. For example, each participant would draw images of the male or the female spontaneously, and then the group would attempt to psychoanalyze them.[7]

In the early 1940s, Baziotes and a group of other Abstract Expressionists joined the Chilean painter Roberto Matta in a futile attempt to form a new Surrealist group to rival that of André Breton. They decided to use automatism as the central feature of their program. As a result, these Americans looked back to the 1920s and the paintings of Miró, Masson, and Ernst for models. Among the American painters that Baziotes tried to recruit for the new group were Jackson Pollock, Lee Krasner, Peter Busa, Gerome Kamrowski, Willem de Kooning, and Arshile Gorky. De Kooning and Busa immediately refused to associate themselves with the plan, and the organizers never managed to assemble an exhibit.

Some of these artists, however, did meet with Matta in an attempt to introduce more coherence and organization into their Surrealist activities. To do that, Matta asked each painter to produce automatic drawings focused on specific themes like fire, water, and earth; the unconscious; or the hours of the day. Lee Krasner recalled that drawings about time were the most interesting for the Americans. Matta also requested that each American keep a log of his thoughts to ascertain if there was any point in time when these painters had a collective unconscious. The results revealed that at four in the afternoon many of these artists believed themselves to be closest to their unconscious. Matta also wanted them to throw dice at each hour and record the score so that additional evidence of collective mentalities could be gathered. Pollock eventually found Matta's guidelines too confining and dropped out of the group. Other Americans grew dissatisfied with the illusionistic aspects of Matta's paintings. Matta too became disappointed with the Americans and abandoned his plan to start his own Surrealist group.

One of the most important manifestations of Surrealism among these American painters was their use of mythic titles. For example, Baziotes painted a canvas called *Cyclops* in 1947. Rothko began studying myth during the late 1930s and used such mythic titles as *Antigone* (1938), *The Syrian Bull* (1943), and *Tiresias* (1944). Gottlieb employed such mythic references as *Eyes of Oedipus* (1941) and *Rape of Persephone* (1943); and Newman chose to name some of his canvases *The Song of Orpheus* (1945), *Dionysius* (1949), *Achilles* (1952), *Prometheus Bound* (1952), and *Ulysses* (1952). Pollock attached his works to ancient myth through the use of titles like *Pasiphaë* (1943) and *Guardians of the Secret* (1943). These mythic titles disappeared after 1947 when only Newman continued to argue that they served as a means of explaining his intentions to the public.

Since the Renaissance, painters have believed that themes and titles from classical mythology were an appropriate way for serious artists to disassociate painting from its status as a craft practiced by artisans. By turning to subjects from classical literature and history, artists, according to Sir Joshua Reynolds, would share the prestige bestowed on poets and philosophers. The Surrealists and the Abstract Expressionists agreed with Reynolds about the importance of art, but they used myth in a very different way. For these twentieth-century artists, mythological references rested on a belief in man's atavistic personality. To modernists, mythic themes offered not an evocation of the hallowed cultural past but a means for freeing poetry and painting from the tyranny of pedantry and politeness. For example, by using myth, painters like Rothko and Gottlieb wanted to reveal what they characterized as the "primeval and predatory" instincts in modern man.[8]

The mythic themes of the Surrealists and the Abstract Expressionists were given form and substance by the ideas of Sigmund Freud and Carl Jung who had used ancient mythology to link primitive and modern man. To illustrate the basic human instincts present in the unconscious, Freud, for example, turned to the legend of Oedipus who killed his father and married his mother. For Freud, these desires were timeless aspects of the human personality. He explained this continuity through Darwinian recapitulation theory for, as he wrote, "each individual somehow recapitulates in an abbreviated form the entire development of the human race."[9] Jung, too, adopted the concept of recapitulation, but stressed that the unconscious had a collective nature that could be traced through common archetypes. In 1924 the Surrealists made Freud the central reference point in their movement. To this Freudian framework, American painters added an interest in Jung. Even before the Surrealists arrived in New York, both Gottlieb and Pollock were well acquainted with Jungian ideas.

During the 1930s the Surrealists discovered that myth offered a means for expressing basic Freudian psychoanalytic concepts. For example, they used the legend of Theseus and the Minotaur to focus on how psychoanalysis can penetrate to the recesses of the mind. In the center of the labyrinth, the human mind, lived the bull-monster, the Minotaur, representing the irrational forces of the unconscious. In order to slay the Minotaur and then escape the labyrinth, Theseus turned to Ariadne's thread, symbolizing human intelligence. During the 1930s the bull was also used to represent political evil in the form of fascism. Picasso, for example, in *Guernica* placed a bull standing for Franco and other fascists in the upper left corner of his canvas and turned its head away from a lamp representing the light of human reason. The Surrealists named one of their magazines *Minotaure,* and Masson chose that myth as a central theme for a number of works in the late 1930s.[10]

During the 1940s this mythological interest reappeared in New York among the European refugees and their American counterparts. For instance, in the Surrealist magazine *VVV* in June 1942, the editors asked a number of European and American artists to rank a series of mythological creatures in order of their attraction. The results of the survey revealed that the five most appealing mythological characters were the Sphinx, the Chimera, the Minotaur, the Gorgon, and the Unicorn. In 1946, in *View,* another Surrealist publication, Harold Rosenberg wrote an essay on Kierkegaard that began by pointing to the parallel between ancient Greek culture and Freudian psychoanalysis. As Rosenberg noted:

> The central intuition of Greek tragedy, as of psychoanalysis, is: there is one unique fact that each individual anxiously struggles to conceal from himself, and this is the very fact that is the root of his identity.[11]

For American intellectuals of the 1940s, this Surrealist interpretation of myth also presented an alternative to Marxism. Although the Surrealists considered themselves Marxists while they lived in New York, their interest in myth aroused the antagonism of more orthodox radicals. Rosenberg attempted to summarize these positions in a short piece he wrote for *View* in 1942. In the form of an imaginary dialogue among three speakers, Rem, Hem, and Shem, Rosenberg recreated the arguments that must have been taking place then among intellectuals and artists. Rosenberg's Marxist character observed: "To be free, man must be free of all myths. Myths are themselves a symptom of enslavement." Rosenberg's Marxist also discounted the social influence of myth by claiming that a system of belief "reflects the unification brought about by material historical factors" and that "the myth of the nation is likewise the shadow of a cohesion already established in fact." On the other hand, another of Rosenberg's characters pointed to the need of even Marxists themselves for myth: "the failure of Marxism to date has been due precisely to the inability of the socialist parties to discover a myth that would mold the workers into a compact fighting brotherhood." He went on to suggest that "Marxism needs an initiation ceremony that will seal the workers to one another in life and in death."[12]

The possible political implications of myth continued to interest the American avant-garde after the war. Rosenberg and Motherwell, for example, included an article on myth and politics in their 1947 little magazine *Possibilities*. In an article by Andrea Caffi, translated by Lionel Abel, myth again appeared as an alternative to Stalinism. Claiming that Marxists often seem to want to create an ideal society without recourse to social communion, Caffi asserted that they overlooked the constructive and generative functions of myth. Following the premise that "mythology determines the relations between individuals in society," Caffi praised the role that it might take in political revolution.[13]

By introducing myth into the New York art world, the Surrealists presented some American artists with an alternative to Marxism and Stalinism. Yet that course did not demand a total renunciation of political radicalism. The Surrealists seemed to be saying that a revolutionary movement that was well-grounded in Freudian concepts and mythological thinking was apt to be more successful. As Lionel Abel, an American Surrealist sympathizer, wrote in *VVV* in June 1942:

> It is time to say frankly that the propaganda art of the last decade was so much waste of time and energy.... But, on the other hand, that art which justifies its conceptless character and lack of social direction under the slogan of 'experimentalism,' does not attract us either.... We support Historical Materialism in the social field, and Freudian analysis in psychology.[14]

Surrealism, then, presented American painters with a modernist art that was political because it sought to create a universal, mythological content based on the concepts of Marx and Freud.

An interest in primitive art and culture was closely tied to the mythic themes of these artists. Because primitive man suffered from less repression than those who live in civilization, he was thought to be closer to his unconscious. Myths and legends from primitive or prehistoric times, then, furnished the artist with material more directly related to the unconscious. For example, in 1945 Breton announced that Surrealism was allied with all peoples of color because they were the victims of white imperialism and because there were "profound affinities between surrealism and 'primitive' thought." He concluded that "both envision the abolition of the hegemony of the conscious and the everyday, leading to the conquest of *revelatory emotion.*" One Surrealist painter, Wolfgang Paalen, particularly admired primitive art and printed reproductions of it in his magazine *Dyn* in the early 1940s. In New York, John Graham and Barnett Newman emerged as fervent defenders of primitive art. Gottlieb collected it during the 1930s; and Pollock admired American Indian art of the Southwest.[15]

By borrowing from ancient myth and primitive art, the Abstract Expressionists hoped to extend the exploration of the unconscious begun by the Surrealists. Toward that end, Gottlieb painted *Eyes of Oedipus* (1941), which portrayed the king's guilt and suffering through his haunted, unseeing eyes (see figure 11). Using the pictograph format, Gottlieb associated his images with primitive, prehistoric cave drawings. The king's eyes, as the gate to the mind, functioned as symbols for the unconscious. This Gottlieb painting represents one of the few attempts by the Abstract Expressionists to employ concrete mythic imagery.

After turning to a mythic content in the early 1940s, Rothko and Gottlieb issued statements defending their choice and attacking American realism. They published their first mythic manifesto in the *New York Times* in 1943 as a reply to a critic who they felt had misinterpreted their art. With Newman's help in writing the statement, they dismissed representational art as an inadequate means to depict the violence and cruelty they saw in the world around them. They argued that the only appropriate subject matter for the era was a "tragic and timeless" one and that myth would allow them to explore these "primitive fears and motivations." To show their disdain for realism, the artists added sarcastically, "Would you have us present this abstract concept with all its complicated feeling by means of a boy and girl lightly tripping?"[16]

The contemporary political crisis among intellectuals accounted for part of this new interest in myth. Like other Depression artists, Rothko

and Gottlieb had been absorbed in the milieu of realism and radicalism forged by Robert Henri and later intensified by the Communists. Though drawn to modernism, they pursued it with a social conscience. As the international political crisis grew more complex in the late 1930s and early 1940s, these artists concluded that a political art could no longer be concrete but had to be universal. At the same time that they withdrew from the organized left, they were using myth. The atavistic implications of Surrealism offered a much more compelling interpretation of man's nature. At a time of totalitarianism and mass murder, Henri's political vision seemed naive, and Stalinism, bankrupt.

While the imagery in Gottlieb's *Eyes of Oedipus* (1941) was easily identifiable and directly linked to an ancient myth, most other mythic works lacked such specific symbolism. For example, when Gottlieb painted *Rape of Persephone* in 1943, he avoided any forms that might suggest the elements that comprise that legend (see figure 12). Instead of a realistic representation of Persephone and Pluto, Gottlieb relied on the automatically generated organic forms of abstract Surrealism. Therefore, the painting cannot be "read" in a literal sense. Yet these biomorphic forms are meaningful in another way. Gottlieb's shapes and colors conveyed what he considered to be the "poetic essence" of the myth. In earth colors, these primitive organic shapes evoked the recurring cycle of nature through the use of ambiguous sexual forms.

Gottlieb's biomorphic vocabulary also appeared in the works of most of the Abstract Expressionists during the early 1940s. Borrowed from the works of Jean Arp, André Masson, Joan Miró, and other painters, the semi-abstract natural form was by 1940 a standard part of modernist painting. Among these American biomorphists, Newman dealt with flat, quiet, and simple forms resembling single cell organisms. Rothko, Stamos, Gottlieb, and Baziotes all used forms that suggested primitive life forms from off the ocean floor. Some of these marine forms were immobile, but others were more animated and more indicative of conflict and tension. Rothko also divided his canvases into horizontal planes that recalled geological layers in the earth's surface where fossilized protozoa lay embedded. Pollock's works of the early 1940s used human rather than animal or plant forms. On the other hand, Gorky's biomorphic shapes were both vegetable and human and usually presented in a disguised manner. De Kooning's biomorphic abstraction centered on the disintegration of the human anatomy while Clyfford Still chose an ominous skeletal imagery either in elongated human form or in more ambiguous bony shapes. Some of their titles reflected this interest in biological and reproductive images. Rothko's *Birth of Cephalopods* (1944) and Newman's *Genetic Moment* (1947) are two examples.[17]

Biomorphic imagery provided the Abstract Expressionists with the ambiguity and the poetry that they wanted in their interpretations of myth. Like atavistic mythological themes, biomorphic forms were thought to be appropriate for the modern world. Rejecting machine imagery and industrial and urban landscapes, these artists entered into a pastoral world that was primitive and elemental. This primal biomorphic world was also evocative of the unconscious realm, and supplied the necessary psychological and sexual allusions for an art based on the ideas of Freud and Jung. To return to the simple, early forms of life implied, further, a profound and momentous content. In 1945, for example, Breton praised one of Gorky's biomorphic works, *The Liver is the Cock's Comb* (1944), for the way its allusive, semi-abstract natural shapes served as *"springboards* towards the deepening...of certain spiritual states."* According to the leader of the Surrealists, in Gorky's paintings, "nature is treated here like a cryptogram upon which the artist's previous tangible imprints have just left their *stencil,* in the quest for the rhythm of life itself."[18]

Many of these artists used automatic drawing to produce their biomorphic imagery. It was believed that these allusive organic shapes were material directly drawn from the unconscious. It was this conjunction of automatic drawing and biomorphic forms that furnished the fundamental characteristics of gesture painting. As one of the two broad categories of Abstract Expressionist art, gesture painting embraced the Surrealist faith in the spontaneous movement of the hand and its abstract organic vocabulary. As a group, then, Jackson Pollock, Willem de Kooning, and Franz Kline continued to construct their art on premises borrowed from Surrealism and from Freudian psychoanalytic concepts.

Surrealist techniques gave the gesture painters an opportunity to loosen their drawing. Before this encounter with automatic drawing, they were a diverse group. As a young artist, Franz Kline had been the least affected by modernism for he remained a figurative painter until 1947. Willem de Kooning, on the other hand, considered himself a modernist during the Depression. Following the example set by his close friend Arshile Gorky, he had painted figures using compositional principles from late Cubism. When he discovered Surrealism, he began to fragment, soften, and confuse what had been a relatively rigid Cubist structural format. Jackson Pollock worked through Regionalism and Social Realism very quickly to model his painting after the more Expressionist Mexican muralists, the Surrealists, and Picasso. Unlike Gorky and de Kooning, Pollock found the ordered and rational optical aspects of Cubism too confining and chose instead to work with the dramatic chiaroscuro and extravagant style that he admired in Mexican and Surrealist painters.

Among the gesture painters, Pollock emerged as the most original. Between 1947 and 1950, he developed images composed with an all-over web of interlaced lines and swirls of paint, a style that grew out of years of experimentation with media and methods. Even early in his career, he had drawn quickly and spontaneously, crowding his works with a multitude of recognizable and abstract shapes. In the Siqueiros workshop in 1936, he had apparently used spray guns and air brushes. Then with the arrival of the Surrealists in New York, he and his friends, as we have seen, poured paint in an automatic fashion. In 1947 after these years of trial, Pollock fused painting and drawing into the famous poured canvases. By joining and merging automatic line into a single image, he achieved pictoral unity. Immersing himself in automatism, Pollock transformed what had been a Surrealist technique for forcing inspiration from the unconscious, confined to the movement of the hands of Masson and Miró, into an activity that involved the whole body of the artist and initiated an entirely unique painting style.[19]

Automatic line was in and of itself expressive — tortured, twisting, and dissolving in and out of its ground. Yet the gesture painters remained determined to enhance those qualities even further. Like other modernists, they discovered that one certain way to intensify the power of their images was to eliminate extraneous elements from their art. They chose to do so by reducing their palette to black and white. No longer distracted by the variety of associations created by color, viewers could concentrate on the poetic resonance of the automatic line and the spontaneous brushstroke.

All three of the major gesture painters worked in black and white, but the painter most closely identified with that decision was Franz Kline (see figure 13). When his first one-man show of abstract black and white paintings was held at the Egan Gallery in 1950, critics compared his art to Oriental calligraphy. It was, however, totally Western in origin since it was based on value contrast. To critic Clement Greenberg, for example, Kline's paintings represented an "extreme statement" of the quantitative differences of illumination present in easel painting since the Renaissance.[20] Like the other gesture painters, Kline developed a style that reflected the energy and speed with which he worked. Yet his paintings seem spare and clear when compared to the dense and ambiguous imagery in a Pollock or a de Kooning. With an austerity of means, Kline combined an amplification of image. Some of his canvases were six or eight feet in width and were painted with correspondingly larger brushes, sometimes six or eight inches wide.

Kline chose black and white imagery for expressive reasons. It intensified the reading of the brushstroke and lent a sense of drama and portentousness to his art. Another Abstract Expressionist, Robert Motherwell, also narrowed his palette to black and white, to instill a serious and omi-

nous tone in his works. Motherwell's most important works, the series *Elegies to the Spanish Republic,* begun in 1949, consisted of black ovals or rectangles in a frieze-like sequence on a white ground. By choosing to associate the Spanish Civil War with black and white imagery, Motherwell reminded his viewers of the desperation and hopelessness of a time when liberty and democracy met defeat at the hands of fascism. In *Guernica,* a painting with a similar theme, Picasso had also chosen to eliminate color. Motherwell, however, used shapes with only vague biomorphic connotations, because he believed that simple black and white forms conveyed the tragedy of Spain as well as Picasso's more naturalistic imagery.

Gesture painters also recognized that the human figure remained a fertile expressive means. For instance, Pollock after 1950 expanded his work from the wall-size, all-over webs of automatic line to canvases with some figural imagery. One of his last works, *Portrait and a Dream* (1953), contained more recognizable elements than any of the other later works. Using two masses of automatic line as a structure, Pollock added a face to one to illustrate directly the Freudian separation of the conscious and the unconscious. In a 1956 interview, Pollock explained that he used both representational and nonrepresentational imagery because his art originated in his unconscious.[21]

De Kooning remained even more attached to the human figure and returned to it in the early 1950s to paint his famous series of women (see figure 14). Attracted by the expressive possibilities of the figure, de Kooning portrayed his women on canvases that were dense, crowded, and extravagant in color and forms. As an artist particularly sensitive to the history of art, de Kooning dismissed the notion that modernist art had to be totally abstract. He believed that the modernist could continue the tradition of female imagery that stretched back to primitive idols, classical statuary, and Renaissance nudes. Describing abstract art as too utopian, he wrote that he chose the human figure because it possessed "the emotion of a concrete experience." Oil paint, he argued, was particularly well suited for the color and texture of human flesh, "the stuff people were made of." He deliberately sought out what he called the "vulgarity" and the "fleshy" qualities in art. For de Kooning, the intersection of abstraction and naturalism was at the heart of modernist painting.[22]

De Kooning's obsession with the figure rested in part on his interest in eroticism. He shared that preoccupation with other Abstract Expressionists and with the Surrealists. The exploration and examination of man's sexual instinct was fundamental to Freudian psychology and to the Surrealist poetry and painting based on its premises. Like the abstract Surrealists Miró and Masson, American painters preferred an ambiguous and permissive eroticism. In an art with such multiple levels of meaning, what

resembled a breast could also be a leaf or an eye. De Kooning's friend Gorky filled his canvases with erotic shapes closest to those of the abstract Surrealists. De Kooning's sexual imagery, however, focused on the female figure. Like the Surrealist painters before him, he treated it violently with visible, unordered brushstrokes making his interpretation of female sexuality one that stressed the bawdy, the frenzied, and the destructive.[24]

Though the gesture painters moved away from the use of mythic themes and biomorphic forms to develop more abstract styles, the basic content of their works still reflected the influence of Surrealist ideas and techniques. At the heart of gesture painting stood the spontaneous, unordered brushstroke, an element that grew out of Surrealist automatism. As gesture painting matured, it generalized this automatic impulse and its Freudian associations, but in its imagery it still affirmed the notion that the free movement of the hand is more meaningful than any conscious direction by the artist. The gesture painters' figural work also retained a central Freudian aspect. Pollock always claimed that his shapes emerged from the unconscious; and de Kooning explored the ominous and dangerous aspects of female sexuality.

The other major group of Abstract Expressionists, the color-field painters, eliminated most of the overt traces of Surrealist imagery and technique from their art. Unlike the gesture painters, Barnett Newman, Mark Rothko, and Clyfford Still discarded automatic drawing and organic shapes in the late 1940s. Still and Rothko also stopped titling their paintings. Only Newman persisted in associating his art with mythic themes. In their writings, they also denounced Surrealism and denied its influence on their works. For example, in 1968 Newman wrote the editor of *Art News* to complain about an article that compared his art to that of Max Ernst. Newman asserted that his paintings were, instead, "a confrontation with Surrealism." Still not only rejected Freud and Surrealism but also "all cultural opiates, past and present."[24]

Among the color-field painters, Clyfford Still was the first to remove all direct references to Surrealism from his art. Like the rest of the Abstract Expressionists, he had worked with the biomorphic vocabulary during the early 1940s (see figure 15). But he eventually put aside his bony, skeletal imagery to create works that were large, totally abstract, and dominated by broad expanses of color. Writing in *Partisan Review* in 1955, critic Clement Greenberg identified Still as the central figure in color-field painting. The critic also argued that this style represented the most revolutionary painting to emerge since Cubism. For Greenberg, Still and the other color-field painters advanced the modernist visual canon by refusing to work with value contrast and sculptural shading. Like Turner and the

Impressionists, the color-field painters avoided the juxtaposition of light and dark colors in order to achieve what Greenberg called a unified or "all-over" effect.[25]

Still's color-field paintings were composed with irregular patches of color broken occasionally by smaller areas of color or uneven lines. This irregularity in form and in placement separated Still's works from the more precise and rigid format found in geometric abstraction. An iconoclast who tried to set his art apart from the history of painting, Still denounced traditional notions of beauty and traditional treatments of space, form, and color. His dour palette defied appeals to the sensuous properties of color; he banished all hints of three-dimensional space; and he refused to accept the size of the canvas as a limitation on his art. Some observers have tried to compare Still's imagery with flames, crevices, or the vast, empty plains of North Dakota where he was born, but he rejected such naturalistic interpretations. In 1947, to discourage critics from drawing such conclusions about his art and to disassociate it from specific themes, he replaced his mythic titles with dates, letters, and numbers.[26]

Still's paintings apparently helped shape the work of Rothko and Newman in the late 1940s. Like Still, Rothko began painting large, abstract canvases in the late 1940s when he also dropped most references to myth and nature in his titles. Yet unlike Still, Rothko was a colorist who composed his works with warmly hued and softly modulated rectangles centered on the canvas and floated on an indeterminate ground. By applying his paint thinly and by muting the edges of his rectangles, Rothko allowed them to oscillate and to dissolve in and out of the ground.

First shown publicly in 1950, Newman's mature canvases were equally large and similarly intense in their use of fields of color. They contained broad areas of a single hue that was divided by thin, uneven bands of contrasting paint. Some were in a horizontal format, but most of the stripes were vertical. On first glance, it seemed that Newman had used his stripes to divide space in an irregular fashion. Subsequent observers, however, have discovered that Newman devised a "secret symmetry" within many of his works.

By 1950 the color-field painters had established the wall-size canvas as a primary feature of their art. In Still's works, the large size lent to them a sense of the infinite and the boundless and represented part of his attempt to destroy the limits and the tradition of easel painting. One of the first of Still's large works (*1947-S*), a painting in irregular fields of black, red, and white, with one partially obscured short blue line and two smaller patches of yellow, measured eighty-four by seventy-one inches (see figure 16). Newman adopted the wall-size canvas in 1949 in *Be I,* a cadmium red work divided by a thin line of white paint running down the center, that was

ninety-four by seventy-six inches in size. Rothko also significantly enlarged his canvases after 1949, when one of his works, *Violet, Black, Orange, Yellow on White and Red,* measured eighty-one and one half inches by sixty-six inches (see figure 17).

As Greenberg pointed out in 1955, the properties of color-field painting made it seem far removed from Surrealism and closer visually to Impressionism. Its imagery clearly did not reflect the automatic drawing and biomorphic form central to gesture painting. These artists also publicly disassociated their works with Surrealism and from the unconscious. Yet, there was some fundamental continuity between Surrealism and color-field painting. First of all, the manipulation of light and atmosphere was a primary element in both types of painting. In addition, the premises of color-field painting closely resembled those of Surrealism. Both groups of artists assumed that they were seers and that their art had a prophetic, divining function in society.

From Surrealism the color-field painters learned that light and atmosphere could be used to establish a disquieting tension between the work and its viewers. In the paintings of Giorgio de Chirico, Yves Tanguy, Salvador Dali, and other Surrealists, a mysteriously lighted landscape served to place the imagery in the unconscious or in the dream. These works became theatrical dramas in which Freudian concepts could be visually illustrated. Disembodied shadows, cloudy horizons, and eerie lighting created the disturbing environment necessary for the Surrealist exploration of the unconscious.

The color-field painters took this interest in light and atmosphere and translated it into a more generalized, less specific meditative field. Unconcerned with the concrete depiction of Freudian ideas, these American painters yet wanted art to be engaging and disconcerting. Newman and Rothko both wanted viewers to stand close to their paintings and to be enveloped in them. The large scale of the works combined with their compelling areas of color and evocation of light created a special and intimate environment for their audience. These artists also asked that their works be exhibited in groups to give them additional force as a meditative experience. Rothko compared viewer response to his works with theatrical dramas in which audiences could contemplate the tragedy of human history.[27]

The color-field painters also shared the Surrealist perspective on the modern world and its culture. Even though they did not employ a Freudian framework to interpret the world around them, they concluded that there was a fundamental malaise at the heart of contemporary society. Like the Surrealists, they believed that it was their purpose as artists and seers to reveal the disjunctions and dislocations around them. For example, in 1947 Newman wrote that he and his friends portrayed in their paintings "the

mystery of life, of men, of nature, of the hard, black chaos that is death, or the grayer softer chaos that is tragedy." Still proclaimed in 1959 that his works had qualities that could change the course of history. He asserted that "a single stroke of paint, backed by...a mind that understood its potency and implications, could restore to man the freedom lost in twenty centuries of apology and devices for subjugation."[28]

For Rothko, abstract color-field painting allowed the opportunity to depict "the exhilarated tragic experience" of life, what he called "the only source book for art." He explained that he had abandoned representational art because drawing the figure could only evoke the theme of "human incommunicability," not the more momentous goals he sought in art. In Rothko's opinion, realists often mutilated the human figure for expressive ends. He could no longer accept that path because he believed that no figure could "raise its limbs in a single gesture that might indicate its concern with the fact of mortality."[29] For these color-field painters, the purpose of art was to illustrate the profound spiritual discontent they perceived in the society around them. Like the Surrealists they also hoped that through art they could transform that society.

Though the Abstract Expressionists chose different artistic paths in the late 1940s, their art still reflected their experience with Surrealism. In the gesture painting of Pollock, de Kooning, and Kline, there was a strong continuity between Surrealist automatism and their use of the paint brush. In addition, Pollock and de Kooning continued to employ figural imagery that was based on Freudian notions of the unconscious and sexuality. The color-field painters may have rejected more of the Surrealist heritage, but it was the lens through which they viewed the world around them. The psychic distress at the heart of Abstract Expressionist painting owes much of its power to examples furnished by the European Surrealists.

At the same time that the Abstract Expressionists learned a great deal from Surrealism, they also found the doctrinaire nature of the movement unsuitable. None of the Americans ever became close to the Surrealists or joined the group. The relationship was intense in matters of art and artistic techniques but not in terms of personal friendships and alliances. The Americans also showed little interest in forming their own Surrealist group. There was no American Breton and only sporadic group activity involving Surrealist games. The Americans were already aware of Jung and preferred to deal with psychoanalytic themes on a more generalized level than the Surrealists. Just as these painters had removed themselves from leftist political groups at the end of the Depression, they also kept themselves independent of the Surrealists.

Yet the lessons learned from the Surrealists were the most pervasive influence on Abstract Expressionism. Surrealism taught these American painters that the only content that mattered derived from the unconscious or the dream, from the interior rather than the exterior world. This perspective was not a subjective one but rather a scientific, impersonal exploration of forces and instincts common to the human race throughout time. Because of its "timeless" nature, Freudian psychoanalytic theory spoke not only of individual maladjustment but of longstanding, powerful drives within all men and all cultures.

Psychoanalytic explanations for human behavior seemed particularly appropriate to these artists during the 1940s, when Marxian class analysis had proved inadequate to explain the evil and brutality of the modern world. Surrealism furnished these Americans with the methods and concepts for understanding human history and for revealing its metaphysical desolation. It was from Surrealism that Abstract Expressionism acquired its political resonance.

Figure 8. Pablo Picasso. *Seated Bather*. 1930. Oil on canvas.
64¼ × 51″. Collection of the Museum of Modern Art,
New York. Mrs. Simon Guggenheim Fund.

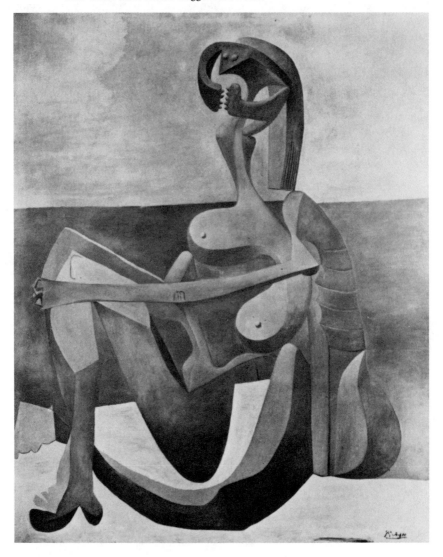

Figure 9. André Masson. *Battle of Fishes*. 1926. Sand, gesso,
 oil, pencil, and charcoal on canvas. 14¼ × 28¾".
 Collection of the Museum of Modern Art, New York.
 Purchase.

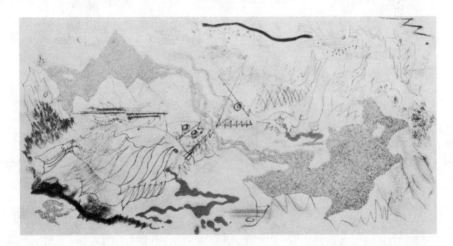

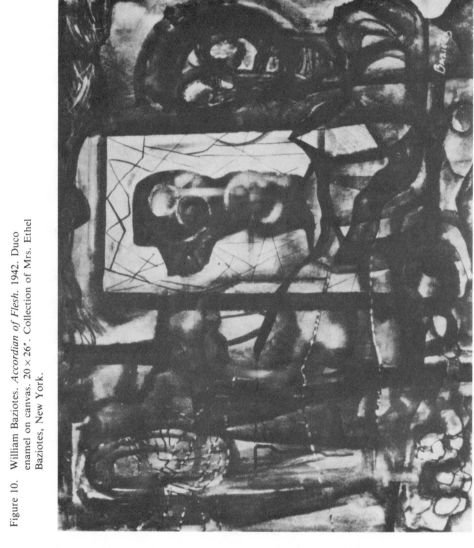

Figure 10. William Baziotes. *Accordian of Flesh*. 1942. Duco enamel on canvas. 20 × 26″. Collection of Mrs. Ethel Baziotes, New York.

Photo: Jeffrey Wayman

Figure 11. Adolph Gottlieb. *Eyes of Oedipus.* 1941. Oil on
canvas. 32¼ × 25″. Collection of Mrs. Adolph
Gottlieb, New York.

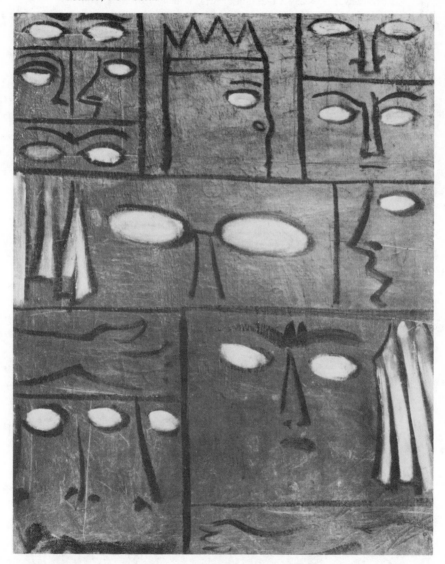

Photo: Otto E. Nelson

Figure 12. Adolph Gottlieb. *The Rape of Persephone.* 1943. Oil
on canvas. 33 × 25″. Collection of Mrs. Annalee
Newman, New York.

Photo: David Preston

Figure 13. Franz Kline. *Chief*. 1950. Oil on canvas. 58⅜ × 6'1½".
Collection of the Museum of Modern Art, New York.
Gift of Mr. and Mrs. David M. Solinger.

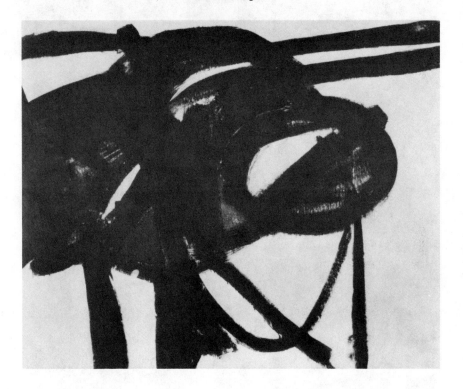

Figure 14. Willem de Kooning. *Woman I*. 1950–52. Oil on
canvas. 6′3 ⅞″ × 58″. Collection of the Museum of
Modern Art, New York. Purchase.

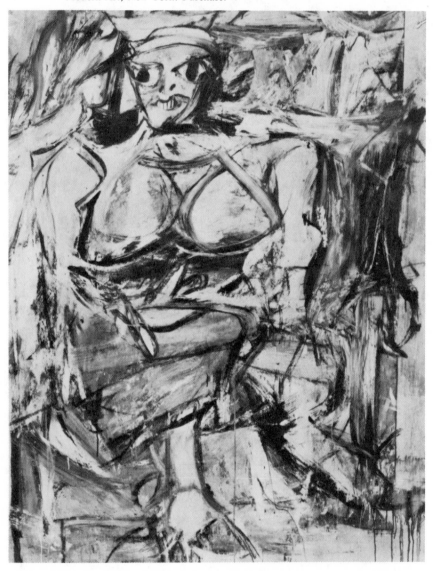

Figure 15. Clyfford Still. *Untitled*. 1945. Oil on canvas.
70⅞ × 41¹⁵/₁₆″. PH-233. Collection of the San
Francisco Museum of Modern Art. Gift of Peggy
Guggenheim.

Figure 16. Clyfford Still. *1947–S*. Oil on canvas. 84 × 71″.
 PH-371. Collection of the San Francisco Museum of
 Modern Art. Gift of the artist.

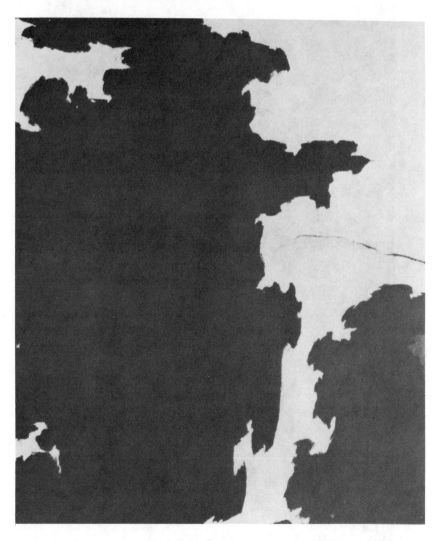

Figure 17. Mark Rothko. *Violet, Black, Orange, Yellow on White and Red.* 1949. Oil on canvas. 81½ × 66'. Collection of the Solomon R. Guggenheim Museum, New York. Gift of Elaine and Werner Dannheisser and the Dannheisser Foundation.

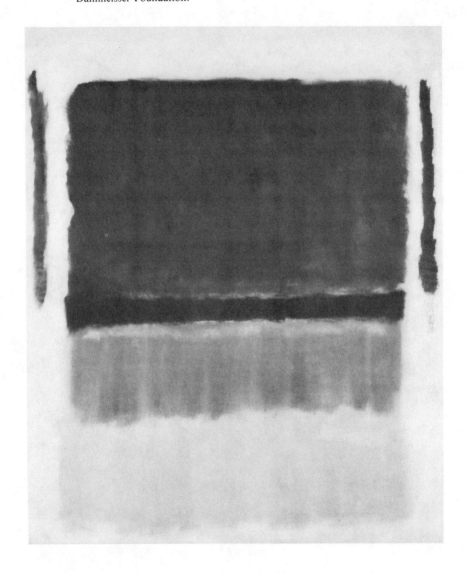

4

Utopian Color: Anarchism and the Art of Barnett Newman

One of Barnett Newman's most important paintings, *Vir Heroicus Sublimis,* demonstrates the difficulty of interpreting abstract art (see figure 18). First of all, this canvas seems to be only an exercise in the treatment of form and color. Minimalist sculptor Donald Judd, for instance, believed that Newman's painting was defined by its visual qualities alone. In his description of it, he ignored any metaphorical or symbolic possibilities and focused on its properties as an object:

> *Vir Heroicus Sublimis* was done in 1950 and the colour of one stripe was changed in 1951. It's eight feet high and eighteen long. Except for five stripes it's a red near cadmium red medium. From the left, a few feet in, there is an inch stripe of a red close in colour but different in tone; a few feet further there is an inch of white; across the widest area there is an inch and a half of a dark, slightly maroon brown that looks black in the red; a few feet further there is a stripe like the first one on the left; a foot or so before the right edge there is a dark yellow, almost raw sienna stripe, the colour that was changed. These stripes are described in one sequence but of course are seen at once, and with the areas.

Though Judd devoted his attention to the details of the work, he primarily admired the way in which Newman's painting could be understood at once in a single glance as a single image. For this sculptor, Newman's work was also impressive for its "openness, wholeness, and scale." His color was equally compelling and was, in Judd's words, "full" and "rich."[1]

Other artists and critics agreed with Judd about the importance of the formal properties of Newman's paintings. For critic Clement Greenberg, Newman's treatment of space marked a turning point in modernist painting. Because Newman rejected traditional depictions of the three-dimensional world, Greenberg believed that the artist introduced a new kind of space in the form of an oscillating "flatness." Since Newman had also shifted his drawing away from value contrast, Greenberg argued that he and the other color-field painters of the postwar era had finally broken the sway that the

Cubists had long held over other abstract artists. In place of the linear grid and the irrational modeling of the Cubists, Newman chose, according to Greenberg, to work in a large format that drew the viewer into "the darkened, value-muffling warmth of color." Greenberg also admired the scale of Newman's paintings. To this critic, a painting in cadmium red that measured eight by eighteen feet overcame the tendency of color to be merely decorative. Like Judd, Greenberg praised the way that Newman's works attained unity and coherence through simplification.[2]

In statements about his own works, however, Newman himself vehemently denied that he dealt only with color and shape when he painted. Again and again, Newman asserted that his aim was not to create beautiful objects but to express ideas. As he put it, "the basis of an esthetic act is the pure idea"; "the central issue of painting is the subject-matter"; and "it is the artist's intention that gives a specific thing form." By making ideas central in his paintings, Newman believed his art would be elevated to the "sublime" realm of philosophy. Metaphysical discourse in painting seemed to Newman to be achieved best through an abstract visual vocabulary. Abstract shapes, according to Newman, transcended the preoccupations of the everyday world and were an appropriate means for exploring the mystery of life and death.[3]

Because Newman sought what he called a "penetration into the world mystery," he also characterized his art as a religious one. Yet to this artist, painting was not a way for inducing piety in viewers. Instead Newman borrowed subjects from Christianity and Judaism to use as metaphors for what he characterized as a search for "the basic truth of life which is its sense of tragedy." His most important series of religious works, a group of black and white abstractions entitled *The Stations of the Cross,* addressed, the artist claimed, "the unanswerable question of human suffering." In his opinion, abstraction was a more meaningful way to deal with these themes than the sentimental illustrations that were usually associated with Christ's crucifixion. He argued that looking at his abstract black and white works produced an experience similar to that of the "first pilgrims [who] walked the Via Dolorosa to identify themselves with the original moment...[and] to stand witness to the story of each man's agony; the agony that is single, constant, unrelenting, willed—world without end."[4]

When Newman identified the artist's purpose as a quasi-religious pursuit for truth, he demonstrated his belief in one of the key concepts of nineteenth-century Romanticism. Throughout his life Newman remained firmly committed to the Romantic notion that the artist possesses insight into the human condition and can lead the rest of mankind toward knowledge. In Newman's opinion, the artist should never resort to the manipulation of color and form for their own sake. In plain terms Newman felt

that the artist should search for truth. In a language familiar to the readers of the German Romantics and the American Transcendentalists, Newman portrayed the role of the artist as an exalted one. According to this painter, he and the other Abstract Expressionists sought "the absolute emotions" through an art that seeks to understand the mysteries of life, nature, and death. This knowledge superseded that gained by the scientist or the engineer. As Newman wrote, artistic truth remained paramount for "man's first expression, like his first dream, was an aesthetic one."[5]

Like the Romantics, Newman and other American painters of the 1940s pursued these themes through the study of nature. While nineteenth-century landscape painters had hoped to show the glory of God's handiwork in their depictions of the natural world, Newman felt that concrete natural imagery was no longer necessary. He claimed that he was not interested in trees, animals, or the sea but in the state of meditation or "communion" that one could attain in a natural setting. This process of contemplation would result in what Newman called "totemic affinity" with natural objects.[6]

After Newman's death in 1970, another major interpretation of his art appeared. In an exhibition catalog for the Museum of Modern Art in 1971, Thomas B. Hess contended that Newman had developed a "secret symmetry" in his paintings that relied on the carefully calculated placement of his stripes. Using the material found in Newman's library, Hess concluded that the painter had chosen to work with vertical stripes and secret symmetry because of his interest in the Kabbalah, the Jewish mystical tradition. Though Newman had read these texts, he himself had never used the Kabbalah to explain his art. Hess, however, pointed out that Newman's vertical stripes could be compared with the images of God's omniscience that the artist had seen in ancient Jewish texts. Hess discovered one likely source in these lines from the Jewish hymn "Zohareriael, Adonai, God of Israel," in the *Greater Hekhaloth:*

> With a gleam of His ray he encompasses the sky
> and His splendor radiates from the heights.[7]

Hess also found that Newman had titled many of his paintings with names and phrases from the Old Testament that were significant to Jewish mystics. The first painting that used the vertical stripe, *Onement* (1948), a work with an orange stripe on a dark red background, referred, according to Hess, to the Day of Atonement, a time when Jewish mystics traditionally meditated on the coming of the Messiah.

Hess described Newman's fascination with secret symmetry as a seeking of "a power hidden within a power." Citing Gershom Scholem, the

leading authority on Jewish mysticism, Hess asserted that Newman, by using secret symmetry, was identifying the artist with Abraham who "on the strength of his insight into the system of things and the potencies of letters," could "imitate and...repeat God's act of creation."[8] Hess supported this thesis by noting that this secret symmetry first appeared in a 1949 painting that was, appropriately enough, entitled *Abraham* (see figure 19). Seven feet high and three feet wide with a shiny black stripe on a mat black field, the work at first glance seems to be asymmetrical. Yet the stripe, located on the left side of the work, actually bisects the canvas with its right edge. In addition, the width of the stripe is one-third the width of the section on its right and one-half the width of the left-hand section. The mathematical relationship among the sections of *Abraham,* according to Hess, can be understood as 2a-a-3a. Only through careful scrutiny and measurement would the viewer ascertain the existence of this pattern.

The painting admired by Judd, *Vir Heroicus Sublimis,* contains an even more complicated mathematical symmetry. Its stripes are placed and colored in such a way that they prevent the viewer from reading the work as calculated symmetry. While appearing to be divided into five areas of radically different widths, there are important relationships among the sections. The large middle section is actually a perfect square that is flanked on either side by equal areas of cadmium red. In addition, the section second from the left is equal in area to a combination of the first section on the left and the last two sections on the right. Newman's fascination with shape and proportion represented, in Hess's words, an attempt "to measure the unmeasurable" and to instill in his art "a unity and a transcendental presence."[9]

As an abstract artist who employed imagery that had no relationship to the objects of the visible world, Newman composed his works without readily accessible clues to their meaning. On their surfaces there lies no hint of the goals that the artist had in mind or that critics like Hess imposed on them. Yet Newman tried to endow this hermetic art with messianic and visionary meaning. Following a tradition of utopian abstraction that stretched back to Wassily Kandinsky, Kasimir Malevich, and Piet Mondrian, Newman devised a set of interpretations of his art that associated it with a universalized idealism.[10]

Newman himself also tried to give his canvases a radical political meaning. As well as being sublime and tragic, abstract art expressed, according to Newman, a fundamental hostility to all state authority and political dogmatism. Although this claim of political relevance seems to add only another layer of confusion and contradiction to the understanding of Newman's art, it actually reflects the same utopian thinking that is found in the rest of Newman's writing. Because Newman was an anarchist

who advocated a return to the first primitive and communal forms of social organization, his political essays possessed the same visionary qualities found in his writings about art. His attempt to invest his works with a political meaning that was anarchist and anti-dogmatic also proves that, like other Abstract Expressionists, Newman wanted to avoid an association with ideological politics while retaining some sort of social resonance in his painting.

Because many of Newman's philosophical and religious justifications for his art seem pretentious and strained, it is sometimes difficult to treat them seriously. Yet his political explanation for abstract art can reveal much about Newman and his generation. Looking at his political views and his essays on the social context of art clarifies the motivations of Newman and his friends during the 1940s. As he and the other Abstract Expressionists began to abandon naturalistic imagery, they became troubled over their course. In Newman's writings, one can see that his change of direction needed defending and explaining. He turned to an examination of the social and political sources of the new abstraction in order to justify the choice he and his friends had made. He also wanted the new abstraction to be more meaningful and relevant to the contemporary world than realism had ever been.

Newman's anarchist sentiments were not unusual among intellectuals with his background. His preference for abstract art was probably more surprising than his political radicalism. As a young Jew growing up in New York City during the 1920s where he attended classes at the Art Students League and the City College of New York, Newman lived among artists and writers who found the national political and economic system unfair and misguided. Intellectuals like Newman, who were the children of socialist or anarchist immigrants from Eastern Europe, found it natural to become critical of the American political system. Newman himself always identified with radicalism, but he did not associate with the leftists on the Federal Art Project. After graduating from college in 1927, he worked for his father to help keep his faltering clothing manufacturing business open. When his father became ill in 1937, Newman was free to close the business and pursue his artistic ambitions.[11]

Newman was exceptional among members of his generation because he never joined or sympathized with the Communist Party. In the early 1930s, at a time when economic conditions seemed to demand collective class action, Newman remained aloof from the Party and concentrated on other issues. For example, in 1936 he published an attack on the corruption of city politics by Tammany Hall. He later explained his distaste for Communists as an aversion to "shouting dogmatists." He also believed that the Party was more concerned with political expedience than with genuine

reform. In the 1960s, when he was surrounded by a new generation of radicals, Newman remained skeptical about the ideological nature of the left. The radical youth of the 1960s seemed to Newman to be trapped in dogmatic thinking that amounted to no more than "a new prison with its Marcusian, Maoist, and Guevara walls."[12]

Newman preferred to stay independent of organized groups on the left. Unlike Greenberg, Rosenberg, and other intellectuals of his era, Newman never joined any of the Trotskyist organizations that offered themselves as alternatives to the Communist Party. For example, in 1933, he ran on his own for mayor of New York City on a ticket for artists and anarchists. As a gesture of contempt for the other contenders and to call attention to cultural issues, Newman presented himself as an alternative candidate. There is no record that he received more than his own vote, but as a keen student of public relations, Newman convinced reporter A. J. Liebling of the New York *World Telegram* to write a story on his campaign. In his interview with Liebling, Newman condemned the other candidates as "sullen materialists or maniacs who express the psycho-pathology of the mob minded." Artists seemed to Newman to be one solution to this problem since they were free of political ambition and greed. A society run by artists would, in Newman's opinion, be the only one worth living in. In his administration he promised municipal opera houses, orchestra halls, and art galleries. Streets would be closed for open air cafés. Life would also be more pleasant, Newman suggested, if the air and water were clean and if there were more parks with open forums for speakers. Free art and music instruction would be available for all New Yorkers. His plan also contained socialist elements in its call for city ownership of banks, businesses, and housing. Newman's vision for the city of New York was a utopia where citizens freed from the oppression of poverty could engage in the pursuit of culture.[13]

When the Second World War began, Newman was put in a difficult position. As an anarchist, he found it impossible to accept induction into the military. When faced with a draft notice, he asked for an exemption by claiming that service in the military would deprive him of his own "right to kill." Not adverse to killing Nazis, Newman insisted to his draft board that he only objected to killing under an order from a military officer. He received a deferment, but it was granted for physical as well as political reasons. Newman's opposition to fascism was never in question. In 1939 and 1940 he was close friends with Rothko and Gottlieb, who had denounced the American Artists' Congress for its support of the Nazi-Soviet pact.

Newman did express support for the war in an unpublished essay he wrote in 1942. In that piece, he attacked those who had opposed American

entry into the war. Among his targets were figures of both the left and the right. For example, he characterized Norman Thomas, the Quakers, Charles Lindbergh, Father Coughlin, and others as "corrupt peace leaders who cannot tell the difference between peace and surrender."[14]

After the war, like most of the Abstract Expressionists Newman avoided overtly political activities. In 1950 he did help organize a protest against the conservative policies of the Metropolitan Museum of Art, but that gesture was directed solely at the conservative aesthetic tastes of a jury sanctioned by the museum. Only during the 1960s, when a new wave of political radicalism developed among artists, did Newman make any further public statements on politics. In 1968 he joined a group of other artists in calling for a boycott of Chicago to express their "disgust and revulsion" at the actions of that city's police during the riots surrounding the Democratic Party convention. As part of a generation of artists familiar with the regimes of Nazi Germany and Stalinist Russia, Newman and his friends reminded other artists that "art cannot exist where repression and brutality are tolerated." Later, Newman and the others dropped the idea for a boycott and assembled an exhibit for a Chicago gallery that served as a protest of police practices at the convention. For his contribution, Newman constructed a six-by-four-foot frame of steel laced with barbed wire and coated with red paint. The piece recalled the barbed wire that had encircled not only the convention hall in Chicago but also the death camps of Hitler and Stalin.[15]

Because Newman had always been committed to political radicalism, he wanted to keep his art relevant to the cultural and human situation around it. That course became troublesome for Newman when he developed a style that rested on a fusion of chromatic and geometric abstraction. To explain this transformation, Newman wrote frequently on art and the society around it. In these pieces he explored the dilemma faced by a whole generation of American painters caught between political radicalism and aesthetic ambition. Newman's own solution to this crisis was to invest his painting with utopian political meaning.

Newman began his career as a realist in a manner that he later described as similar to that of postwar painter David Hockney. It is impossible to examine these works since he destroyed his earliest paintings and drawings, an act which likely indicates the profound sense of crisis that Newman felt around the time of the Second World War. The earliest extant drawings come from the last two years of the war when his imagery strongly resembled that of the Surrealists Joan Miró, André Masson, and Max Ernst. Though he later denied that his work had been significantly shaped by Surrealism, it is clear that in the early 1940s he shared with the Surrealists a

concern for an art that explored the interior of the human mind and that portrayed the regenerative quality of the creative imagination. As Newman later wrote, Surrealism seemed amenable to the American painters of the 1940s because it had "freed painting from its old subject-matter of nature, of still-life, the figure, and formal abstraction." He admitted some debt to the Surrealists for convincing him that "it was possible to paint a subjective thought, a feeling, a subjective idea."[16]

From the Surrealists Newman borrowed biomorphic imagery and mythic titles. For example, the titles of three of Newman's drawings from 1945 — *Gea, The Slaying of Osiris,* and *The Song of Orpheus* — refer to mythological characters who represent the struggle between death and creation. To depict these mythic themes, Newman used biomorphic forms that resembled eggs, insects, and foliage. These shapes appeared on the canvas in rich earth-colors. In *Gea* (1944-1945), he chose an oval, egglike form and enlarged it so that it assumed a central position in the imagery (see figure 20). That oval and its surroundings could also be read as an insectlike creature. The title *Gea* refers to a Greek goddess associated with Mother Earth who was one of the first of two beings created out of the original state of chaos in the universe. Executed in rubbed crayon and looped lines, the images seem those of generation, fertility, and ripeness. As such, the drawing appears to be a celebration of creativity. After years of working in a realistic style, Newman may have felt that he had found in Surrealism satisfying new themes and images.[17]

Even as Newman worked within this Surrealist format, he began experiments with imagery that would serve as models for his mature works. He simplified his forms and eliminated the intricacy in his treatment of line. He reduced his imagery to fewer forms and found the vertical stripe particularly compelling. No longer automatic or organic, these stripes or zips possessed precise edges made with masking tape. Sometimes truncated in the early drawings, Newman's stripes eventually extended from edge to edge of the canvas. By 1948, the organic forms he had borrowed from the Surrealists disappeared, to be replaced by a more geometric style. The stripes eventually divided large fields of intense color applied in a carefully modulated manner.

Like the other Abstract Expressionists, Newman had grown dissatisfied with Surrealism. Because its leader, André Breton, demanded strict allegiance to Freudian concepts and Marxist dogma, it seemed too narrow and too ideological for these Americans. Newman also tired of biomorphic forms. Situated as he was in New York during the 1940s, a city free from the horrors of war and home for many artistic refugees, Newman was able to select among various kinds of modernist painting. He must have been impressed with the more geometric works of Piet Mondrian, one of the

prominent abstract painters who settled in New York during the war. Mondrian's work offered Newman an alternative to the meandering auto-matic line of the abstract Surrealists. Yet Newman never adopted the absolute precision of form and line found in the art of the New-Plasticists or the Constructivists. His preference for large scale canvases and intense colors also set him apart from earlier geometric abstractionists. Like the other Abstract Expressionists, Newman is best understood as a synthesizer of the diverse modernist movements of Europe.

As Newman began to make this transition from biomorphism to an even more abstract style, he turned to the writing of the German art his-torian Wilhelm Worringer to explain and defend his course of action. In his influential study, *Abstraction and Empathy,* published in 1908, Wor-ringer had attempted to link abstraction in art with the social and political context in which it was created. Believing that abstraction developed when artists seemed unable to appreciate the natural environment, the German felt he had discovered the key to understanding style transformations in painting. Worringer argued that artists would adopt a representational style when they were confident about their culture and its place in the natural world. When that assurance disappeared, artists turned, Worringer believed, to abstract forms. Since Newman himself was about to undertake a shift away from naturalism, he found Worringer's ideas appropriate.

In an article he wrote in 1946 on the primitive art of the South Seas, Newman borrowed Worringer's theory. Because the people of the South Seas were often terrorized by the forces of the natural world, especially the sea and the wind, their artists, according to Newman, felt no desire to depict recognizable objects in their art. Since these primitive people lived in an "indefinable flux" and faced "an epistemology of intangibles," Newman concluded, they preferred abstract to naturalistic art. Modern man con-fronted an equally baffling world. His terror arose, however, not from the sea or the wind but from what Newman identified as the evil within man himself. Newman then asserted that in such a cultural situation, abstrac-tion was the only possible plastic expression.[18]

To demonstrate the scope of this shift to abstraction among American painters, Newman assembled a show of the new painting for Betty Parsons Gallery in 1947. Included were his own works and those by Hofmann, Reinhardt, Rothko, Stamos, and Still. Though many of these works re-tained the biomorphic imagery of abstract Surrealism, Newman claimed that these artists had rejected naturalistic means in order to deal with the world of pure ideas and pure spirit. He called the images in these works "ideographs," which he defined as symbols used to express an idea and to infuse art with content. Ideographs, according to Newman, sought to convey "the idea-complex that makes contact with mystery." In another

catalog, Newman praised Stamos because he had also abandoned naturalism in order to capture "not only the glow of an object in all its splendor but its inner life with all its dramatic implications of terror and mystery."[19]

Worringer's ideas about art and society offered Newman one way to link abstraction with content and to explain the social and political context of his art. Newman created another link between art and politics through his writings on art and anarchism. By associating his painting with libertarian political principles, he added a further measure of utopian idealism to his art. In the narrow vertical stripes and large color-fields, Newman also claimed that there was a vision of a pure society free of political antagonism and repression. For example, in 1962 when an interviewer asked, "Can you clarify the meaning of your work in relation to society?" Newman replied:

> It is full of meaning,...one of its implications is its assertion of freedom, its denial of dogmatic principles, its repudiation of all dogmatic life. Almost 15 years ago Harold Rosenberg challenged me to explain what one of my paintings could possibly mean to the world. My answer was that if he and others could read it properly it would mean the end of all state capitalism and totalitarianism. That answer still goes.[20]

Newman also believed that some of his methods reflected anarchist principles. Because he worked "directly" without benefit of intervening objects, models, or conventions, he felt his art was as "direct" as life would be in a community without laws, governments, and rulers. Free drawing, the preferred method of the Surrealists, had also possessed this unfettered quality.

The anarchist state of mind also benefited artistic creation. According to Newman, those artists who were attached to the state or to any institution were not free to create but were snared in an authoritarian structure. The art establishment itself harmed artists because it caused vicious competition among them. As Newman wrote in 1968,

> those people practice destruction and betrayal who hunger to accept completely the values of the Establishment in which they seek a place. It's the Establishment that makes people predatory.... Only those are free who are free from the values of the Establishment. And that's what Anarchism is all about.[21]

Newman's attack on artists who appeared to be too attached to authority and to institutions resulted in part from the divisions and jealousies within his own circle of friends. By the 1960s some of the Abstract Expressionists had achieved popular success and considerable financial security, but at the cost of the friendships they had formed with one another when they were unknown artists. Newman blamed that bitterness among old friends on the envy created by the competition for success. Portraying himself as a purist

who had never sought fame and wealth, Newman pointed to his anarchism as proof of his independence.

Newman was always determined to retain his artistic integrity and scorned those that seemed to give way to fame and fortune. Anarchism was the perfect politics for such a position. According to Newman, it was the one political philosophy that did not exist as a means to power. In his opinion, anarchism represented

> the only criticism of society which is not a technique for the seizure and transfer of power by one group against another, which is what all such doctrines amount to — the substitution of one authority for another.[22]

Anarchism seemed virtuous to Newman because it was an isolated, minor political position that was popular in the 1930s only among a few scattered groups and a small number of intellectuals. Before the revival of anarchism in the 1960s, it had remained a marginal political movement because of its association with assassinations and bombings. The deportation of a number of its leaders after World War I also contributed to the decline of the movement. The only anarchist publication available to Newman during the 1930s was the *Freie Arbeiter Shtime,* in Yiddish, which the painter learned to read.

Anarchism also represented another instance of the modernist attraction to the primitive. By characterizing his art as a challenge to the establishment, Newman wanted to reject the civilized world and civilized art. As a utopian seeking a model for the perfect society, he turned back to what he believed to be the primary social organization among primitive men. Primitive societies seemed especially appealing since they seemed to have survived through voluntary cooperation rather than authoritarian government. The Russian anarchist Peter Kropotkin, Newman's hero, had written of his admiration for the Russian peasant commune, the *mir*, that he had once visited in Siberia. Given Newman's antagonism to the official art world, the anarchist commune came to represent the artistic community that he had sought and lost. Uncorrupted by civilization, anarchist communes would remain free of the competitive, spiteful aspects of conventional society. Without an authority to please and obey, the rivalries and jealousies of the civilized world would disappear. In the 1930s and 1940s, this vision of an innocent, cooperative life also reflected the profound despair of a generation that matured during war and depression.

By characterizing abstract painting as a force working against political authoritarianism, Newman attempted to disclose the passion that lay behind the creation of his works. In a similar manner, he had linked his art to the philosophical concept of the sublime and to the Christian theme of human suffering. But rather than convincing his audience, Newman may

have created a dilemma that can never be solved. By rejecting all easily recognizable symbols and images in his art after 1948, he made it difficult for anyone to identify the philosophical, religious, or political issues he imposed on his painting.

When his works and intentions are compared to those of the European Expressionists at the turn of the century, it becomes even more evident how difficult Newman's mission was. Newman and artists like Edvard Munch wrote in similar terms about the emotional response they wanted to evoke in their audience. Both painters described their purposes as the spiritual regeneration of a world facing tragedy and doom. Yet it is only in the paintings of Munch that there is a clear depiction of those themes. To create the same response in their audience, Newman and other abstract painters like him relied in large measure on a physical arrangement of works in museums that would stimulate viewers. The viability of Newman's interpretation of abstract art depends on the ability of the public to recognize his imagery as a utopian one.[23]

Newman's works and those of the other color-field painters also possessed qualities that seemed to deny metaphysical, religious, or political content. Their images were powerful but they were also anonymous ones that could be described in the impersonal terms used by Donald Judd. Through the process of reduction and simplification, the color-field painters eliminated the symbolic and metaphorical imagery they had used in the 1930s and early 1940s. Because they worked in series and consistently repeated their basic formats, they stressed the formal variations possible in abstraction rather than its subject matter. The manipulation of stripes and color areas that appeared to Hess to create a mystical "secret symmetry" could also be interpreted as a purely aesthetic procedure. The questions of scale and shape of the canvas also seem to remove these artists one step further from politics and philosophy, toward the treatment of the painting as an object. The vertical imagery that Newman relied on after 1948 implies an aspiration toward the spiritual, but the lush, sensual nature of his color contradicted the austere and severe nature of his metaphysical rhetoric. To many observers works like *Vir Heroicus Sublimis* with its stripes and its rich, oscillating, cadmium red surface seem more material than spiritual.

Newman's writings do perform one valuable function: they let the historian see the transformation taking place in the avant-garde community of the 1940s. As a generation that had absorbed the lessons of the Depression and the war and that had grown up accustomed to the imperatives of Social Realism and proletarian art, these artists could not allow themselves to forsake the commitment they had all once shared. Though ambitious and determined, they could not leave behind the world of their youth.

When they became abstract artists, it was not a cold and sterile act that they sought. Instead they developed, particularly in Newman's polemics, an aesthetic ideology that spoke of their utopian visions. Their works, they argued, existed in a complex dialectic with their audience. First the paintings established a spiritual presence beyond the ordinary world outside the work. Then the viewer, having experienced the visual idealism of color-field painting, would carry its message back to everyday existence. Newman hoped through his writings to encourage that process, and to keep this painting associated with the utopian spirit of the avant-garde of the 1930s and 1940s.

Figure 18. Barnett Newman. *Vir Heroicus Sublimis*. 1950-51. Oil
on canvas. 7'11⅜" × 17'9¼". Collection of the
Museum of Modern Art, New York. Gift of Mr. and
Mrs. Ben Heller.

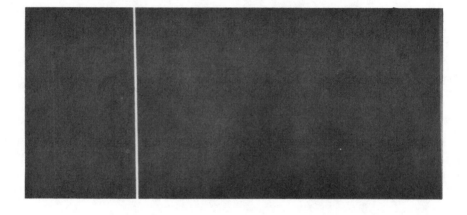

Figure 19. Barnett Newman. *Abraham*. 1949. Oil on canvas.
6′10¾″ × 34½″. Collection of the Museum of Modern
Art, New York. Philip Johnson Fund.

Figure 20. Barnett Newman. *Gea.* 1944–45. Oil and oil crayon on cardboard. 27¾ × 21⅞″. Collection of Mrs. Annalee Newman, New York.

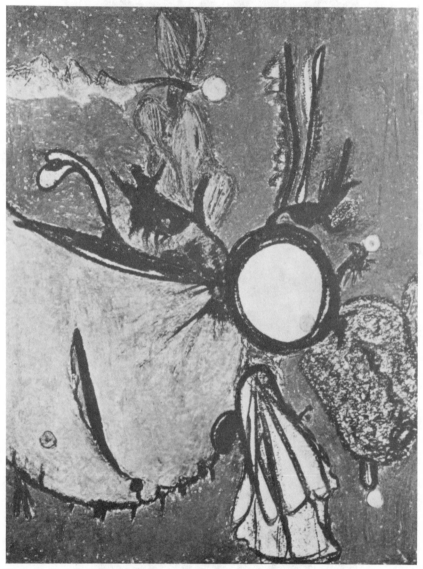

Photo: Jeffrey Wayman

The Aura of the Primitive:
The Photographs of Jackson Pollock

In 1947 in a small barn behind a farmhouse on Long Island, New York, Jackson Pollock began working on a series of abstract paintings that are unique in the history of art. He completed these works by pouring paint off sticks onto canvas rolled out on the floor. This unorthodox method later led *Time* magazine to ridicule him as "Jack the Dripper."[1] However Pollock's pouring technique was not merely "dripping" or "splattering." It created an imagery based on loops and fragments of line. At some points this line was sinuous, thin, and delicate; at others it expanded into patches of paint. In some of these works, Pollock built up a dense, thickly layered, and richly textured linear network. Other paintings presented more open patterns. Some of the surfaces also included foreign materials like sand, wire, and cigarette butts. The web of line usually extended over most of the canvas surface and never seemed to concentrate at any one point. The large scale of some canvases, however, allowed Pollock to separate his linear imagery into sections. The painting *Autumn Rhythm* (1950, 105" x 207", oil and enamel on canvas), for instance, contains a tripartite division in its linear web (see figure 21). To create his imagery, Pollock used oil, enamel, and aluminum paint in a wide variety of colors, but these colors never overshadowed the linear nature of his works.

Once puzzling and irritating to most critics and to the public, these paintings now command widespread respect. For example, art historian William Rubin argues that Pollock's pouring technique should be understood as a sophisticated elaboration on Cubist ideas about line and space and on the Surrealist device of automatic drawing. Pollock himself acknowledged that the Cubist Pablo Picasso and the Surrealist Joan Miró were the two artists that he admired most.[2]

By choosing to paint abstract works in this highly unusual manner, Pollock did not simply seek a greater technical and visual virtuosity. For Pollock, Cubist and Surrealist art carried with them a profound commit-

ment to content. In an interview in 1950 he said, "technique is just a means for arriving at a statement."[3] Yet he must have recognized the difficulties his audience faced in understanding automatic line. To the untutored viewer, works composed entirely of abstract linear imagery appear to be no more than a bewildering tangle of "dripped" and "splattered" paint. In particular, it was doubtful that viewers in museums and galleries could understand the procedures that Pollock had employed inside his studio.

Pollock himself sought a remedy for this dilemma. To disclose his process and to enhance its meaning, he allowed outsiders to enter his studio and photograph him while he worked. While these images of Pollock, some of which later appeared in *Life* magazine, helped make him famous, he permitted them to be made because they allowed a wider comprehension of his artistic intentions. More importantly, these photographs helped restore to Pollock's work the Freudian, visionary, and primitivist qualities consistently displayed in his paintings before 1947.

By the 1960s, these photographs of Pollock had clearly succeeded in expanding the ways in which his art was interpreted. For example, at the major retrospective of Pollock's work at the Museum of Modern Art in 1967, exhibit organizers recognized that public and critical interest in this artist now extended beyond his paintings. Through this show, the museum helped codify the legends surrounding Pollock's process, his life, and his personality. In the catalog, a chronology with family photographs and excerpts from letters described the turning points in his life. The museum also enlarged some of the photographs of Pollock at work to hang on the gallery walls beside his paintings. While the exhibit was in New York, the magazine *Art News* further satisfied public curiosity about Pollock's life by interviewing his friends and family. Art historian Barbara Rose suggested that this exhibit and its focus on the artist and his method marked a significant development in the art world. She argued that it helped turn artists toward methods and images that relied more on personality and process than on the qualities of the finished work itself.[4]

This interest in Pollock's techniques and in his personality was stimulated by the photographs. Without them Pollock would never have been a celebrity, nor would we have as complete and dramatic a record of how his paintings were created. Although these photographs did make him famous and did add to the monetary value of his works, there are grounds for believing that through them Pollock also wanted to augment the meaning of his art. First of all, photographs restored to his abstract, all-over, poured paintings an association with the human figure and with the natural world. Before 1947 his art had usually included natural figures and objects, based on his exposure to Regionalist painting, Mexican Expressionism, and European Surrealism. Photographs of the artist at work further reminded

Pollock's audience that these paintings were generated by an automatic process based on the Surrealist faith in the efficacy of free association. Left only with the finished canvases themselves, the viewer might not be aware of the Freudian framework in which they were created. Furthermore, these photographs offer additional proof for the importance of aesthetic primitivism in Pollock's art and career. Through photography Pollock's art was linked to primitive ritual and dance.

Pollock's career began not with Freud or with Surrealism but with an attraction to an art that was populist in its politics and traditional in its techniques. Beginning in 1930, Pollock studied at the Art Students League with Thomas Hart Benton, the well-known Regionalist mural painter. Benton's stereotypical and sentimental depictions of bootleggers, preachers, and farmers held little interest for Pollock, but he did emulate his teacher's concern for an art that reflected the spirit of the American people (see figure 22). Benton rejected what he called the "aesthetic drivelings and morbid self-concerns" of modernist painters and urged his students to open their minds to the experience of the people. He developed this position after reading Karl Marx, Hippolyte Taine, John Dewey, and William James. From these sources, Benton had learned that "direct" experience with the subject and "direct" contact with the people offered the artist more insight than "artificial" knowledge gained from books or from other artists and critics. Benton claimed that he had reached this conclusion while working on a construction project during the First World War. He decided then that art should be created not for the few but for "the people" that he met in everyday life. As a result, Benton taught his students to abandon the studio and travel throughout America to find subject matter for their art.[5]

During the summers of 1930, 1931, and 1934, Pollock followed his teacher's advice and journeyed across the country, sometimes hopping freight trains, to sketch local color. In paintings Pollock completed during the early 1930s critics have discovered certain qualities that reveal Benton's influence, and others that represented a strong reaction against Regionalist painting. While disdainful of Benton's sentimentality, Pollock, in works like *Going West* (1934-1935), demonstrated an interest in Benton's everyday subject matter, his dense and rhythmic compositions, and his dramatic chiaroscuro[6] (see figure 23).

In Benton's classroom Pollock was introduced to an art that had grown out of a rebellion against both academic and modernist art. It also carried strong political implications, since Benton and the other Regionalists represented a kind of Midwestern aesthetic populism. Pollock was also attracted to another version of "art for the people" in the works of the Mexican Expressionists Diego Rivera, David Alfaro Siqueiros, and José

Clemente Orozco. They painted scenes of Mexican peasant life in a spirit that matched Benton's conviction that art must express the genuine experience of the people. But, whereas Benton had ridiculed loyalty to the Communist Party or any other organized political group, these Mexicans actively supported international revolutionary movements.

Beginning in high school in Los Angeles, Pollock had also clearly identified himself with international radicalism. In 1929 he wrote his brothers that school officials considered him "a rotten rebel from Russia." While still in high school in California, Pollock had come to admire the murals of Rivera and Orozco after being introduced to their works at Communist meetings. After moving to New York in 1930 to study at the League, Pollock associated with radicals he met through the John Reed Club and the Artists Union.[7]

In the summer of 1936, he and his brother Sanford worked in Siqueiros's experimental studio, where murals, banners, and floats for Communist Party demonstrations were built. The work of all these Mexican artists was highly charged with a political outrage that must have impressed Pollock. Unlike American political painting of the 1930s, these Mexican painters produced canvases where the class struggle seemed bitter if not cataclysmic. While American painters like the Soyers portrayed the somber life on city streets during the Depression, the Mexicans depicted the screams of the starving and the violence of revolution. Under their influence, Pollock turned to explicitly radical themes. For example, in 1934 he exhibited a work (since lost) at a John Reed Club show that dealt with the contrast between the calm pervading a gallery filled with abstract art and the suffering of the poor outside on the streets. One painting from the Depression that still exists, *Cotton Pickers* (ca. 1935), portrays farm laborers stooped over their work in the fields[8] (see figure 24).

During the 1930s Pollock discovered that certain European modernists also thought of their art as politically revolutionary. In the Surrealists Pollock found a group of artists who were as radical as the Mexicans but who based their imagery on Freudian ideas about the content of dreams and the methods of unlocking the secrets of the unconscious. Finding the political and aesthetic ideas of the Surrealists amenable, Pollock began incorporating their imagery and techniques into his art in the late 1930s. From that time until the mid-1940s, his paintings contained many semi-abstract biomorphic shapes clearly related to those of the Surrealists Max Ernst, Joan Miró, and André Masson. The avian figure in *Bird* (ca. 1941), for example, recalls Ernst's obsession with his mythological creation Loplop, a bird-monster rooted in Ernst's memories of a childhood pet and his interpretation of human sexuality.

Like the Surrealists, Pollock painted violent or threatening female figures that seemed to depict male sexual fears. Female figures in *Moon Woman* (1942) and *Moon Woman Cuts the Circle* (1943), for example, demonstrate Pollock's affinities with Surrealist notions about eroticism. The Surrealists also used the bull figure, the Minotaur, to symbolize Freud's concept of the dynamic between Eros and Thanatos (the libido and the death-wish). These bull-like shapes also appeared in such Pollock paintings as *Mask* (ca. 1938) and *Head of a Bull or Minotaur* (ca. 1940–41). Like the Surrealists, Pollock used mythological titles and subject matter. In addition to references to the Minotaur, two other paintings, *The Guardians of the Secret* (1943) and *The She-Wolf* (1943) bear direct relationships to Egyptian and Greek myths[9] (see figure 25).

Among European painters Pablo Picasso was the most important for Pollock. Critic Clement Greenberg concluded from Pollock's interest in Picasso that his art should be characterized as late Cubist. What Greenberg failed to recognize was the close relationship between Picasso and the Surrealists during the 1930s. By then Picasso had moved away from the abstract linear grid that served as the structure for works like *Ma Jolie* (1911). His imagery during the 1930s relied instead on fragmented and distorted human and animal forms from a fantastic dream world that was fundamentally Surrealist. Breton himself claimed Picasso as one of his own in 1928 when he wrote that the Spaniard had given "materiality to what had hitherto remained in the domain of pure fantasy."[10] As a result, when Pollock and other American artists looked at Picasso's work in the 1930s and 1940s, they did not assume (as Greenberg did) that his Cubist and Surrealist tastes were antithetical. Pollock obviously found Picasso's Surrealist-like forms compelling, and used them, for example as the central shape in *Stenographic Figure* (1942) and in parts of *The Key* (1946).

Pollock also expanded on the orthodox Surrealist vocabulary of forms. Never a doctrinaire Surrealist, he chose to include in some of his works symbols from Carl Jung's psychoanalytic theories. Yet as he had in other cases, he never made any attempt to make his paintings textbook illustrations of Jungian concepts or to treat them systematically. These elements, instead, were another kind of aesthetic primitivism and became convenient ways for Pollock to evoke images from what Jung called the collective unconscious. During the early 1940s, for example, Pollock included in his paintings such Jungian symbols as the disc sun, the crescent moon, the plumed serpent, the floating eye of consciousness, and magic numbers. In Jung's opinion these were universal symbols found in both primitive and modern culture.

One of Pollock's paintings that used Picasso-like forms and Jungian

themes, *Stenographic Figure* (1942), brought him to the attention of the Surrealists. It was a semi-abstract portrayal of a reclining female figure with a single large eye and numbers scattered across the surface. Pollock's use of these Jungian symbols and his clear debt to Picasso appealed to the Surrealists, and this work appeared in a 1943 exhibit at Art of This Century, the major New York gallery for those European painters.[11]

After considerable experimentation with Surrealist themes in the late 1930s and early 1940s, Pollock abandoned the quasi-naturalistic imagery of Miró, Masson, and Ernst to focus on automatic drawing. European painters had found automatism to be important as the first step in their creative process but they had always restricted it to an auxiliary role. Other American painters of the 1940s found automatic techniques productive, but in the works of such artists as William Baziotes and Robert Motherwell, it remained subordinate to broader aesthetic concerns and was not the central premise of their art.

Pollock's originality as a painter lies in his concentration on this automatic line and the way it can dissolve into its own web and then reemerge. To take advantage of the liquid, accidental properties of paint and the freedom and scope of the wall-size painting, he rolled out large pieces of canvas onto his studio floor and drew his lines by pouring paint off sticks. By turning to a spontaneous technique and large canvases, he broke with the rectilinear grid and the intimate scale of the Cubists. With no hint of three-dimensional space, naturalistic elements, or even biomorphic shapes, Pollock reduced art to one of its essentials—the drawing of a line.

After Pollock had worked with automatic line for several years, he began allowing photographers to visit him at his farm and inside his studio while he painted. His motivation for such a decision remains uncertain, since he apparently never wrote or spoke about it. Only by examining the results of these visits can we say why Pollock found them important to himself, to his career, and to his art. It then becomes evident that these photographs served an expansionist function; by inviting photographers into his life and into his studio, Pollock transformed and extended the subject of his paintings from automatic line alone to a consideration of artistic personality and process. Pollock emerged as a classic example of the bohemian and brought to the American art world a new version of the myth of the "suffering" and "alienated" artist. Even more importantly, he added a significant primitivist association to his use of the automatic process in painting, and reminded his audience that his imagery came from his unconscious.

On a superficial level, it might appear that the photographs simply helped transform Pollock into a celebrity, like any movie star or politician eager for the rewards of fame. German critic Walter Benjamin has pointed

out that because the images in photographs are easily comprehended, they are susceptible to this sort of manipulation. They can help foster, according to Benjamin, a "cult of the movie star," merely a "spell of the personality" similar to the publicity manufactured by Hollywood film studios.[12] Because Pollock fulfilled some popular expectations about artists, the press did attempt to use photographs to help make him the "disturbed genius" of American painting.[13] Photographs of Pollock, however, transcend this exploitation because they were powerful images that reflected authentic qualities in Pollock's art and personality.

Many of the stills that seemed to reveal the artist's rebellious personality appeared in *Life* magazine. Its editors discovered Pollock in the late 1940s after he had been praised by critic Clement Greenberg as the most important contemporary American artist. Always alert for dramatic subjects for photojournalism, *Life*'s editors sent a photographer and reporter to interview him in 1949. The story they wrote appeared in the magazine with the title "Jackson Pollock: Is He the Greatest Living American Painter?" Magazine photographer Arnold Newman provided a still for the article that showed Pollock standing in front of one of his paintings with his arms crossed, full face, a cigarette dangling defiantly from his mouth (see figure 26). His compact, muscular body and assertive demeanor may have further kindled interest in the artist. When the magazine announced Pollock's death in 1956, the editors reprinted that pose.[14]

The most important photographs of Pollock were taken by Hans Namuth, who had become fascinated with Pollock's paintings when he was a student. He met the artist at an exhibition in 1950 and asked if he could visit his farm. At first reluctant to allow Namuth inside his studio with his camera, Pollock eventually agreed. Namuth published his results in a little magazine but the images were so striking that they appeared in *Art News* in 1951 as illustrations for the article "Pollock Paints a Picture." A film that Namuth helped make of Pollock was first shown at the Museum of Modern Art in June 1951. Later, Namuth's photographs of Pollock were published in *Harper's Bazaar, Life,* and the *New York Times Magazine;* in popular works on American painting like Rudi Blesh's *Modern Art USA* (1956) and Bryan Robertson's *Jackson Pollock* (1960); and in the catalog for Pollock's first one-man show at the Museum of Modern Art in 1956. In a sense, Namuth's photographs became inseparable from Pollock's paintings since they appeared with them on the walls of museums and galleries.[15]

Two of Namuth's photographs of Pollock have become classic portraits of the artist. In one, first published in *Harper's Bazaar* in 1952, Pollock squats beside his Model A Ford, his face averted from the camera, looking down. Another Namuth photograph that appeared in *Evergreen Review* in 1956 was a close-up of Pollock's face with his creased forehead

and a cigarette in hand (see figure 27). In 1959 *Life* printed another article on Pollock that focused on the earnest and turbulent qualities that Namuth had captured. The photographs of the artist appeared with a text that reaffirmed his bohemian reputation: "his face deeply furrowed, his eyes... searching." The magazine reminded its readers of Pollock's erratic personality and unusual process by using such headlines as "A Shy and Turbulent Man," "Focused Fury of Creation," and "Phantasms and Turmoil of His Final Years." With these captions, *Life*'s writers left little doubt that Pollock's furrowed brow stood as a sign of the inner struggle and suffering of an artistic genius.[16]

In modern times the public expects genuine artists to rebel. To be authentic an artist must follow the example first set forth in Henri Murger's *Scènes de la Vie de Bohème* and be an outcast, a misfit, and a drunk. During the postwar period, these stereotypes of bohemian life also seemed applicable to writers Dylan Thomas, Ernest Hemingway, and Jack Kerouac. Certainly Pollock's experiences substantiated some of these claims. He grew up in the romantic "Wild West," struggled to survive during the Depression, followed the teachings of mystics, sometimes drank too much, fought with friends in bars, and died in an automobile accident at the relatively young age of forty-four. The popular press so emphasized his drinking that the public also wrongly concluded that he painted while inebriated. His unorthodox method of painting, a style that had led *Time* to dub him "Jack the Dripper," seemed to verify another popular notion about creativity. To the public, Pollock's interest in the Cubist treatment of line and space and the Surrealist technique of automatic drawing merely suggested the undisciplined outpourings of a troubled personality.[17]

Life's writers seized on Pollock's methods to try to dramatize his apparent lack of control. One of the stills taken by *Life*'s Martha Holmes in 1949 shows Pollock crouched over a canvas lying on the floor, pouring sand from his hand. He is stationary and appears to be working carefully despite his unusual methods and materials. Another photograph in the series shows him applying paint with a stick (see figure 28). *Life*'s writers, however, ignored the discipline and conscious direction clearly evident in the photographs. They proceeded to heighten the novelty of Pollock's procedures with the caption "Pollock drools enamel paint on canvas" and with the verbs "dribbles," "scrawls," and "scoops" in the text of the article itself.[18] This vocabulary confused Pollock's primitivism with careless drawing.

Despite these public misconceptions about Pollock's art, the photographs and written descriptions of Pollock's personality clearly captured the attention of writers and other artists. It is perhaps with this narrow audience that Pollock's photographs had the greatest impact. For example,

sculptor George Segal remembered that as a young art student he had associated Pollock with another symbol of tortured rebellion from the 1950s, Marlon Brando. Segal believed that many other young students felt the same way. Photographs of Pollock casually dressed, obviously a man serious about himself and his art, recalled, in Segal's opinion, Brando's "brooding, pouting profile" and persuaded him that Pollock was "wrestling with himself in a game of unnamable but very high stakes." Music critics also suggest that Pollock's personality as presented in photographs impressed the young rock musicians of the 1960s. Performers like Jim Morrison incorporated these same themes of rebellion and suffering into their lives and music. Through these photographs, Pollock reintroduced the myth of the artist as a tortured and defiant personality, a myth that had once been exemplified in the lives of Vincent Van Gogh and Fyodor Dostoyevsky.[19]

While the photographs did popularize Pollock as an example of the bohemian personality, they contributed even more significantly to his art through their exploration of his artistic process. At times the popular press would make Pollock a subject of ridicule and derision, but these photographs, particularly those Namuth took inside the studio, in 1950, helped reveal the visionary qualities that Pollock had always sought in art. Since it was likely that his painting might be misunderstood, the photographs invested them with more meaning and additional layers of complexity. Because the process Pollock used reached to the unconscious, primal areas of the mind, the photographs of the artist at work associated it with primitive ritual.

Pollock himself must have felt that such photographs were important for his art because he continued to permit cameras into his studio while he worked (see figure 29). Among them, Namuth's works best captured Pollock's intensity as he applied the automatic line. Unlike standard depictions of the artist in his studio, Namuth's were taken while Pollock was immersed in his work, not looking at the photographer, but actually pouring paint on the canvas. The introspective qualities of Pollock's art were demonstrated by the artist's concentration on his work and his refusal to look full face into the camera. His face was often bathed in bright sunlight that streamed in through the barn windows and disclosed his solemn demeanor. While the *Life* pictures of 1949 portrayed him in a fixed position working slowly and carefully, Namuth caught him in motion, often turning and gesturing so quickly that his figure blurred in the final print. Propped against the walls surrounding the artist were earlier works executed in the same manner. Working as he was amidst his own canvases, Pollock had created his own environment of automatic line.

Namuth's photographs of the artist moving around his canvas, intent on the process of pouring paint onto them, lent to these works a connec-

tion with primitive religious worship. Since Paul Gauguin, modernist painters have looked to primitive cultures and peoples for images, symbols, and inspiration. Believed to be more direct, simple, and honest than the civilized world, primitive cultures offered models to the most sophisticated modernist painters of Europe and America. In Pollock's case, his method furnished the primitive qualities in his works. Relying on the Surrealist faith in automatic drawing, he rejected the conventional brush and the upright easel in order to apply paint directly on the canvas without any intervening obstacles. It has often been suggested that Pollock may have seen Navaho sand painters working in a similar manner on his travels in the Southwest as a youth. No direct evidence can link these Indian artists with Pollock's method. It seems more likely that Pollock borrowed the automatic drawing from the Surrealists in the late 1930s and early 1940s and then transformed it into his own technique. Primitivism in modernist painting does not necessarily rely on direct contact or emulation of artists in primitive cultures like that of the Navaho. It is a consciously shaped aesthetic premise using "civilized" ideas about the primitive world. And only photographs could convey the "primitive" manner in which Pollock's canvases were created.[20]

Artist Allen Kaprow, famous for the Happenings he staged during the 1950s and 1960s, later amplified the meaning of these photographs. Attributing his interest in art as a performance or an event to Namuth's photographs, he was particularly drawn to the "environment" that Pollock established in his studio. For Kaprow and other artists, Pollock's studio became a near sacred spot. It acquired a "holy" aura as the place where Pollock entered into his art and his unconscious. Namuth's photographs portrayed what might be regarded as a primitive religious rite; cameras had penetrated the sacred walls of the shrine to reveal the mysteries of art. Namuth himself remembers that Pollock's movement seemed like a dance to him. These photographs may also be the inspiration for the terms "action painting" and "gesture painting," both often applied to some Abstract Expressionist painting and both indicative of the movement of the artist as he painted.[21]

This collaboration between painter and photographer also points to the fact that photography, regarded by some as a realistic, demystifying art form, can also help supply primitivist and expressionist qualities to painting. Some critics have claimed that photography and film would bring new kinds of visual experiences to their audience. In his famous 1936 essay, "The Work of Art in the Age of Mechanical Reproduction," Walter Benjamin drew sharp distinctions between photography and painting. In Benjamin's opinion, paintings were unique art objects that were consecrated in museums and part of a long tradition of high culture. Such qual-

ities restricted painting to a small, elite audience and left it inaccessible to the masses. These older forms of culture originated, according to Benjamin, in religious ritual and were therefore invested with what he called an "aura," a divine "halo-effect" like that around the head of a Madonna in a Renaissance painting. This attribute removed them from their audience.

On the other hand, Benjamin argued that film and photography by their very nature possess a broad appeal because they seem to be able to penetrate reality through mechanical means of reproduction. Because they were popular with the mass audience, they became tools used by politicians to shape and manipulate public opinion. In Benjamin's opinion, painting was far less able to affect the course of modern society because it maintained a classical aesthetic distance from reality and from the masses.[22]

These photographs of Pollock would have surprised Benjamin. For it was Namuth's stills that contributed to the almost "sacred" aura that surrounded the artist and his paintings. To Benjamin, the concept of "aura" defined a work as traditional and old-fashioned. It was a religious quality that grew out of the origins of art in the production of ceremonial objects designed to serve cults as instruments of magic. Benjamin argued that in modern society the masses prefer art that is closer to them, without such mystery, and that they can "touch" by way of apparent likeness. But in Pollock's case, the photographs of the artist at work did not destroy the religious quality of his art but stressed that very aspect. Because the photographs revealed an artist alone in his studio, oblivious to the external world, totally immersed in his art, subsequent artists and critics viewed the creation of his paintings as if it took place as an act of primitive religious ritual. Photography brought Pollock and the visionary elements of his painting directly to the mass audience.

Pollock agreed to be photographed because these images restored to his art the Expressionistic naturalism that he had abandoned in the mid-1940s. Without the photographs, Pollock's painting lost some of its energy, its meaning, and its originality. A viewer unaware of the automatic technique that generated the web of line central to Pollock's art would remain ignorant of the relationship between that line, the gesture of the artist, and the unconscious. Standing alone, his paintings might not carry that message in the explicit way that the photographs did. With them, his large canvases crowded with dense webs of automatic line retained their visionary qualities. These photographs reminded their viewers of Pollock's involvement with the unconscious and with primitivism, and his determination to discard all conventionalities and customary ways of seeing and thinking. Pollock sought out automatism because it was a primitive artistic method, a path that promised directness, wholeness, and simplicity for art. The photographs then captured and expanded those qualities in his art.

As these photographs amplified the meanings and interpretations an audience could find in Pollock's paintings, they also offered ideas and themes for subsequent artists. Once the photographs became widely known in the art press and in magazines like *Life,* they were as important as the paintings. As we have seen, they shifted the discussion of Pollock's art away from the canvases themselves to the questions of process and personality. After Pollock it became apparent that other artists were undertaking that same course. The influence of Namuth's photographs can be seen in Happenings, performance art, and conceptual art. These postmodernist movements explored the theatrical elements of the creative process and the theoretical underpinnings of art, paying little attention to the production of finished art objects and more to issues like those raised in the Pollock photographs.

In Pollock's case we also see an artist who seldom wrote or spoke about his art but who at the same time allowed photographs to be taken and printed. Those photographs in turn reflected meaning back on the canvases. Like the other Abstract Expressionists, Pollock was caught between two conflicting impulses. On the one hand, as we have seen, he had once been loyal to the international left and to the idea that art's primary goal was expressive resonance. But after the Depression, Pollock abandoned leftist art organizations. He had grown interested in the Freudian concepts used by the Surrealists, but he had no interest in joining that group either. His art grew more abstract after he no longer had direct contact with the left and with the Surrealists, but that does not mean that he then rejected subject matter in his art. The photographs proved that his inclinations were toward a more accessible and expansive meaning for his canvases.

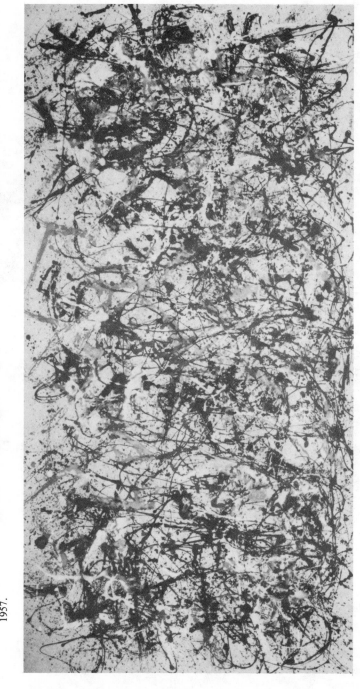

Figure 21. Jackson Pollock. *Autumn Rhythm*. 1950. Oil and enamel on canvas. 105 × 207". Collection of the Metropolitan Museum of Art, George A. Hearn Fund, 1957.

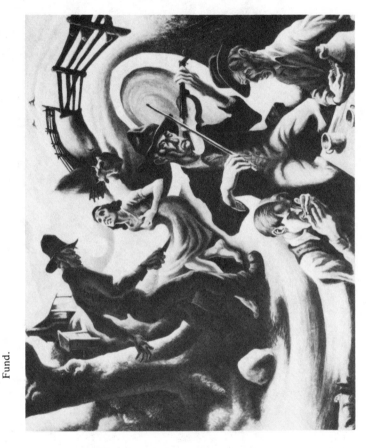

Figure 22. Thomas Hart Benton. *The Ballad of the Jealous Lover of Lone Green Valley.* 1934. 42¼ × 53¼". Oil and tempera on canvas, mounted on aluminum panel. Collection of the Spencer Museum of Art, University of Kansas, Lawrence, Kansas. Elizabeth M. Watkins Fund.

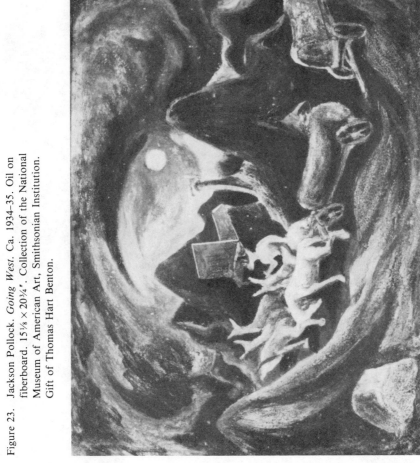

Figure 23. Jackson Pollock. *Going West*. Ca. 1934-35. Oil on fiberboard. 15⅛ × 20¾″. Collection of the National Museum of American Art, Smithsonian Institution. Gift of Thomas Hart Benton.

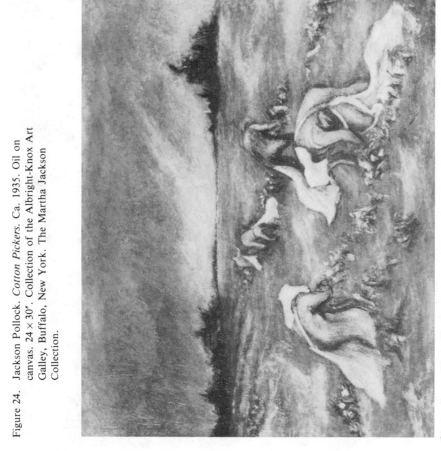

Figure 24. Jackson Pollock. *Cotton Pickers*. Ca. 1935. Oil on canvas. 24 × 30″. Collection of the Albright-Knox Art Galley, Buffalo, New York. The Martha Jackson Collection.

Photo: Runco Photo Studios

Figure 25. Jackson Pollock. *The She-Wolf*. 1943. Oil, gouache, and plaster on canvas. 41⅞ × 67″. Collection of the Museum of Modern Art, New York. Purchase.

Figure 26. Photograph of Jackson Pollock by Arnold Newman.
Appeared in *Life,* 8 August 1949, p. 42 in article
entitled "Jackson Pollock: Is He the Greatest Living
Painter in the United States?"

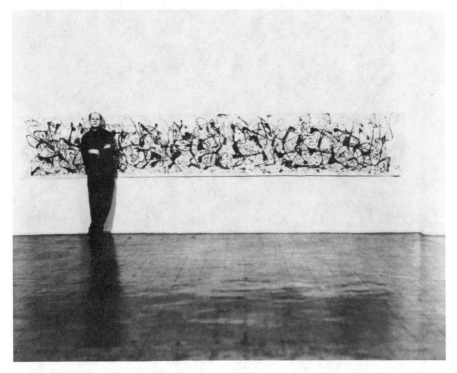

Photo: Arnold Newman

Figure 27. Jackson Pollock. Photograph by Hans Namuth. 1950.

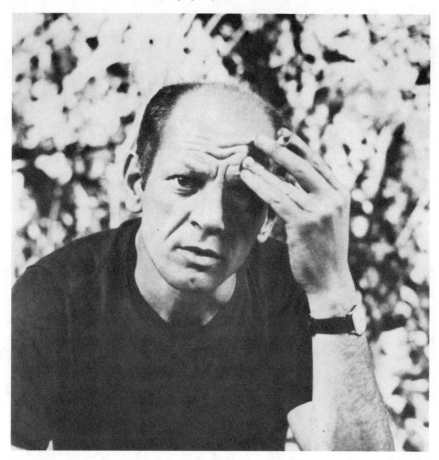

Photo: Hans Namuth

Figure 28. "Pollock drools enamel paint on canvas." From
"Jackson Pollock: Is He the Greatest Living American
Painter?" *Life,* 8 August 1949, p. 45. Photograph by
Martha Holmes Life Magazine © 1949 Time Inc.

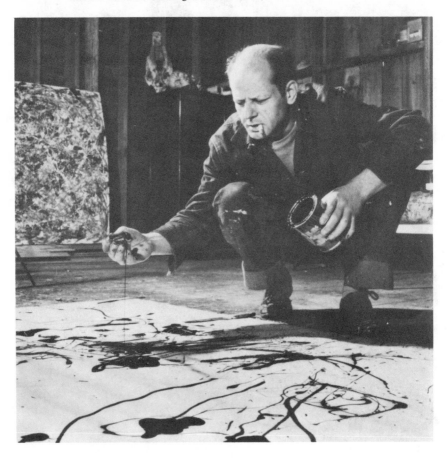

Figure 29. Jackson Pollock. Photograph by Hans Namuth. 1950.

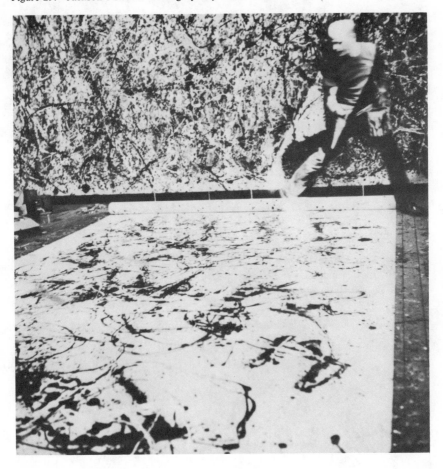

Against Interpretation: Ad Reinhardt and His Art-As-Art Dogma

After the Nazi-Soviet pact was signed in 1939, most intellectuals associated with avant-garde painting became anti-Stalinists. One remarkable exception to this generalization was the painter Ad Reinhardt. Unlike the Abstract Expressionists who joined anti-Communist or Trotskyist groups, Reinhardt remained loyal to the American Communist Party during and after the Second World War. He demonstrated that fidelity by supporting groups affiliated with the Party and by contributing cartoons to such Party publications as the *New Masses* and *Soviet Russia Today*. Even after the war, when the tide of conservatism among intellectuals was at its height, Reinhardt retained the leftist political allegiances that he had first forged as an art student during the Depression.

Though Reinhardt always identified with the political left, his paintings never reflected the qualities usually admired by radical reformers. Unlike his fellow leftists, who preferred realism in art and literature, Reinhardt always painted abstractly and never included any recognizable subject matter in his paintings. During the Depression his works drew on the principles of Cubist abstraction found in the paintings of Piet Mondrian. Then, a typical Reinhardt painting involved an orderly arrangement of clearly delineated and brilliantly colored bars, rectangles, and squares (see figure 30). He shared this geometric, totally abstract style with a small number of other American painters who belonged to the American Abstract Artists group.

After serving briefly in the military during the Second World War, Reinhardt moderated the rigidity of his forms and exhibited his works with those of other Abstract Expressionists in shows like *The Ideographic Picture* (Parsons Gallery, 1947). Reinhardt's participation in that show illustrated his attraction to the expressionistic and mythic interests then dominant among New York avant-garde painters. Like the others, Reinhardt's works of the late 1940s tended to be more painterly, with forms

that were often blurred and colors applied with a concern for all-over luminosity (see figure 31).

Reinhardt's painting underwent a final transformation during the early 1950s. Because he disavowed spontaneous brushwork and simplified and reduced the number of shapes in his imagery, his canvases continued to bear some resemblance to other color-field paintings. Reinhardt, however, separated his works from Abstract Expressionist painting by using geometric forms precisely drawn and painted in nearly homogenous colors. The geometric quality of Reinhardt's forms associated his paintings to some degree with Newman's large canvases, but Reinhardt never used contrasting stripes to mark off space in the way that Newman did. Instead, Reinhardt placed his flat rectangles and squares in a cruciform pattern. Reinhardt himself described his paintings of the 1960s as "classical black-square uniform five-foot timeless trisected evanescences" (see figure 32). He repeated this general arrangement of shapes and application of colors until his death in 1967. Although versions of these works appeared in shades of red, green, brown, and blue, Reinhardt called all of them his "black paintings."[1]

Reinhardt removed himself and his art even further from traditional leftist expectations when he turned to writing about his paintings. In the 1930s and 1940s, a time when American reformers called for an art that reflected the genuine experience of the common people, Reinhardt was a utopian abstractionist whose views on art and society demonstrated his admiration for the Dutch painter Mondrian. For example, writing in 1943, Reinhardt claimed that he found in Mondrian's paintings an "emotionally intense, dramatic division of space" that would "challenge...disorder and insensitivity" and that would then serve as "greater propaganda for integration." He suggested that mankind could only hope that society would someday be "organized...as intelligently and as beautifully as the spaces have been in some paintings."[2] Reinhardt's faith in abstract painting as an ideal toward which man should strive echoed the views of the other members of the American Abstract Artists group.

In the 1950s, after Reinhardt developed the "black paintings," he renounced political utopianism in art. In its place, he began demanding what he called "art-as-art." In the writings he published in the 1950s and 1960s, he separated himself even more from other leftists by completely rejecting any political uses for art. His first version of "art-as-art dogma" appeared in the little magazine *It Is* in 1958 in the form of aphorisms like the following:

1. ART IS ART. EVERYTHING ELSE IS EVERYTHING ELSE.
2. ART-AS-ART. ART FROM ART. ART ON ART. ART OF ART. ART FOR ART. ART BEYOND ART. ARTLESS ARTIFICE.

Claiming that art needed none of the external justifications provided by religion or politics, Reinhardt argued that it should stand alone. To reiterate that point, he quipped in one of his pieces that, "The one thing to say about art and life is that art is art and life is life, that art is not life and that life is not art."[3]

Reinhardt also appointed himself the guardian of morality and ethics in the art world. In that role he often cruelly condemned artists whom he felt had succumbed to the temptations of greed and ambition. His insistence on artistic purity sometimes led him to attack other Abstract Expressionists with whom he had once been friends and who had once shared common aesthetic concerns. Since Reinhardt's demands on art and artists were so rigorous, it became apparent that he was the only artist who could meet his own standards. His art-as-art dogma, then, marked not only a retreat from political utopianism in art but also revealed his isolation from his fellow avant-garde artists.

Reinhardt's art and criticism offers further proof of the significance of the debate over meaning and interpretation that took place within the New York avant-garde in the postwar era. In his case, the denial of meaning was a conscious and relentless attempt to silence his own art. That effort stands in sharp contrast to his continuing affiliation with leftist political groups. It also differs considerably from the kind of claims made for abstract painting by Barnett Newman. While Newman issued statements linking his art to anarchism, to the philosophical concept of the sublime, and to primitive art, Reinhardt ridiculed such assertions as pretentious and unrealistic. By refusing to join Newman's campaign to invest abstract art with meaning, Reinhardt repudiated the notion that the works of the Abstract Expressionists addressed what Rothko and Gottlieb had called the "tragic and timeless" questions of human history.

Reinhardt's strategy might be compared with that of the French New Novelists of the 1950s, like Alain Robbe-Grillet, whom critic Roland Barthes has described as "writing at the zero degree," and working in a style that is "neutral" and "transparent" and that achieves a kind of "absence" of meaning. In a similar vein, Susan Sontag has pointed out that the most important issue in painting for Reinhardt was not content but the formal principles of repetition, variety, and redundancy. By adopting a course that Sontag describes as "against interpretation," Reinhardt was radically extending one of the fundamental aspects of modernist art.[4] Like all modernists, Reinhardt refused to follow the conventional subject matter for art set out by the Christian and classical traditions. Yet unlike other modernists who then substituted for those traditions a content resting on utopian, mystical, or Freudian alternatives, Reinhardt chose to deny all meaning in his works. Art, he believed, could then remain pure and untainted by the political or religious needs imposed by outsiders.

Reinhardt's sympathy for the Communist Party, therefore, did not translate into any kind of traditional leftist aesthetic position. Instead he seemed to have borrowed the "extremism" and "dogmatism" associated with the Party during the 1930s to make his case against the art and artists of the postwar era. He felt that an uncompromising radical posture would dramatize his displeasure with the course of events in the postwar art world. It allowed him to show his distaste for the utopian, expressionist, and primitivist rhetoric of his fellow Abstract Expressionists. To Reinhardt, the most radical position for the artist was to deny all meaning and interpretation, thus freeing art from specific and concrete associations that might somehow damage it or constrain it. From an examination of Reinhardt's painting, politics, and criticism, it becomes apparent how much he departed from the rest of the Abstract Expressionist avant-garde. While the other artists and critics wanted to expand meaning outside the ideological frameworks of Freud and Marx, Reinhardt simply gave up on the whole problem. He denied all meaning and turned that denial into an ideology.

Like many other young intellectuals of the Depression, Reinhardt came to political radicalism easily, since his immigrant family had taught him socialism at an early age. Because his father was an organizer for a clothing workers' union, Reinhardt also maintained a lifelong allegiance to labor activism. He first publicly demonstrated his political views at Columbia College in New York City, when he earned some notoriety as a cartoonist for the campus humor magazine *Jester.* For that publication he drew savage satires about world and college affairs. For example, his cover for the February 1935 issue of *Jester* included Cubist-like portrayals of the dictators Stalin and Mussolini and a cigar-chewing capitalist. Another *Jester* cover displayed an orthodox leftist position by characterizing only the fascist and capitalist leaders as "enemies of the people." For another issue Reinhardt drew what he described as a "cubist-mannered" cartoon of the president of his college, Nicholas Murray Butler, whom he portrayed as a "'rectilinear'" figure "beating 'curvilinear' babies with a big club." That cartoon referred to Butler's opposition to child labor laws.[5]

After college Reinhardt joined the two major radical groups for artists, the Artists Union and the American Artists' Congress. After the Soviet invasion of Finland in the winter of 1939–1940 shattered the unity of the Congress, Reinhardt, unlike the other Abstract Expressionists Rothko and Gottlieb, did not join the new anti-Communist group, the Federation of Modern Painters and Sculptors. He remained loyal to the artistic left and the new organization, the Artists League of America, formed in 1942 out of the remnants of the groups from the Depression. Other artists who

supported the League included the Social Realists Philip Evergood, Anton Refregier, and Moses Soyer.[6]

Further proof of Reinhardt's confidence in the left appeared in his cartoons for the *New Masses* in 1938, 1939, and 1940, years when the Abstract Expressionists and other intellectuals were growing increasingly hostile to the policies of the Communist Party. Rather than join this anti-Stalinist faction, Reinhardt drew the Christmas cover for the *New Masses* in 1938 and anti-fascist cartoons from January 1939, through July 1939. In one cartoon in January 1939, entitled "Returned, No Thanks," he portrayed a group of American conservatives and European fascists as unwelcome Christmas gifts (see figure 33). After the Soviet Union announced its alliance with Nazi Germany in the August of that year, Reinhardt abandoned his attacks on fascism and instead directed his criticism toward British leaders. In one such cartoon entitled "The Unhappy Warriors" (October 1939), he depicted the capitalist fear that the defeat of Hitler would unleash a proletarian revolution in Europe (see figure 34). Another of these anti-British cartoons, "Millennium" (February 1940), pictured the threat of British imperialism to smaller European nations (see figure 35). As one further example of Reinhardt's fidelity to Party policy, he drew illustrations in October 1939, for a *New Masses* article that warned that pro-British sentiments might bring the United States into the war. Reinhardt switched targets again after the German invasion of the Soviet Union and resumed his attacks on fascism. For example, in a cartoon for the newspaper *P.M.* in 1943, he drew Franco as a puppet sitting on Hitler's knee.[7]

After the war, Reinhardt continued his political activism. For example, in 1945 in a review for the *New Masses,* he chided painter Stuart Davis, once a leader of the American Artists' Congress, for deserting the left when the war began. Reinhardt also kept on drawing cartoons and illustrations for radical publications. In 1947, for instance, he produced a series of drawings for an article in the Party magazine *Soviet Russia Today* that advocated cooperation between the United States and the Soviet Union. By choosing to draw illustrations for an openly Communist journal, Reinhardt clearly isolated himself from the rest of an avant-garde community that by the late 1940s had become resolutely anti-Stalinist. Reinhardt's association with *Soviet Russia Today,* for example, would have been interpreted by intellectuals like Clement Greenberg as treasonous activity.[8]

When the movements for black civil rights and for an end to the war in Vietnam emerged in the 1960s, Reinhardt again joined the picket line. He was the only Abstract Expressionist to participate in the March on Washington for black rights in August 1963. He also donated paintings to auctions held to raise money for civil rights groups and black churches.

After the Vietnam conflict escalated, he supported the anti-war movement by signing numerous petitions against the war and contributing to the artists' tower against the war erected in Los Angeles.[9]

From this sketch of Reinhardt's political experience, it is obvious that he identified himself with reform, if not revolutionary, groups, throughout his life. His paintings, however, remained completely abstract and never reflected any of the ideas or qualities associated with the political left. It was only in Reinhardt's writings in the 1940s that we can find any attempt on his part to try to reconcile his political radicalism with the style of painting that he preferred. Then, as a young artist, he sought to infuse abstract art with political meaning by turning to the utopian aesthetic theories of Dutch modernists. In the writings of Europeans like Mondrian, Reinhardt found a profound faith in the spiritual powers of abstract art. For these painters, abstract art served as an ideal of clarity and logic that could resolve the conflict and chaos found in the material world. For Mondrian and his fellow abstractionists in the *de Stijl* group, abstract art could represent the utopian future for mankind because it no longer had to imitate the objects of the natural world or reveal the personality of the individual artist.

Mondrian's essay, "Plastic Art and Pure Plastic Art," published in the British journal *Circle* in 1937, served as a source of inspiration for Reinhardt and other American abstract painters eager for a way to reconcile their aesthetic tastes with the imperatives of their political conscience. For Mondrian the only possible course for art was geometrical abstraction because it represented an evolution toward the "pure," the "universal," the "objective," and "the essence of things and of ourselves." Abstractionists, according to Mondrian, did not seek an art that rested on a political truth or a political need. In fact, the pioneers of abstract art worked in a direction that opposed that dictated by the society around them. Yet that did not mean that Mondrian believed that abstract art remained aloof from the world. Instead he argued that nonfigurative artists "further human development" by discovering "the fundamental laws hidden in reality." Nonfigurative art, therefore, in the Dutchman's words, "serves mankind by enlightening it." To express these universal, fundamental laws and truths, Mondrian claimed, rectangular forms, straight lines, and primary colors provided the artist with purer, more profound means of expression. Such abstract elements moved the artist further away from the particular, natural, and subjective world and into the realm of the universal. At the end of his essay, Mondrian predicted that this purified and totally abstract art would then act on the environment to make it "pure and complete in its beauty."[10]

Mondrian's abstract painting attracted admirers who established small groups to spread his ideals. These included the *Abstraction-Creation* group formed in Paris in 1931, and its counterpart in New York, the American Abstract Artists, founded in 1936. These American abstractionists had gone to Paris to study during the 1930s and had been impressed by Mondrian's art and ideas. When they returned to New York, they quickly came to resent the notion that American painters had to be realists to be true to their culture. When even the Museum of Modern Art refused to acknowledge that Americans could paint abstract works, this small group of Mondrian disciples took action. Because the Museum omitted them from its major 1936 exhibit, *Cubism and Abstract Art,* they decided to form their own exhibition group. Following the example of one of his teachers, Carl Holty, Reinhardt joined that group in 1939 and later served as its treasurer and on its publicity and exhibition committees. Although few members were wealthy and well-established figures in the art world, most, like Reinhardt, were younger, unknown artists. Another Abstract Expressionist active in the organization in the early 1940s was Lee Krasner, who worked on the committee that assisted European artists who wanted to settle in the United States during the war. Arshile Gorky, William de Kooning, and David Smith also attended early meetings of the American Abstract Artists. Mondrian himself became a member in 1940, when he fled the war to live in New York City.[11]

The essays in the early catalogs for American Abstract Artists' exhibits echoed Mondrian's views on the relationship between abstract art and society. One member asserted that abstract painters worked for "the physical and psychic benefit of all humanity" through the universal nature of nonfigurative art. During the war, when many called on art to be useful in the struggle for a military victory, these abstractionists reminded the public that culture could only be a force for "POSITIVE progress" by remaining independent of war propaganda. They noted that it was the fascists who wanted to use culture to satisfy the needs of the war machine. Another member of the group, Balcomb Greene, praised abstract art for its refusal to be appropriated for what he called "the tunes of home-soil nationalism" and "proletarian discontent." Greene did not deny that the political situation in 1938 was bleak, but abstract art offered hope because it was created by "the independent thinker." At a time of bitter conflict between national interests, Greene argued that men of culture provided an example of disinterested internationalism. The paintings of Greene and his friends, then, played a crucial role in world politics because, Greene argued, "abstract art arrives as the first international language of the brush."[12]

In 1943, Reinhardt expressed similar views on the proper role of culture during war in a piece he presented to the Artists' Council for Victory.

The Council was a coalition of groups formed after American entry into the war to coordinate the art world's contribution to victory. As abstractionists, Reinhardt and his friends were in a difficult position in 1943. Observers like Edward Alden Jewell, the critic for the *New York Times,* and Francis Henry Taylor, an official at the Metropolitan Museum of Art, were raising questions about the role of the fine artist in the war. Reinhardt issued a defiant response to such pressures. He asserted that "the fine artist can be important to the war effort as fine artist" and not in any other role. Others may demand that the fine artist become a "soldier, draughtsman, camoufleur, cartoonist, poster designer, or work-relief recipient," but Reinhardt recommended that he remain detached from useful tasks. To Reinhardt the potential of aesthetic knowledge was best represented in an exhibit of Mondrian's works that asked from their viewers a "concentrated," "direct," and "firsthand" aesthetic experience. Like Mondrian, Reinhardt believed that straight lines arranged in horizontal and vertical formats and primary colors gave viewers the "stronger" and most "dynamic" aesthetic impression.[13]

In another essay written during the war, Reinhardt continued to echo the utopian views set out earlier by Mondrian. First, like the Dutchman, Reinhardt dismissed realism as mere picture-making that could be better accomplished in the modern era through cinema or photography. Another trap for the artist was Surrealism, which reflected, according to Reinhardt, the world of "chaos, confusion, individual anguish, terror, horror" in which the artist lived, but which offered no solution, only "a prisonlike enigma...without any understanding, direction, or rest." Abstract art, on the other hand, provided man with "a discipline, a consciousness, and order that implies man can not only control and create his world but ultimately free himself completely from a brutal, barbaric existence." In a comparison borrowed from Marxian dialectics, Reinhardt then suggested that art works would disappear once "the environment itself became an aesthetic reality."[14]

However determined, Reinhardt and the other members of the American Abstract Artists group remained on the defensive during the war. Their fellow leftists demanded an immediate and committed response to the imperatives of the war against fascism. After the war, Reinhardt found that antagonism toward abstract art persisted. He then worked as a cartoonist for the liberal daily newspaper *P.M.* and sought through his drawings to rectify the leftist preference for realistic painting. To do this, Reinhardt chose to portray realism as unprogressive and old-fashioned (see figure 36). He ridiculed the left's predilection for realistic art by equating it with "reactionary, big-business, exploitative politics." He linked abstract art, in turn, with more progressive political forces. In Reinhardt's car-

toons, the realist became an unsavory bohemian while the abstractionist was the clean-cut, patriotic proletarian. The abstractionist created an art that, according to Reinhardt, was based on the exploration of new realms of thought in the same way that Albert Einstein worked on the newest problems in physics. The realist, on the other hand, continued to believe that the principles of Aristotle, Euclid, and Newton represented the latest in scientific discoveries.

In another cartoon, Reinhardt playfully identified the realist with racism, isolationism, capitalism, and dirty restaurants (see figure 37). On the other hand, the abstract painter and the political progressive were both portrayed sympathetically as the supporters of equality, democracy, decency, order, and clean living. Reinhardt obviously enjoyed needling his fellow leftists by reminding them that realism was no longer the most advanced and progressive kind of painting. His cartoons, however, failed to convince the left. The art critic for the *Daily Worker* responded by calling the cartoons "ridiculous" and "inaccurate," and by defending realistic art as the proper one for the masses.[15]

Beginning in 1952, a new tone and new concerns appeared in Reinhardt's writing and cartoons. The essays of the 1940s had relied on the utopian interpretation of abstract art developed by Piet Mondrian and were written in a fervent, yet logical and reasoned prose style. After 1952 his language and style changed dramatically. To illustrate this new extremism and purity, he abandoned normal syntax and paragraphs and developed a more difficult, sometimes impenetrable style filled with omissions, contradictions, and obscurities. He also displayed a savage, merciless wit. Eventually he named this new writing his "art-as-art dogma," in an attempt to compare it to the purity and extremism of the ideology of the Communist Party during the Depression. No longer a utopian like the followers of Mondrian, and equally disdainful of the other Abstract Expressionists, Reinhardt attempted to silence his art completely and prevent anyone from interpreting it. As a result, he was forced to isolate himself and his art from every other artist around him. For the rest of his life, he carried on this insistent, relentless campaign against the corruption of art by politics, religion, ambition, or greed.[16]

One of the first examples of this new style was a short piece, "Abstract Art Refuses," that he wrote for an exhibition catalog in 1952. After reminding his readers that modernist painters had always defined their art through the process of rejecting the art of the past, Reinhardt then broke off his normal prose to make a list of what he had dismissed. This final paragraph comprised a list of what Reinhardt forbade in painting. For example, he characterized realism in painting as "fooling-the-eye"; expres-

sionism in painting as "sadism or slashing"; and religion in painting as "divine inspiration or daily perspiration." He ended his list by calling on artists to be free of all "involvements" and to avoid "confusing painting with everything that is not painting."[17]

Reinhardt continued his campaign for purity in art by vilifying every kind of painter active in the American art world. He made one of his first attacks on other artists in 1954 at a symposium on the Reality group, an organization formed in 1953 by more traditional artists, many of them Social Realists, who felt that officials in museums and galleries had become too partial to abstract art. Certainly Reinhardt would have supported Reality's protests about the state of the art world, but the thrust of his speech was not friendly to any one type of artist. His piece was a devastating attack on other artists, a wholesale indictment that omitted no one, friend or foe. In what one critic has called a "sniping" and "bitchy" tone, Reinhardt labeled the American realist as a "crackerbarrel sophisticate," "atomic-age art reporter," and "dogpatch dandy."

Though Reinhardt had been friendly with the avant-garde in the 1930s and 1940s, he showed them even less mercy than the realists. Rothko, in Reinhardt's opinion, was a "Vogue magazine cold-water-flat fauve;" and Pollock, the "Harpers Bazaar bum." Newman became, in Reinhardt's eyes, "the avant-garde huckster-handicraftsman and educational shopkeeper" and "the holy-roller explainer-entertainer-in residence." He ended his attack on his fellow painters by telling a story about a child who had refused to raise his hand when his teacher had asked the class who wanted to go to heaven. When the teacher inquired why the boy did not want to go to heaven, he replied that he did want to go but "'not with them guys.'"[18] These insults to his former friends isolated Reinhardt from the rest of the avant-garde for the remainder of his life. Newman for one felt the sting of Reinhardt's venom and responded by demanding an apology from the *College Art Journal,* the magazine that had published Reinhardt's piece. When Newman discovered that the only way to receive an apology was through the courts, he sued. He lost the case, but Reinhardt never mentioned him in print again.[19]

In the first art-as-art statement, Reinhardt again abandoned ordinary prose to cast his dogma in short, numbered statements printed in boldface type. He stated his formulas endlessly as if he wanted to drown out all objections. For example, he defined his policy on art in one line as "PAINTERS' PAINTING. PAINTING'S PAINTERS. PAINTERS' PAINTERS." He also enjoyed linking contradictory qualities in order to give his readers the sense that he constantly moved in a circle. For example, he ended his 1958 statement using the same terms that he had borrowed from the utopian writings of Mondrian, but he then went on to contradict all of them. Art-as-art, then, meant to Reinhardt:

THE MOST COMMON MEAN TO THE MOST UNCOMMON END.
THE EXTREMELY IMPERSONAL WAY FOR THE TRULY PERSONAL.
THE COMPLETEST CONTROL FOR THE PUREST SPONTANEITY.
THE MOST UNIVERSAL PATH TO THE MOST UNIQUE. AND VICE-VERSA.

When these statements are compared with the essays written by Newman, they appear to be an attempt to deflate the solemn, serious rhetoric that had come to be associated with Abstract Expressionism. Reinhardt's dogma may in the end be a kind of parody of artists' writings. His contradictions were part of an evasive strategy, for as he explained in one of the few straightforward lines in the 1958 statement, he wanted an art "ABOUT WHICH NO QUESTIONS CAN BE ASKED."[20] He probably would have added "ABOUT WHICH NO QUESTIONS COULD BE ANSWERED."

Critics have also noted the way in which the dogma resembles the black paintings of the 1950s and 1960s. In the 1958 statement in *It Is,* Reinhardt listed some adjectives that he thought applied to his art. They included: "CENTRAL, FRONTAL, REGULAR, REPETITIVE, STYLE AS RECURRENCE, COLOR AS BLACK, EMPTY, RECTILINEARITY, STASIS, MONOTONES." Certainly, Reinhardt found that repetition worked in language as well as in art. He also used a kind of droning voice that recalled the monotone quality of his paintings. And his contradictions leave the reader so bewildered that the content of the statements seemed as empty as the canvases. Like his paintings, his prose was reductive since he had eliminated all that was ordinary and unnecessary. One key quality of his writing was a hardness, a reduction to only the idea, without any texture or superfluous decoration. His dogma was therefore as conceptual as his paintings. These outlandish paintings that befuddled and angered the public were accompanied by an equally bewildering and controversial prose.[21]

In Asian art and artists, Reinhardt found inspiration for the purity that he praised in his art-as-art dogma. He admired what he called classical Chinese painting because it was "complete, self-contained, absolute, rational, perfect, serene, silent, monumental, and universal." Asian sculpture was equally admirable for its "intensity, consciousness, and perfection." After a visit to the ruins of Angkor in Cambodia in the 1960s, Reinhardt wrote that the jungle overgrowth on the buildings symbolized the threat to art from external forces. In his opinion, politics and religion overran art the way vines had covered the architecture that he had seen in Asia. He also praised the way that Chinese painters withdrew from the world of politics and religion to become "sage-scholar-hermit-gentlemen."[22]

Reinhardt wished that American painters, too, would withdraw from the world. He suggested that art education be conducted in a modern-day version of the cloister. According to Reinhardt, an art school should be "an

ivory-tower-community of artists, an artists' union and congress and club, not a success school or service station or rest home or house of artists' ill-fame." Reinhardt also believed that museum officials should turn away from popularizing art. A museum, in his opinion, should be "a treasure house and tomb, not a countinghouse or amusement center."[23]

Reinhardt was equally harsh on art critics. Because he received little of the critical praise accorded other Abstract Expressionists during the 1950s, he remained an outsider. In a piece written for *Art News* in 1964, he must have even delighted some of the artists he had once insulted. Comparing art criticism to "pigeon-droolings," Reinhardt cataloged the failings of contemporary art critics by transforming their names into those of unpleasant birds. Clement Greenberg, never an admirer of Reinhardt's paintings, became "the clammy green-bird," Harold Rosenberg was "the howling rosen-bird;" Thomas B. Hess, "the tawney-hess pippett;" Emily Genauer, "the emily-jinn-hour harpy;" and John Canaday "the canny-day common crow." In 1966 Reinhardt leveled more serious charges at the two art critics associated with Abstract Expressionism when he claimed that they were more concerned with establishing successful careers than with art. He asked the readers of *Art News:* "Remember when a C. Greenberg-type critic could take in a 'hungry-for-success' artist and cut him in?"[24]

Reinhardt's cartoons carried on his campaign for purity in art. One of the most complex and elaborate of his pieces, "FOUNDINGFATHERS-FOLLYDAY" (1954), took on the artists, museums, dealers, and magazines of the New York art world (see figure 38). The "fathers" were the Abstract Expressionists, the founders of the New York School; and Reinhardt drew up a humorous guide to them, their art, and the people around them. The Parsons Gallery, once the representative of many of the Abstract Expressionists, became in Reinhardt's cartoon, "ParsongiftShoppe antiquesjewelry workesofarte forthe uppermiddlebrow." Janis, the commercially-oriented dealer who had replaced Parsons, became: "Wholesale& Retail JanissButcherBaker &CandystickMaker fakedupHistory forthetrade Museums& millionaires." Reinhardt called the Museum of Modern Art, the "MUSEUMOFMIDDLEBROWART." He also drew up a satiric family tree for the Abstract Expressionists where he linked these artists to Old Masters like Cimabue and Giotto. In this drawing Reinhardt implied that critics who had already labeled these paintings as masterpieces had been a bit premature. He also devised a series of games to satirize his fellow artists. In one boxing match, Reinhardt suggested that Newman battle Beelzebub, a contest that would match, according to Reinhardt, "superman" and a "demigod." Another bout pitted Pollock against de Kooning, a pairing that Reinhardt characterized as "whyomingpolecatvsdutchslasher."[25]

The key to understanding Reinhardt's art-as-art dogma, his vicious attacks on his former friends, and his cartoons lies in his insistence on ethical conduct among artists. Reinhardt wanted avant-garde painters to remain untainted by commercial success. The other Abstract Expressionists had earned some financial rewards for their works by the mid-1950s. Before then, these artists had exhibited in galleries like those of Betty Parsons and Samuel Kootz, where their paintings were appreciated by a few but for the most part remained unsold. Beginning in 1952, a number of the artists switched to dealer Sidney Janis, because they considered him more aggressive than Parsons or Kootz. During the 1950s, Janis represented Pollock, de Kooning, Kline, Rothko, and Motherwell and obtained greater monetary security for them. Ad Reinhardt alone remained with Betty Parsons.[26]

Reinhardt's loyalty to Parsons demonstrated his isolation. There were a number of reasons for his separation from the other Abstract Expressionists. He continued to be more sympathetic to the organized left than any of the other artists. He was also one of the few among these artists who taught for a living and found the academic routine an amenable way to survive. He and Motherwell were also among the few avant-garde artists of the era to have a college education. But, more importantly, the success of Reinhardt's works never matched that of his former friends. For example, he was one of the last of the Abstract Expressionists to be included in shows at the Museum of Modern Art. The Museum had put Motherwell in an important show as early as 1946, and Pollock had his first one-man show there in 1956. Reinhardt had to wait for such recognition. In the 1960s, for example, he complained to a Museum official that his works were appearing in shows of new talent.[27] That development was hardly a comfort to an artist whose career had begun during the Depression.

Reinhardt frequently spoke out against the commercialization of the art world. Alarmed at what he called the "rapidly expanding interstate commerce of 'avant-garde entertainments'" he called on artists to retreat from the marketplace. The most serious threat to art came, according to Reinhardt, from "philistine" artists, profit-seeking art dealers, and the "utilitarian, acquisitive, exploiting society" that could not tolerate art done for "its own transcendental sake." Art, according to Reinhardt, was a serious and ethical pursuit that should avoid "gallery gimmicks," "the entertainment business," "vested interest," and "bargain-art commodity." Reinhardt predicted that a revolution would take place in the art world that would drive out the "pricing and buying and selling" of the "international art cartels." When he held a show of his black paintings in 1963, he described them as "unsalable," and "priceless." He claimed that his art "has no price tags, no markets, no buyers, no sellers, no dealers, no collectors."[28]

Reinhardt singled out Willem de Kooning as the prime example of the artist who had succumbed to the enemies of art-as-art. Reinhardt and de Kooning had been friends in the 1940s, even sharing a studio. Reinhardt had also printed a reproduction of a de Kooning painting in one of his *P.M.* cartoons. In the 1950s, however, Reinhardt began to chide de Kooning for his success. He ridiculed him for his alleged remark that "'The rich are all right.'" Reinhardt also criticized de Kooning for becoming a celebrity. De Kooning committed a serious error, in Reinhardt's words, by "living like Elizabeth Taylor." "Everybody wants to know," Reinhardt fumed, "who he's sleeping with, about the house he's building and everything." Reinhardt also lambasted Pollock for dining at the 21 Club and sniped at Rothko:

> Religious strength through market-place joy!
> The first word of an artist is against artists.

> What's wrong with the art world is not Andy Warhol or Andy
> Wyeth but Mark Rothko.
> The corruption of the best is the worst.

Pop artists like Warhol or realists like Wyeth could make money but their crime was not nearly as hideous as that of Rothko, one of Reinhardt's old comrades from the Artists Union and Betty Parsons Gallery.[29] One development that Reinhardt found particularly offensive was the annual art exhibition and contest sponsored by the Pepsi-Cola Company. The beverage company had awarded prizes and printed reproductions of winning paintings in their calendars. To Reinhardt this contest fostered a "'grand abstract manner'" that would offend no one and please as many people as possible. In 1946, he condemned the competition in a cartoon for *P.M.* that used an engraving of the death of Socrates to point out that the American painter drank from a poisonous bottle when he entered the Pepsi-Cola contest[30] (see figure 39).

In his art-as-art dogma and his cartoons, Reinhardt set up a standard of behavior for artists. He felt compelled to do so because of the changed circumstances of the art world after the Second World War. The avant-garde, to which Reinhardt belonged and that had once attacked the official art world with righteous indignation, was no longer ignored by critics and museums. Fame and wealth came to the Abstract Expressionists and transformed them from the avant-garde into the art establishment. Reinhardt believed himself to be the only artist resisting the corruptions and temptations offered in the newly affluent American art world.

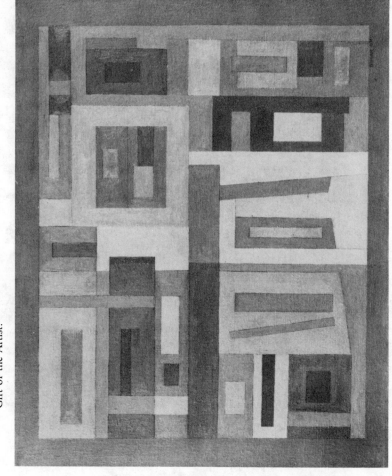

Figure 30. Ad Reinhardt. *Untitled*. 1938. Oil on canvas. 16 × 20″.
Collection of the Museum of Modern Art, New York.
Gift of the Artist.

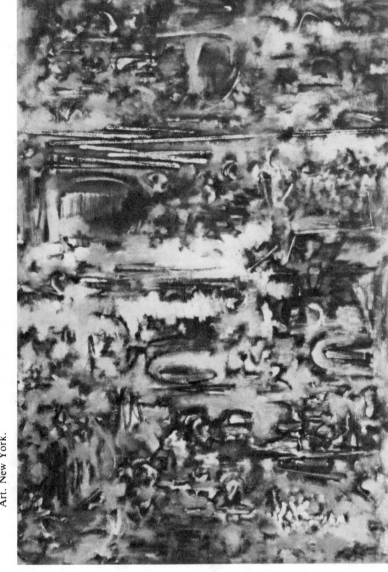

Figure 31. Ad Reinhardt. *Number 18*. 1948–49. Oil on canvas. 40 × 60". Collection of Whitney Museum of American Art. New York.

Photo: Oliver Baker

Figure 32. Ad Reinhardt. *Abstract Painting, Number 33.* 1963. Oil on canvas. 60 × 60". 50th Anniversary Gift of Fred Mueller. Collection of Whitney Museum of American Art, New York.

Figure 33. Ad Reinhardt. "Returned, No Thanks." *New Masses* XXX (3 January 1939): 15.

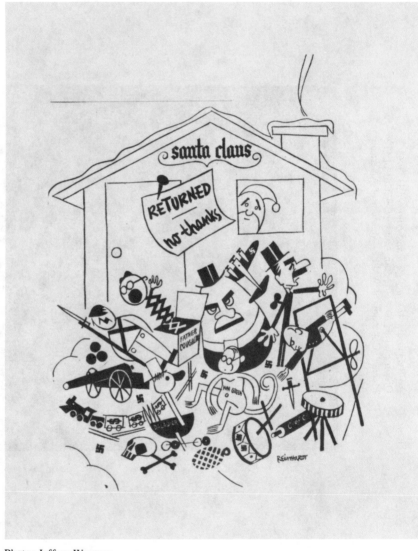

Figure 34. Ad Reinhardt. "The Unhappy Warriors," *New Masses*
XXXIII (10 October 1939): 15.

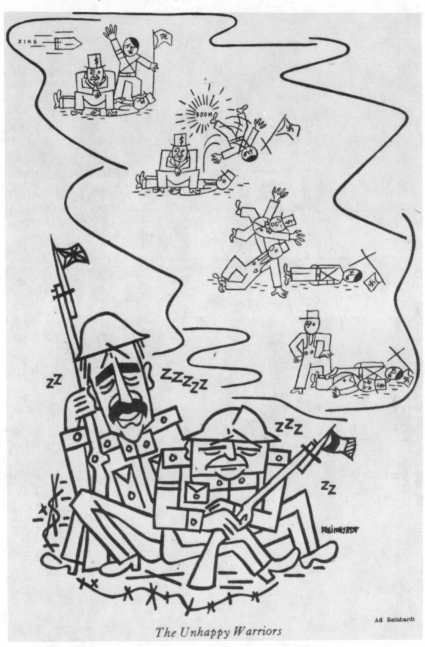

The Unhappy Warriors

Figure 35. Ad Reinhardt. "Millennium," *New Masses* XXXIV (6
February 1940): 7.

Photo: Jeffrey Wayman

Figure 36. Ad Reinhardt. "How to Look at a Cubist Painting."
P.M. (27 January 1946).

Figure 37.　Ad Reinhardt."How to Look at Looking." *P.M.* (21 July 1946).

Photo: Jeffrey Wayman

Figure 38. Ad Reinhardt. "FOUNDINGFATHERSFOLLYDAY."
1954. Collage of ink and paper. 12 × 20'. Collection of
Whitney Museum of American Art, New York. Gift of
Mrs. Ad Reinhardt.

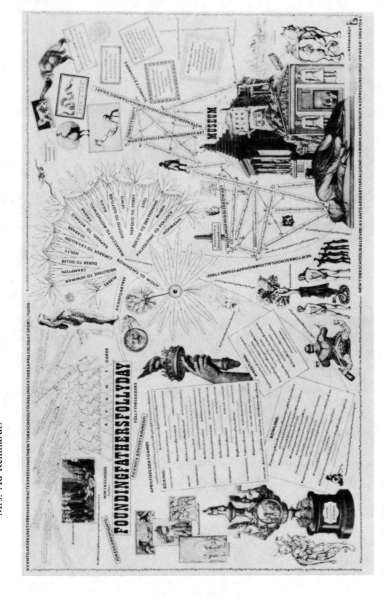

Photo: Geoffrey Clements

Figure 39. Ad Reinhardt. "How to Look at Art and Industry."
 P.M. (6 October 1946).

Photo: Jeffrey Wayman

Playing Cowboy: The Art Criticism of Harold Rosenberg

In 1961 when reviewing a book about Jackson Pollock, art critic Harold Rosenberg began his piece by comparing that painter to Daniel Boone. By claiming that Pollock resembled "the 'ring-tailed roarer'" of the American West who "liked to go to saloons and play at bustin' up the joint," Rosenberg suggested that this artist sometimes deliberately posed as a cowboy. Pollock adopted that role, according to Rosenberg, because it gave him the courage to challenge the European masters of modernist painting. In Rosenberg's opinion, "playing cowboy helped make it possible for Pollock to paint under hardships that regularly filled him with despair." The critic complained that some observers, particularly Europeans, failed to understand the difficulty of being an American modernist artist. They often reduced Pollock and his art to what Rosenberg called "a kind of sideshow" in which the artist became "a twentieth-century abstract Buffalo Bill."[1]

Behind this comparison between Jackson Pollock and Daniel Boone lies the key to understanding Harold Rosenberg's art criticism. His most famous essay on Abstract Expressionism, "The American Action Painters" (*Art News,* December, 1952), usually occupies a central place in any analysis of his criticism. Yet that piece examines what Rosenberg saw as cultural failure. Once a radical who had demanded that painters use their art to further socialist revolution, Rosenberg concluded after the Second World War that the only choice open for the Abstract Expressionists was "to hang around in the space between art and political action."[2] After 1945, Rosenberg's writing on art and politics centered on this note of despair about lost opportunities. He believed that painters like Pollock and de Kooning lived and worked at a moment of crisis when politicians made demands on artists that they could not meet and did not want to meet. Rosenberg lamented that they consequently had to retreat to the studio to avoid intense political pressures. There, these "Action Painters" created an art that stood as a symbol of freedom in an age of political conformities. Yet Rosenberg never seemed particularly delighted about this situation.

After the Depression, in Rosenberg's opinion, painters faced a nearly hopeless task when they attempted to fuse art and politics. Only when this critic addressed the question of cultural nationalism was he able to shed his pessimism and proclaim the dawn of a new age in painting. By associating Jackson Pollock with Daniel Boone, Rosenberg not only pointed to the struggle of provincial American painters to understand European modernism but also to their eventual triumph over it. Pollock might find it impossible to be a Marxist painter in the postwar period, but he could be a hero of another kind. In Rosenberg's essays, Pollock became an expert frontier sharpshooter taking aim at the best twentieth-century European painting and hitting his mark. When this task became difficult, the American artist turned, Rosenberg argued, to the solace of "playing cowboy." It was this image of Pollock as the cowboy artist with the courage and the audacity to tackle and master the most difficult forms of European culture that revealed the energy and faith at the heart of Rosenberg's art criticism.

Rosenberg's praise for Pollock and de Kooning rested on the ambiguities of experience of a whole generation of intellectuals who, as members of immigrant communities, sought assimilation through the pursuit of high culture. In the end, Rosenberg found the American tradition of "rugged individualism" more amenable to his disposition than any other aspect of cultural and political life. Rather than finding a true political radicalism in Abstract Expressionism, he interpreted it in terms of the cultural nationalism prevalent in postwar American intellectual life.

Born in Brooklyn in 1906, the son of Jewish immigrants from Eastern Europe, Rosenberg quickly abandoned the concerns of his family and his community to explore the international cultural scene. Although he obtained a law degree after graduating from City College of New York, he followed his artistic ambitions during the Depression by writing for the avant-garde magazines *Poetry, transition,* and *Symposium.* During those same years, he also developed an interest in modernist painting and sculpture. He worked as an assistant to a muralist on the Federal Art Project, joined its Artists Union, and served on the editorial board of its magazine *Art Front.* In the next decade, he wrote for *View* and *VVV,* two magazines associated with the European Surrealist refugees.

After the war he emerged as a major spokesman for the Abstract Expressionist painters. In 1947 he and painter Robert Motherwell assembled the little magazine *Possibilities* that included some of the first published reproductions of Abstract Expressionist paintings. In that same year, Rosenberg wrote the catalog foreword for the first major show of the new American art in Paris, and two years later he contributed the introduction to another early Abstract Expressionist catalog, *The Intrasubjectives.* Then

in 1952, his essay, "The American Action Painters," offered one of the first general interpretations of the new painting. Seven years later, he published *The Tradition of the New,* a collection of essays on culture and politics that reaffirmed his position as one of the most influential commentators on contemporary intellectual life. In the 1960s he became the regular art columnist for the *New Yorker,* the culmination of his journey from a Brooklyn immigrant neighborhood to Manhattan's international cultural community.

Like many other intellectuals around him during the 1930s, Rosenberg believed that the cultural program of the Communist Party offered him the means to join American cultural life. Because the Party presented him with a key to understanding, transforming, and thereby belonging to his home-land, he could find a place for himself in American intellectual life and still retain his radical and cultural ambitions. For example, in the mid-1930s Rosenberg displayed great enthusiasm at the prospect of a socialist revolution that would elevate the poet to a preeminent position in society. Remembered as a talkative radical usually "surrounded by a band of disciples, admiring ladies who enjoyed listening to his Marxist-Hegelian discourses on literature, art, and philosophy," Rosenberg seemed certain that a socialist revolution would only enhance creativity. For example, in one of his poems he predicted that a workers' society would endow artists with prestige and power. In another, he exhorted them to join the cultural front for revolution:

> Poets, seize the festivals,
> Capture the holidays, possess
> The central cable offices of belief...
> Poets, steal the spotlights.

In his criticism Rosenberg defended Marxism against the accusation that it was a utopian, rigid ideology by claiming that a proletarian revolution would protect and foster culture. Capitalism, Rosenberg charged, made the artist a "voluptuous taster of spiritual commodities, secure from the partisanships of life and without responsibility." He called for writers and artists to renounce aestheticism and "step forth from the little magazines...and walk once more upon the stage and street."[3]

Despite Rosenberg's obvious commitment to social change and to the artist's central role in such a process, he soon discovered that his artistic standards differed greatly from those of the Communists. For example, he bickered constantly with the Party members he worked with on the Federal Writers' Project. Assigned to edit *American Stuff,* a magazine for Project employees, he chose to include poetry and short stories that did not meet

Party guidelines. As an editor of *Art Front,* he also met with criticism for his preference for modernists like Vincent Van Gogh. While Party members demanded that art be judged solely for its political content, Rosenberg wanted to make editorial decisions on the basis of aesthetic merit.[4]

The Party's encouragement of these editorial battles over politics and art, even during its Popular Front period, drove Rosenberg from the Stalinists to a short-lived alliance with the Trotskyist group, the League for Cultural Freedom and Socialism. Like other Trotskyist intellectuals of the Depression, Rosenberg admired the Russian leader as a brilliant, cultured, and radical fellow Jew who supported an independence for art as well as a socialism uncorrupted by the horrors of Stalinism. Though Rosenberg rejected capitalism, he could not accept the totalitarian alternative of the Soviet Union.

Trotskyism became the first step away from radicalism for many Depression intellectuals. For example, the editors of *Partisan Review,* William Phillips and Philip Rahv, close associates of Rosenberg, moved from Trotskyism to a more favorable assessment of American culture and society. That process culminated in *Partisan Review*'s famous 1952 symposium "Our Country and Our Culture." To others, Trotskyism was an indication of a fervent anti-Stalinism that would be translated during the 1950s into anti-Communist liberalism. Two of the Trotskyists who wrote for *Partisan Review,* Sidney Hook and Clement Greenberg, abandoned their support for socialist revolution after the Second World War.

Rosenberg too detested what he described as the immorality of Communist leaders. In 1949 in *Commentary* he published an attack on Soviet leaders for their willingness to sacrifice human life for the sake of the revolution. But Rosenberg did not long remain in the company of *Commentary*'s other anti-Communist contributors. He did despise the Soviet Union and the Communist Party, but he remained wary of the accommodations with capitalism and conservatism made by the anti-Communist liberals on *Commentary*'s staff. He maintained his faith in the intellectual as an independent critic of society.[5]

During the 1950s Rosenberg joined with Irving Howe and Lewis Coser, two other anti-Stalinist socialists, in writing political and cultural criticism for the magazine *Dissent.* Founded in 1954 by Howe and Coser, *Dissent*'s editors attempted to establish a radical alternative to the Communists and their "fellow-travelers." They were especially critical of the Progressive Party and Freda Kirchwey, editor of the *Nation.* After the revelation of Stalinist excesses, only an independent radicalism seemed possible to Rosenberg and other *Dissent* contributors. Their concern for domestic reform and civil liberties also made them bitter critics of the anti-Communists who wrote for *Commentary* and those who belonged to the international cultural group, the Congress for Cultural Freedom. For

example, during the McCarthy era the *Dissent* group objected to the willingness of Congress supporters like Irving Kristol to dispense with the right of free speech when pursuing alleged subversives.[6]

In one of Rosenberg's more biting essays for *Dissent,* "Couch Liberalism and the Guilty Past," he denounced the contradictions within anti-Communist liberalism. Echoing Howe's opposition to both Communism and anti-Communism, Rosenberg charged that the Soviet leaders and America's liberals actually shared certain totalitarian political methods. Using a comparison designed to enrage liberals, Rosenberg claimed that both camps manufactured political myths by exacting confessions from former "sinners" within their midst. For example, during the purge trials of the 1930s Stalin forced admissions of treason from his victims. According to Rosenberg, the liberals of the 1950s did the same when they demanded that all ex-radicals admit their past errors and assume the guilt they must bear for their support of Communism during the Depression. Rosenberg argued that some radicals like Alger Hiss may have been guilty of crimes, but that he, Rosenberg, was one of many intellectuals who had seen the weaknesses within the Communist position. As he sarcastically explained, "I raise my right hand and reply that I never shared anything with Mr. Hiss, including automobiles or typewriters, certainly not illusions."[7]

Finding little to admire in the intellectual life of the 1950s, Rosenberg and the editors of *Dissent* looked to the past for a model and found it in the *Masses* (1911–1917). That magazine symbolized the socialist political sentiments and experimental cultural tastes of American intellectuals before the Russian Revolution and the rise of the Communist Party. In a piece on the *Masses,* Howe mourned the loss of enthusiasm for political and cultural radicalism that had been expressed with "energy" and "hope" in that magazine.[8] He and the other contributors to *Dissent* wanted American radicals to remain independent from the dictates of a foreign power like the Soviet Union and to be able once again to support avant-garde culture.

Looking back on Depression radicalism, Rosenberg drew a distinction between those intellectuals who became Communist Party loyalists and those who found Marxism an intriguing idea. To intellectuals like himself, Rosenberg argued, Marxism had represented the life of the mind and a way to investigate the questions of individualism and identity found in literature and painting. During his youth, Rosenberg concluded, he had found in Marx's writings "a new image of the drama of the individual and of the mass."[9] Rosenberg would remain fascinated by that issue throughout his life. While Party bureaucrats focused on internal matters, intellectuals like Rosenberg studied the class struggle as an historical drama or as a literary metaphor. There was a significant difference in interests and perceptions between Party functionaries and intellectuals like Rosenberg.

Yet Rosenberg continued to demand a political commitment from artists. And because the old formulas found in the *Masses* and *Partisan Review* were inappropriate in the wake of Stalinism, Rosenberg sought a new meeting ground for art and politics. Not surprisingly, the only possible political stand that Rosenberg could imagine for the artist of the postwar era was resistance to conformity. For Rosenberg it was no longer possible to focus on specific social questions. The issue of the era for the intellectual was not class struggle but individual freedom. Because Joseph Stalin and Joseph McCarthy threatened to obliterate artistic freedom, Rosenberg called on artists to shift their focus from the streets to the protection and maintenance of their own right to create. In his widely read essay, "The American Action Painters," he argued that the independence of mind necessary in an age of dangerous ideologies was the highest intellectual value.

This intellectual integrity was expressed most vividly, according to Rosenberg, in the gesture paintings of Willem de Kooning and Jackson Pollock. Central to Action Painting was the rejection of external forces that crippled art and artists. During the 1940s and 1950s, the most intense pressure to conform came from totalitarian politicians of the right and the left. According to Rosenberg, the Action Painters de Kooning and Pollock were able to throw off the yoke of politics and renounce the illusion that any of these ideologies offered "the Good Life of the Future." At the same time, they also freed themselves from the European painting tradition that had become burdensome to them as "the Great Works of the Past." Action Painting then became, in Rosenberg's words, "a gesture of liberation from Value—Political, esthetic, moral." But to Rosenberg such "a gesture of liberation" was itself a political position. Action Painting was not a retreat from life but was still, according to this critic, an art of "the same metaphysical substance as the artist's existence."[10] For Rosenberg, the supreme political act of the 1940s and 1950s was the denial of demands from those outside the artist's studio. Amidst the clamor raised by the Communists on the left and by the McCarthyites on the right, Rosenberg's Action Painters worked alone in their ateliers preserving individual liberty.

De Kooning's paintings played a central role in the intellectual's struggle for independence. Rosenberg argued that de Kooning's visible, unordered brushstrokes were primary symbols of the opposition of the true intellectual to Stalinism and McCarthyism. The spontaneity so crucial to de Kooning's works became, in Rosenberg's opinion:

> a quasi-political attitude—one condemned by Lenin, outlawed in totalitarian countries, and repugnant to conformists and programmers. De Kooning's expansion of the resources possessed by painting presupposes that the individual as he is pits himself against all systems, while the temperament expressed in this artist's canvases affirms ...the disorder of the epoch.

Rosenberg went on to characterize de Kooning as a hero because he repre-
sented "the nuisance of individual self-affirmation in an ideological age."
In his art, de Kooning expressed, according to Rosenberg, his "refusal to
be either recruited or pushed aside."[11]

Except for this description of spontaneity and its political implica-
tions, Rosenberg ignored the images found in gesture painting and dealt
instead with the frame of mind of the artist as he worked. The critic be-
lieved that these attitudes mattered more than the finished canvases them-
selves. Rosenberg's gift as a critic, then, did not rest on his eye or his
knowledge of art history but on his sensitivity to the mood of his friends
and associates. In fact, the term "Action Painting" may rest not on the
canvases of the gesture painters but on the photographs taken of Pollock at
work in his studio in the early 1950s. Art historian Barbara Rose suggests
that Rosenberg may have coined the term after seeing stills of Pollock
published in *Art News* in May 1951.[12] His famous essay appeared in that
same magazine in December 1952. While the finished works of Pollock and
de Kooning might be difficult to link to the contemporary political situ-
ation, the photographs made Rosenberg's task simpler. Here in Hans
Namuth's stills were direct visual statements of the "gesture of liberation"
that the critic defined as the essence of Action Painting. After the publi-
cation of these photographs, Rosenberg could then offer his interpretation
of the mood in the studios of these painters.

Rosenberg's reliance on photographs rather than paintings demon-
strates the dilemma he faced during the postwar period. While the artists
and illustrators for the *Masses* could depict the suffering of the urban
poor, confident of the efficacy of their work, intellectuals of the postwar
era found politics far from simple and often frustrating and disillusioning.
Rosenberg himself had been optimistic, even strident, about the prospects
of cultural radicalism during the Depression. After the war he lost faith in
the cultural program of the Communist Party and warned artists to be
cautious about uniting political and cultural radicalism.

Indeed, Rosenberg and Motherwell were so gloomy about art and
politics that in 1947 they titled their little magazine *Possibilities,* an un-
usually meek self-description for an avant-garde publication. In their
editorial for *Possibilities,* they characterized politics as a "trap" about to
close on them and as a "drastic" presence in their lives.[13] Other publica-
tions by artists during the 1940s and 1950s— *Tiger's Eye, Modern Artist in
America,* and *It Is*—also lacked the aggressiveness normally associated
with the avant-garde. Compared to the attitudes expressed in earlier avant-
garde titles like *Masses, Partisan Review, Broom, Die Aktion, Der Sturm,*
and *Blast,* the artists of the 1940s and 1950s, brutalized by Stalinism and
McCarthyism, grew weary of politics and timid in their expectations.

When comparing Action Painting to Dadaism, Rosenberg's pessimism

becomes even more evident. Shaped by exiles in Zurich and New York City during World War I, Dadaism rested on a renunciation of both contemporary art and contemporary society. For Rosenberg it served as a model of the activist and antagonistic spirit of the avant-garde. He demonstrated his admiration for Dadaism by publishing one of its manifestos in *Possibilities.* Entitled "En Avant Dada," it defined the Dadaist as a political activist "who has fully understood that one is entitled to have ideas only if one can transform them into life." Dadaists chose their course because only activist artists possessed "the possibility of achieving knowledge."[14] Motherwell, who helped Rosenberg edit *Possibilities,* recalls that the critic had become particularly excited about that passage and suggested that he may have drawn on it for some of his ideas in "The American Action Painters."

Yet the Dadaists were much more confident than Rosenberg that their actions and their art mattered to the world at large. They staged public protests about the absurdity of the war and the bankruptcy of art. Scornful of all tradition, they considered their undertakings to be "anti-art."

The Abstract Expressionists may have been critical of postwar American society, but they never translated that attitude into any kind of public artistic demonstration. As painters de Kooning and Pollock never ventured into the cafés or onto the streets. Working in studios far from the public arena, isolated from the "deadly political situation," these artists, according to Rosenberg, found it possible "to hang around in the space between art and political action."[15] Only in the privacy of the studio could these Action Painters make political statements.

Though Rosenberg wanted Action Painting to reflect the spirit of Dadaism, it differed significantly from that earlier movement. Because the Dadaists disdained traditional painting, even that of the Cubists, their performances and objects bore little resemblance to the finished pieces of de Kooning and Pollock. Rather than relying on the absurdist and "anti-art" qualities of Dadaism, the Abstract Expressionists adopted a more synthetic approach to the history of art. The new American painting of the 1940s did not define itself in opposition to past art but took its images and themes from Surrealism, Cubism, and Expressionism. As a result, these Americans worked within the modernist tradition more than they rebelled against it. Rosenberg wanted the gesture painters to be truly revolutionary, but they were not the aesthetic or political activists that he proclaimed them to be.

By ignoring the images on the canvases, Rosenberg stranded his readers. He gave them no help in finding the mood he described in his essays within the works they saw on museum and gallery walls. The article, "The American Action Painters," defines a position for artists and intel-

lectuals that allows them independence and integrity, but it tells its readers very little about gesture painting. Rosenberg failed to explain how the interlaced webs of line, broad brushstrokes, and fragmented shapes of gesture painting represented opposition to Stalinism and McCarthyism. His only physical clue for understanding the paintings was the phrase "the gesture of liberation," but that only suggested that automatism in painting represented a resistance to conformity in politics. By ignoring the complex of meanings associated with automatism, Rosenberg lost the opportunity to explore a technique with multiple political and intellectual implications.

The fragile and tenuous connections that Rosenberg was able to draw between culture and politics during the 1940s and 1950s disappeared during the 1960s. He could find no true radicals in art after the Abstract Expressionists. For example, Frank Stella's paintings were for Rosenberg only "sedate decorations" that illustrated the artist's "delight in patterns" and a "cocktail-lounge taste in color." The lack of anguish and struggle in Stella's art infuriated Rosenberg. He demanded that the artist struggle with the problem of identity in a mass society and that he separate himself from that society. In Rosenberg's eyes, Stella seemed to be denying the entire Romantic tradition in the arts. Artists should not manipulate colors and shapes, Rosenberg asserted. To him that was no more than "aesthetic engineering," an impulse that reminded him of "Stalin's eulogizing of his academicians as 'engineers of the soul.'"[16]

Pop Art also disappointed Rosenberg. By using symbols from popular culture like Campbell's soup cans, Coca-Cola bottles, and comic strips, Pop artists, according to Rosenberg, destroyed the distinction between high and low culture. To Rosenberg it was imperative that the intellectual separate himself from mass culture. On this issue, Rosenberg agreed with other members of the *Partisan Review* crowd who generally feared the effects of mass society on serious art.

For Rosenberg, Pop Art's identification with "the impersonality of advertising-agency art-department productions" was a breach of faith for the artist. Pop Art represented, according to Rosenberg, a new aestheticism in its retreat from "the intensifying politico-social crisis and intellectual confusion" of the 1960s. If Rosenberg had only seen "possibilities" for art and politics during the 1940s, he felt even gloomier about cultural radicalism during the 1960s. Lamenting what he called the "de-definition of art," Rosenberg believed that the individual had disappeared from painting. He mourned the low quality of art in the 1960s and wondered bitterly if anyone still cared to take the trouble to become a great painter.[17]

Rosenberg's obsession with individualism prevented him from appreciating any painting that lacked an overt acknowledgment of that theme.

Unable to forget the years when Stalinism and McCarthyism were the primary political issues among intellectuals, Rosenberg continued to judge painters by standards he had developed in response to those threats to artistic freedom. Because he used criteria meaningless to the artists of the 1960s, his criticism of the new art seemed incongruous. Only in his earliest writing on culture during the 1930s did he demonstrate an unquestioning faith in the ability of culture to affect the society at large. A tone of disappointment crept into his writing after the Depression, and his emphasis shifted to the struggle of the artist to remain free from political ideologies. During the 1960s, when the battles and issues of the 1940s and 1950s seemed not to matter to young painters, Rosenberg's criticism lost its appropriateness.

Though Rosenberg seemed dismayed about the efficacy of cultural radicalism after the war, he became enthusiastic about one aspect of postwar culture. Because European intellectuals and artists feared the rise of fascism, many of them had fled to New York and abandoned cultural life in Europe. This diminution of European culture occurred at the same time as the emergence of Abstract Expressionism, a sign to many of a new vitality in American painting. Rosenberg greeted these developments with unmitigated joy. His pride in the national culture emerged in the postwar period as an even stronger theme than art and politics.

Rosenberg's identification with cultural nationalism seems surprising since he scorned other forms of nationalist sentiment. For example, like many of his fellow Jewish intellectuals who wrote for *Commentary* and *Partisan Review,* Rosenberg avoided identifying himself with Zionism. Though the postwar era was a time of heightened interest in Jewish issues like the Holocaust and Israel, Rosenberg, the supreme individualist, always refused to acknowledge ethnic questions as crucial political problems. He claimed to value his ethnic heritage but refused to allow it to shape his life or his intellectual pursuits. Looking back on his childhood in Brooklyn, he agreed that his family provided him with "fantastic emotional residues," but he refused to permit ethnicity to shape his personality. He urged each Jew as an individual to seek in himself "the hidden content of his Jewishness."[18]

Rosenberg also rejected the notion that ethnicity influenced painting in any significant way. Jewish artists like Abraham Walkowitz, Max Weber, and the Soyer brothers may have painted scenes from Manhattan's lower East Side, but to Rosenberg they should be more properly considered as realists or modernists. What some might see as Jewish subject matter— bearded men, Synagogues, and Torahs—remained for Rosenberg only superficial elements in painting. In a similar fashion, Rosenberg argued that the Abstract Expressionists Rothko and Newman transcended ethni-

city. Though he believed that these Jewish painters confronted the problem of identity in an "especially deep and immediate way," their paintings represented a more universal engagement with what Rosenberg called "the aesthetics of self." Their art was not just ethnic but, according to this critic, was "loaded with meaning for all people of this era."[19] Being a Jew mattered to Rosenberg, but he refused to identify himself or his favorite artists with ethnic issues.

Though Rosenberg resisted the demands of those he called "the ideologists of positive Judaism," he and some of his fellow intellectuals had no reservations about supporting cultural nationalism.[20] These new cultural patriots had once been outsiders in American cultural life and had settled first on Marxism and then on modernism as their intellectual territory. In their eyes, ethnicity and nationalism were to be transcended and subsumed by the more international worlds of leftist politics and modernist culture. Then, when Marxism seemed exhausted and when the cultural life of Europe appeared nearly moribund, Rosenberg and other intellectuals came to believe that America offered the best hope for the future of culture. Paris, once the international center of culture and, in Rosenberg's words, "the Holy Place of our time," lost its ascendency to New York.[21]

Intellectuals like Rosenberg, who had roots in immigrant and Jewish communities and who had always considered themselves outsiders, hailed America's new cultural achievements. During the 1940s and 1950s this study of the distinctive and exceptional American qualities in the arts assumed an importance once held by Marxism. Other examples of this new interest in America's cultural life included three very influential works of literary criticism — F. O. Matthiessen's *American Renaissance,* Alfred Kazin's *On Native Grounds,* and Philip Rahv's essay, "Palefaces and Redskins."[22]

Rosenberg greeted the new American painting of the 1940s and 1950s with special excitement. While he had been bleak about the future for a truly radical art and uneasy about associating himself with ethnic causes, he approached the question of a new national culture with great zeal. He chose to begin his collection of essays, *The Tradition of the New,* not with the well-known essay on Action Painting, but with "A Parable of American Painting," a spirited defense of the freshness and vitality of American painting. Using terms reminiscent of Philip Rahv's palefaces and redskins, Rosenberg divided American writers and painters into two categories — Redcoats and Coonskinners. While the Redcoats relied on European models, the Coonskinners, a group that included Thomas Eakins, Albert P. Ryder, Walt Whitman, Edgar Allen Poe, and the Abstract Expressionists, followed no foreign patterns or standards. Rosenberg's heroes were the Coonskinners, the unconventional, fearless pioneers who sniped

from behind the trees of the American forest at the Old Masters of Europe. In this metaphor Rosenberg had discovered a tradition of "rugged individualism" in American literature and painting with which he could identify completely. Here he finally reconciled his admiration for individualism with his cultural tastes.[23]

In Rosenberg's opinion, American innocence offered artists this opportunity to assault European cultural standards. For example, poets benefited from living in America since they could work with a language that was still new and growing. They were fortunate, according to Rosenberg, that America possessed "a lingo that hadn't yet settled into a literary language."[24] Pollock's painting method was another example of the way Americans could transform European cultural traditions. Instead of merely copying European landscape painting, Pollock, one of Rosenberg's "Coonskinners," rolled canvas out on the floor and walked into it as he painted. As a result, Pollock, according to Rosenberg, treated the canvas itself as part of the landscape.[25]

Rosenberg's passion for the exceptional nature of American art reflected his final assimilation. As a young intellectual during the Depression, this critic readily abandoned whatever cultural heritage his parents had brought with them from Eastern Europe and replaced that with Marxism and modernism. Then, frustrated by the contradictions and inconsistencies he found on the left and eager for cultural prestige, Rosenberg and other intellectuals like him turned more and more to literature and painting. Unlike some of his more conservative contemporaries, Rosenberg himself refused to surrender hope for a truly radical culture. Yet, in the postwar period that hope diminished. When he discovered Action Painting in the 1950s, he could only define its political meaning as an act by artists in the privacy of the studio, not on the streets. His only solace came from the originality of American culture. Concluding that culture was "played out" in Europe, he took pride in the vitality of postwar American culture. No longer an exile in his native land, Rosenberg transformed the Abstract Expressionists into national heroes.

The Facts of Culture: The Art Criticism
of Clement Greenberg

After the Second World War, some American anti-Communists charged that modernist painting was politically subversive. They borrowed their arguments from conservative art critics who had become alarmed at what they had seen in the Armory Show of 1913 and from Nazi and Soviet propagandists who characterized modernist artists as agents of social instability. In postwar America, conservative Congressman George Dondero of Michigan led this renewed assault against modernist art by painting a vivid picture of how these works undermined patriotism. This campaign drew support from more conventional artists who feared losing lucrative commissions and patronage to modernists. Dondero's charges also struck a responsive chord with the public. As another manifestation of what Richard Hofstadter called "the paranoid style," Dondero identified modernist art as another piece of evidence to prove that intellectuals and Communists wanted to desecrate America.[1]

In one way, Dondero and the other anti-Communists were correct. During the postwar period, modernist painting seemed to be replacing realism as the predominant style in American art. Cubism, a movement that Dondero had condemned as a plot to destroy America through "designed disorder," was by 1950 one of the primary standards by which the New York avant-garde wanted its own art to be judged.[2] Influential American art critics agreed that Cubist paintings were the masterworks of the twentieth century. Foremost among these spokesmen for modernist art was Clement Greenberg. An influential critic who wrote for the *Nation* and *Partisan Review,* Greenberg praised those American painters, like the Abstract Expressionist Jackson Pollock, who he felt drew on Cubist principles and techniques.

Dondero and Greenberg disagreed so fundamentally about culture in postwar America that it is astounding that they could agree about any political issue. In fact, they both supported a vigorous anti-Communist

foreign policy during the Cold War. Although Greenberg had supported the left before the Second World War, he became a leading anti-Communist liberal after the war. As an editor of *Commentary* from 1945 to 1957, he helped shape the anti-Soviet attitudes of his fellow conservative intellectuals.

In one of the more bizarre convergences in American history, Dondero, the man who found a Communist conspiracy behind modernist painting, endorsed Greenberg's campaign against liberals with alleged pro-Soviet sympathies. This strange alliance took place in 1951 during a controversy over Communist infiltration of political news magazines. An anti-Communist group, the American Committee for Cultural Freedom, led this effort to expose Soviet sympathizers on the staff of the *Nation*. Once a contributor to this journal, Greenberg made the first public charges against his former editors. Delighted with Greenberg's accusations, Dondero immediately reprinted them in the *Congressional Record*.[3]

The Cold War had brought a sophisticated, anti-Communist intellectual like Greenberg into political circles inhabited by nativist, anti-intellectual conservatives like Dondero. The Michigan Congressman tried to save American culture by attacking modernist painting as un-American and proclaiming that the only genuine American style was traditional representational art. Greenberg also wanted to see a strong national culture, but he believed that there could be a great American modernist art. He tried to prove this point in his criticism by associating Abstract Expressionism with the "cult of consensus" developed by postwar conservative anti-Communist intellectuals.

Greenberg believed that the best modernist painting could only be created in societies where there was no need for political change. Using ideas also found in the descriptions of the American political system by Daniel Boorstin, Greenberg claimed that the strength of Abstract Expressionism rested not on the themes of the paintings but on the way in which the artists treated line, space, and color. In Greenberg's opinion, the Abstract Expressionist painters, like the political leaders described by Boorstin, avoided ideological thinking. Successful modernist painting like Abstract Expressionism appeared, according to Greenberg, where artists renounced political ideologies like Marxism and demonstrated their confidence in their own society and its values.

In a nation that had solved its major social problems, it was then possible for artists to ignore the distractions presented by the external world and concentrate on the essentials of painting. Greenberg believed that the Cubists were able to do that in Paris before the First World War. After the Second World War, when the center of world power had shifted from Western Europe to America, the political climate had made it pos-

sible for artists like the Abstract Expressionists to turn again, as the Cubists had, to the basic visual vocabulary of painting. American cultural superiority during the Cold War rested then, in Greenberg's opinion, on the nation's newly won power and affluence and on the absence of disruptive political ideologies.

The political aspects of Greenberg's criticism have been neglected for some time. By the mid-1950s, Greenberg himself avoided even the slightest reference to such issues in his art criticism. When his book of essays, *Art and Culture,* appeared in 1961, he chose not to include the columns on art and politics that he had written during the 1940s. By that time he had left the staff of *Commentary* to become a free-lance critic. After that he never wrote on political matters again and focused instead on more narrow aesthetic questions.

While Greenberg's views on art and politics have been ignored, he did become famous as "the critic who discovered Jackson Pollock." Although several other critics and museum officials helped enhance Pollock's reputation during the 1940s and 1950s, it was primarily Greenberg who brought the artist to the attention of other intellectuals and magazine editors. As the art critic for the *Nation* and *Partisan Review* during the 1940s, Greenberg relentlessly attacked sentimentality in American art and lauded only those works, like Pollock's, that drew on the principles of European modernist art.

Europeans also recognized Greenberg as the leading authority on the American art scene. In 1947, for example, the British intellectual journal *Horizon* asked Greenberg to write a piece on contemporary American painting and sculpture. For his British audience, Greenberg characterized Pollock as America's "most powerful painter." In New York, the editors of *Time,* always alert for controversial material, found Greenberg's article appropriate for their art page. Under the headline "The Best?" they summarized Greenberg's article and printed a reproduction of a Pollock painting. This was Pollock's first appearance in the popular press. Because he had "discovered" Pollock, Greenberg's position in the art world was so preeminent that cartoonist David Levine could satirize him in 1975 in the *New York Review of Books* as the pope of the art world.[4]

Greenberg's background was strikingly similar to that of his fellow postwar conservative intellectuals. Like many of those raised in Eastern European immigrant families, Greenberg inherited a radicalism from his parents that he tempered with a strong desire for success and assimilation. Born in 1909 in the Bronx, New York, Greenberg was the eldest of three sons of Jews who had emigrated from Lithuania. Because his father was a storekeeper and manufacturer, he led a comfortable middle-class life. At

home, both parents spoke Yiddish and taught their socialist principles to their children. After graduation from Syracuse University in 1930, Greenberg worked in his father's business; after it failed, he turned to the civil service. A position he held with the customs service of the Port of New York after 1937 allowed him enough spare time to begin his writing career. In 1938 he made his first appearance in *Partisan Review* with a piece on Bertolt Brecht, and three years later he joined the editorial board of that magazine. After attending a series of lectures by the German modernist Hans Hofmann in the late 1930s, Greenberg also started writing art criticism. He began painting himself in 1945.[5]

Greenberg never attained any recognition as a painter but quickly established himself as the chief art critic for *Partisan Review*. In his first articles for that magazine, Greenberg wrote from a political viewpoint consistent with that of his fellow contributors. During the late 1930s, they combined a fervent Trotskyism with literary tastes that were decidedly cosmopolitan and modernist. Although many of these Trotskyists later abandoned their radicalism for more conservative positions, they adhered to a revolutionary line into the 1940s. In addition to the editors of *Partisan Review,* Philip Rahv, Dwight Macdonald, and William Phillips, this well-known group of Trotskyist intellectuals included the philosopher Sidney Hook, literary critic Lionel Trilling, art critic Meyer Schapiro, and literary editor Elliot Cohen. Many of them taught at Columbia University and contributed to the *Menorah Journal,* a magazine concerned with Jewish culture. They had left the Communist Party in the early 1930s when they became disillusioned with its policies toward labor unions and Nazi Germany. As members of the American Committee for the Defense of Leon Trotsky, they helped arrange asylum for the Soviet leader in Mexico. Because Greenberg lived outside New York during the early 1930s, he did not participate in regular Communist Party activities and only joined this group after it had attached itself to Trotskyism.

At the heart of the Trotskyist sentiment among these intellectuals was a growing hesitation, a growing reluctance to embrace the logical imperatives of radicalism. If, as the Communist Party maintained, the political exigencies of revolution overshadowed the autonomy of art and literature, then the Party relegated culture to mere propaganda. Never convinced of such a conclusion, many of the contributors to *Partisan Review* spent the greater part of the Depression trying to remain radical while disengaging themselves from the needs of the Party—first from its proletarian cultural movement and then from its Popular Front. Trotskyism represented a radical communism untainted by Stalinist perfidy.[6]

Greenberg's art criticism reflected the views and concerns of the *Par-

tisan Review's staff. For international-minded Trotskyists, the nationalistic art of the 1930s amounted to no more than a provincial, tame, and derivative style. For example, in Greenberg's opinion, two of the leading exponents of the American Scene painting of the Depression, Thomas Hart Benton and Grant Wood, were among the "notable vulgarizers of our period." According to the critic, they offered "an inferior product under the guise of high art." The sentimentality and patriotism found on such canvases represented to Greenberg a cowardice on the part of the artist.[7]

Greenberg and the other editors of *Partisan Review* also found most art approved by the Party and by other leftists to be a betrayal of artistic standards. In 1943, for example, Greenberg attacked an artist who purported to represent the true spirit of the working class as a mere "comic strip" illustrator. The leading Social Realist, Ben Shahn, had, in Greenberg's judgment, only "surface felicity." Lacking "density" and "resonance," Shahn, Greenberg concluded, displayed "a poverty of culture and resources, a pinchedness, a resignation to the minor, a certain desire for quick acceptance."[8]

Socialist Realism, the art sanctioned by the Soviet state, provoked Greenberg's derision. He denounced it as "the truly new horror of our times...in the vulgarity it is able to install in places of power—the official vulgarity, the certified vulgarity." In general, radical art of the 1940s suffered, in Greenberg's opinion, not from politics itself but from "the incomplete resolutions offered by the merely political view." He suggested that the political artist "poses too elementary a situation, or else, which is more rare, ...resolves too simply...situations presented in all the complexity of the real." Intellectuals around *Partisan Review* like Greenberg demanded a more sophisticated vision from artists, one far removed from the formulas offered by the Party.[9]

For these intellectuals Trotskyism became a curious mixture of cultural elitism and political radicalism. Their attitude toward mass culture is particularly indicative of the dilemma they faced as socialists who valued the sort of literary and artistic works inaccessible to most of the general public. Like many of his contemporaries at *Partisan Review,* Greenberg lamented the state of mass culture in the industrialized world. In a 1939 essay entitled "Avant-Garde and Kitsch," Greenberg argued that peasants who had moved to cities to work in factories had lost their appreciation for true folk culture. Greenberg believed that they then turned to kitsch, a simplified, mechanical, inauthentic art borrowed from an already existing cultural tradition. The masses preferred the more easily digestible format of kitsch because under the capitalist system they had little leisure time to study or pursue other kinds of culture. Greenberg concluded that capi-

talism was the underlying reason for the proliferation of kitsch and that socialism offered the only hope for the preservation of serious culture or for the improvement of the cultural life of the masses.[10]

The outbreak of the Second World War forced these Trotskyist intellectuals to reexamine their political beliefs. Even before America entered the war, two of the editors of *Partisan Review,* Phillips and Rahv, already supporters of the Allies, wanted to abandon radical political writing and devote more attention to avant-garde literature. The other two editors, Greenberg and Macdonald, continued to oppose the war and call for international socialist revolution. In 1941, before Pearl Harbor, these two issued a statement on the war that expressed their revolutionary idealism. Greenberg and Mcdonald wrote that despite the war the primary issue of the era remained the overthrow of capitalism. They conceded that the Germans constituted a real evil, but they questioned the ability of the capitalist nations to wage a successful war effort. Citing Great Britain as one example of how ineptly the capitalist powers mobilized against the Axis nations, the two editors argued that a proletarian socialist revolution was the only direct and realistic hope for the defeat of fascism.[11]

Rahv quickly disassociated himself and the other editors from Greenberg and Macdonald, whose position he considered fanciful. Unable to compromise on the issues surrounding the war, the editors stopped discussing the matter in the pages of the magazine. Greenberg left the staff in 1942 and entered the Army Air Force the next year. The conflict over the war still unresolved, Macdonald resigned in 1943 to found his own pacifist magazine *Politics.* By 1949 he had also lost his revolutionary ardor and gave up writing on political matters. By 1952, when Mcdonald debated Norman Mailer on American policy in the Cold War, he supported the West in its struggle with the Soviet Union.[12]

After serving in the military, Greenberg returned to New York. Much as his career before the war centered around Trotskyism and *Partisan Review,* his postwar political activities reflected his association with anti-Communist liberalism and *Commentary* magazine. That magazine mirrored the assimilationist attitudes of its sponsor, the American Jewish Committee. Because of the positions of influence held by Committee members, the magazine was closely read in the State Department as a primary source for Jewish opinion on questions involving the Cold War and Israel. Prominent anti-Communist intellectuals like Sidney Hook, Arthur Schlesinger, Jr., and Irving Kristol appeared regularly in its pages. The same contributors also published in *Partisan Review* and gave that magazine a similar political identity. During this period, Greenberg also

wrote art criticism for the *Nation*. It remained critical of American foreign policy during the Cold War, although its literary editor Margaret Marshall shared Greenberg's political perspective.

When Greenberg joined the staff of *Commentary,* its senior editor was Elliot E. Cohen. Also born into a Lithuanian Jewish family, Cohen had studied literature at Yale University before giving up his graduate study because he felt Jews had no future in college teaching. During the Depression, as an editor for the *Menorah Journal,* he had served as a literary "godfather" to young writers like Lionel Trilling, Clifton Fadiman, and Herbert Solow. Because the American Jewish Committee wanted its magazine to be more than an ethnic publication, more like a Jewish *Harper's,* Cohen's strong literary background made him a natural choice for editor.

Cohen's politics also qualified him for the job. Like Greenberg, he had been a Trotskyist but by 1945 had moved away from radicalism. One *Commentary* staff member described Cohen as sensitive about his past and determined to prove that not all Jewish intellectuals were Communists. Since both Greenberg and Cohen held cultural and political views different from those often associated with the Jewish community, they were compatible with the assimilationist aims of the Committee. In their hands *Commentary* became a forum for New York's community of ex-radical Jewish intellectuals.[13]

Greenberg proved to be acceptable to the American Jewish Committee because he had always rejected ethnicity as the sole basis for judging art. Even when he acknowledged ethnic elements in literature or painting, he avoided using them as a criterion in assessing individual works. For example, in essays he wrote on Franz Kafka and Sholem Aleichem, he described the effect of Jewishness on their writing, but he did not claim that their heritage alone made them great writers. He also believed that the provincial Eastern European backgrounds of the Jewish modernist painters Marc Chagall and Chaim Soutine and the sculptor Jacques Lipchitz shaped some of the imagery in their art, but in the end, that same heritage prevented them from achieving the greatness of a Pablo Picasso. In 1949, when asked to comment on the propriety of awarding a national poetry prize to Ezra Pound, Greenberg refused to condemn Pound's art simply because the poet was an anti-Semite. Greenberg concluded that Pound failed on artistic rather than political grounds.[14]

When Greenberg wrote about his own life, he argued that ethnicity mattered very little to him. In 1944, for example, when questioned by the *Contemporary Jewish Record,* he dismissed the influence of his childhood or his parents on his writing. He claimed no "conscious position" toward his Jewishness because he believed that his parents had rejected much of it

before him. At that point still a socialist, he declared that the plight of the Jews was shared by all peoples. Their situation, he surmised, was yet another "version of the alienation of man under capitalism."[15]

Later, after he had renounced radicalism, he continued to distance himself from his ethnic background. In a revealing article for *Commentary* entitled "Self-Hatred and Jewish Chauvinism," Greenberg admitted that he had suffered from self-hatred and believed it to be a common trait among Jews. But Greenberg could not accept what he called "Positive Jewishness" because it resembled Nazi attitudes toward race and ethnicity. He wrote that he wanted to come to terms in his own way with his background and with the horrifying events of the Second World War without being "typed." According to Greenberg, it was necessary to overcome self-hatred "in order to be more myself, not in order to be a 'good Jew.'"[16]

Greenberg and the other *Commentary* editors also enthusiastically endorsed anti-Communism. In a curious displacement of energy, *Commentary*'s editorial staff diverted its magazine away from ethnicity toward wholehearted support for the Cold War against the Soviet Union. At a time of passionate, intense feeling about the Holocaust and about Israel, the editors of *Commentary* displayed a growing attachment to America. As Cohen wrote in his first editorial, "*Commentary* is an act of faith in our possibilities in America." A large part of that faith then became translated into a fervent anti-Communism. In the pages of *Commentary,* the editors and contributors warned of Soviet aggression and ridiculed anyone who sympathized with Stalin. In 1945 Cohen wrote that he and the other editors would, as Jews, be better able to detect the dangers presented by the Soviet Union because such totalitarian forces have "so often marched over us as a people." Particularly concerned with any "softness" toward the Soviet Union among liberals, Cohen, Greenberg, and the other editors vigorously attacked any manifestation of what they called "anti-anti-Communism."[17]

The aggressive foreign policy advocated by *Commentary* closely followed the course pursued by the American Committee for Cultural Freedom. Established in 1951 by Arthur Schlesinger, Jr., James Burnham, and James T. Farrell, the Committee grew out of an international anti-Communist group, the Congress for Cultural Freedom, that first met in West Berlin in 1950. *Commentary's* senior editor, Cohen, was among the founders of the Congress. In 1967 it was revealed that the Central Intelligence Agency also helped initiate and finance the Congress. The Agency believed that a conference attended by well-known anti-Communist intellectuals would diminish the impact of similar conferences held by the Communist Party. In both this international group and its American affiliate, anti-Communist intellectuals argued that a truly moral individual could not be neutral in the Cold War and that any tolerance of Soviet policies had to be

eliminated. These themes followed the basic outlines of American foreign policy.[18]

Greenberg endorsed these tenets of anti-Communism and thereby associated himself with a broad range of anti-Communist feeling, ranging from Joseph McCarthy and George Dondero on the right to anti-Soviet liberals and socialists on the left. Greenberg himself eventually accepted the American political and economic system. For example, in 1956 this ex-Trotskyist announced that American politics "has worked—for whatever extra-political reasons—better than the politics of most other countries." At another point he defended McCarthyism by attacking its critics. Some people became upset about the conformism they saw in McCarthyism because, Greenberg charged, "anti-Communist 'conformism' weighs most on people actually drawn to Communist politics." The critics of McCarthy also suffered from what Greenberg called "an inner, voluntary conformism." In Greenberg's opinion, the intellectual community had become much too agitated about McCarthyism. Like many other anti-Communist intellectuals, Greenberg believed that the American political system remained unaffected by the ideologies of either the left or the right.[19]

Greenberg's identification with the anti-Communist activists of *Commentary* and the American Committee for Cultural Freedom should not be interpreted as a dramatic shift in his political loyalties. He had never belonged to the Communist Party or to any of the radical groups in the art world like the Artists Union or the John Reed Club. His experience with radical politics during the Depression was limited to the Trotskyism of the late 1930s and to the editorial staff of *Partisan Review.* Nor was he as deeply immersed in political matters as other editors like Macdonald and Hook. It may be more important to note the strong continuity in his views during and after the Depression. At all times, he remained fervently anti-Soviet. Joining the staff of *Commentary* in 1945, an anti-Soviet magazine committed to the serious discussion of culture, was not a dramatic shift away from the interests Greenberg had shown when he worked for *Partisan Review.* Unlike intellectuals such as Max Eastman, Greenberg's political migration did not involve a startling transformation. Within the circles of radical intellectuals of the 1930s were numerous figures like Greenberg whose attachment to Marxism was far less important than their interest in painting or literature or their desire to achieve some sort of cultural prominence.

Whatever hopes Greenberg had for socialism during the Depression accompanied cultural tastes that were elitist. He never took part in any of the radical art activities of the Depression and never endorsed "art for the people" in any form. His contacts with the art world were limited during

the 1930s and remained confined to the staff of *Partisan Review.* One of the other editors there, George L. K. Morris, was an abstract painter and a member of the American Abstract Artists, but he did not associate with any of the Abstract Expressionists. These painters identified more with the Surrealist refugees than with the staff of *Partisan Review.* There was also some antagonism between the two groups. In 1940 the Surrealist Nicholas Calas charged that Greenberg and the other *Partisan Review* editors represented reactionary modernism when they praised the work of the conservative poet T. S. Eliot. Surrealists like Calas saw themselves as more genuinely revolutionary. Both Greenberg and Morris were unsympathetic to Surrealist painting and the literary critics for *Partisan Review* had also criticized Surrealist writing.[20]

In many ways, then, Greenberg changed very little in the years immediately after the Depression. His clear anti-Soviet bias was evident during both the Depression and the postwar period. It is not surprising then that he supported the Cold War and the aims of the American Committee for Cultural Freedom. That commitment led him to join a 1951 Committee campaign to expose Communist sympathizers in the liberal press. The Committee's two targets that year were the *Nation* and the British magazine, the *New Statesman and Nation.*

To lead these attacks, the Committee selected former staff members from each publication. In the case of the *Nation,* Greenberg, once its art critic, made the first public charges of Communist influence. The Soviet sympathizers Greenberg identified were the *Nation*'s editor, Freda Kirchwey, and its foreign editor, Julio Alvarez del Vayo. Kirchwey, the daughter of a college professor and a graduate of Barnard College, had participated in radical causes since her undergraduate days. She had joined the staff of the *Nation* in 1919 and also served on the board of the *New Masses* during the 1920s. A dedicated anti-fascist during the Depression, she welcomed the presence of the Communist Party in leftist coalitions and frequently urged the left to unify. After the war she was a consistent critic of McCarthyism and United States policy in the Cold War. Her tolerant attitude toward the Communist Party and the Soviet Union had long infuriated anti-Communists like Sidney Hook.[21]

However, Kirchwey was not an easy target for the anti-Communists. She had at times criticized Soviet policy and had never totally adopted the Communist line. Greenberg, therefore, directed the charges of collaboration toward the more vulnerable, foreign editor, Julio Alvarez del Vayo. He had been a diplomatic official and foreign minister of the Spanish Republic during the 1930s and then fled the country after Franco's victory. He remained active in the underground campaign against the Spanish dictator by editing a newspaper distributed secretly in his homeland. On his

death in 1975, one observer characterized him as a consistent supporter of Soviet policies. In his memoirs, del Vayo himself praised Stalin's leadership of the Soviet Union.[22]

In a letter to the *Nation* in 1951, Greenberg first charged that del Vayo was a Soviet agent. After Kirchwey refused to print that letter, Greenberg then toned down his accusations and had them printed in the *New Leader,* an anti-Communist labor magazine that supported the Congress for Cultural Freedom. The public version of Greenberg's letter stopped short of labeling del Vayo as an espionage agent but did assert that he had used his column in the *Nation* as "a vehicle through which the interests of a particular state power are expressed." Claiming that the Spaniard's writing "parallels that of Soviet propaganda," Greenberg pointed to his praise of the Soviet role in the Cold War and to his condemnation of American aggression in Korea.[23]

Kirchwey responded to Greenberg's letter with a libel suit against the *New Leader* that demanded $200,000 in damages. Greenberg's magazine *Commentary* in its April 1951 issue retaliated with another attack on the pro-Soviet editorial policy of the *Nation.* The essay, entitled "The Liberals Who Haven't Learned," written by Granville Hicks, another ex-Communist, focused on the pro-Soviet articles in the *Nation's* eighty-fifth anniversary issue. According to Hicks, the views expressed by *Nation* contributors were "so biased that, if they were widely held, they would seriously weaken this country either in the maintenance of peace or the waging of war."[24]

Letters supporting Greenberg and Hicks poured into the offices of the *New Leader* and other magazines, some from members of the American Committee for Cultural Freedom like Arthur Schlesinger, Jr., and Sidney Hook. Two members of the *Nation's* editorial board resigned to protest Kirchwey's views on foreign policy. Feelings were so strong on both sides that the controversy lingered for several years. Two years later, Kirchwey fired her literary editor, Margaret Marshall, from her staff. Although Kirchwey claimed that she acted for reasons of economy, Marshall charged that the firing was political: Marshall had brought Greenberg to the *Nation's* staff in the 1940s and shared his hostility toward the Soviet Union.[25]

It was this campaign against the *Nation* in 1951 that brought Greenberg to Dondero's attention. The Congressman's endorsement of Greenberg illustrates the uneasy alliance that existed then between conservative intellectuals like Greenberg and those politicians associated with the more nativist and anti-intellectual elements of McCarthyism. As an advocate of modernist art *and* a devoted anti-Communist, Greenberg seemed to be in a tenuous and difficult position. By championing the paintings of the Cubists and the Abstract Expressionists, he appeared to be endorsing the

art of painters who were admitted Communists, socialists, or anarchists. Their works also lacked the clear, unambiguous patriotism that figures like Dondero lauded in art.

Greenberg resolved these contradictions through a mixture of cultural nationalism and a reshaping of the modernist tradition. First of all, like Harold Rosenberg, he claimed that uniquely favorable cultural conditions in postwar America stimulated an artistic awakening not possible anywhere else in the world and certainly not in the Soviet Union. Then he undertook to link America's role in world affairs and its apparently successful political system to its cultural fecundity. All the while he ignored the radical backgrounds of many of these painters, their general hostility to the cultural conservatism of postwar America, and their strong affinities to Surrealist and Freudian ideas.

The first step in Greenberg's re-evaluation of American painting was a growing appreciation for the unique qualities of the national culture. For example, even a Currier and Ives print had what Greenberg called "a pervasive and stubborn color of its own...a tone, a tempering, a shading, or a grain...that is enough...to distinguish it as American." The critic also detected what he felt was a particularly American taste for chiaroscuro. He thought he found that tendency in the writings of Herman Melville, Nathaniel Hawthorne, and Edgar Allan Poe, and in the paintings of Ralph Blakelock and Albert P. Ryder. Other American artists appeared to Greenberg to have a preference for "the abstract fact more than anything else." Both Walt Whitman and Winslow Homer seemed obsessed with what Greenberg called "the power of concrete observation."[26] Like the politicians described in Daniel Boorstin's history books, Greenberg's American artists were practical men who focused on the means of art rather than fanciful spiritual notions.

Though the European modernists remained Greenberg's favorites, he acknowledged that some American artists like Winslow Homer, Thomas Eakins, and Albert P. Ryder possessed an "original temperament and character" and "strove...for a maximum of personal truth." While some contemporary European artists seemed to Greenberg to be "tamed" and "disciplined," if not "coarse" and "inept," he found the American tradition to be "fresh" and "open" and capable of producing an art with real "force." The critic argued that the newer, less sophisticated American art world, even if it lacked the reservoir of experience available to the French, offered a substantial heritage to the painter.[27]

Like many other intellectuals of this era, Greenberg identified the newness of American society and culture as the source of its vitality. In terms reminiscent of Louis Hartz, he echoed the themes of American cultural exceptionalism common among many postwar intellectuals. For

example, he preferred American primitive painting over that of Europe because the American variety showed a "first-hand quality, an immediacy" only possible because there was no substantial body of academic work for American primitives to copy. Pollock too earned Greenberg's approbation, for moving beyond the works of the Europeans Joan Miró and Pablo Picasso to what Greenberg called "painting mostly with his own brush." Pollock also had acquired the American taste for chiaroscuro and was even able to gain "something positive from the muddiness of color that so profoundly characterizes a great deal of American painting." To Greenberg, American culture seemed to be distinctive and forceful enough to warrant study from those artists devoted to European modernism.[28]

In addition to establishing the uniqueness and vitality of American culture, Greenberg also reinterpreted the political framework in which modernist art had been created. If he were to make Abstract Expressionism a manifestation of American power and achievement in the postwar world, then the art and the artists had to be separated from political radicalism. Determined to disassociate these artists from any revolutionary or anarchist sentiments, Greenberg stressed their concern with the innovations in visual vocabulary initiated by the Cubists. At the same time, he ignored their affinities with Surrealism and its anti-capitalist impulse.

Greenberg's description of the emergence of Cubism in France before World War I rested on what he perceived as a truce between artist and society. According to Greenberg, French society before World War I was at the highest stage of industrial capitalism. As a result, it "seemed to have demonstrated its complete capacity to solve its more serious internal as well as environmental problems." That "optimism, boldness, and self-confidence" created, according to Greenberg, "a positivist or empirical state of mind" among intellectuals. He concluded that artists were then able to concentrate on art and art alone without any outside interference. Because the Cubists had "an all-pervasive conviction that the world would inevitably go on improving," they were then capable, according to Greenberg, of making "final statements" in painting. After the First World War, this "faith in the supreme reality of concrete experience" faded, and, as a result, the quality of painting declined. Cubism then gave way to Surrealism, a style Greenberg loathed for its reliance on external forces for its imagery. He could not accept Surrealism as a valid example of modernist painting because it used Freudian psychoanalytic premises to generate its images.[29]

Greenberg argued that significant modernist painting could be created only when the avant-garde rejected politics. That disillusionment with radical politics first occurred in nineteenth-century France when artists turned away from the public arena and decided that the "true and most

important function of the avant-garde was not to 'experiment,' but to find a path along which it would be possible to keep culture *moving* in the midst of ideological confusion and violence." The avant-garde could accomplish this, in Greenberg's view, by "narrowing and raising" art to a point when "all relativities and contradictions would be either resolved or beside the point." In other words, Greenberg demanded that modernist painters purge all external concerns from painting. As he wrote, in terms that recall Kantian aesthetics, modernist painting appeared in the nineteenth century because "it was becoming important to determine the essential elements of each of the arts."[30]

Greenberg found that, as painting turned more in on itself, its primary goal was to deny the portrayal of "realistic perspectival space." In 1940, in what he described as an historical apology for abstract art, Greenberg explained that the rejection of three-dimensional space and the growing preference for "flatness," was the necessary and inevitable course for modernist painting. This was true because painters had exhausted the study of perspective.

In Greenberg's interpretation of the history of painting, artists by the seventeenth century had become so adept at creating the illusion of space that they then felt they could turn to emulating the effects of literature. As the "ghosts and stooges" of literature, painters ignored their own medium in order to concentrate on poetic subject matter. During the Romantic era, artists like Eugene Delacroix and Théodore Géricault turned to a more compelling content and in the process achieved what Greenberg called "a greater boldness in pictorial means." But it was only when nineteenth-century painters decided to abandon overt subject matter in an attempt to save painting from the corrupting influence of literature that painting became independent. The depiction of space then no longer mattered, and painting was free to become increasingly flatter. This development allowed painters to dispense with sculptural shading. The brushstroke became more prominent. Color was no longer a matter of tone but of primary experience. Line too was disassociated from the depiction of objects and achieved its own autonomy. To echo the rectangular shape of the canvas, geometric shapes replaced naturalistic forms.[31]

According to Greenberg, the Cubists did the most to attain this purity of means in painting. After the United States reached world dominance during the 1940s, its artists also took up these problems. Greenberg hoped they could assume that the very survival of society and culture was not at stake, and that therefore they could be liberated from the burden of political radicalism. For Greenberg, then, it was possible for Jackson Pollock to lead an "efflorescence" of Cubism in America. Like the European art, Pollock's paintings were, in Greenberg's words, works of "immediate

sensations, impulses, and notions." They demonstrated the same "posi-tivist" and "concrete" qualities as the Cubists had. According to Green-berg, Pollock had reached this empirical state of mind by overcoming his paranoia and anger and by accepting the society around him. As a result, his art reflected a "detachment" and a "rationality" that could only be described as Apollonian. For Greenberg, Pollock's greatness rested on the "balance," "largeness," and "precision" found in his works.[32]

Not all the Abstract Expressionists immediately earned such praise from Greenberg. When any of these painters seemed too concerned with the spiritual aspects of their art, he found them less interesting. The uto-pian and metaphysical rhetoric they sometimes used reminded Greenberg of "something half-baked and revivalist." He deplored the manifestos issued by Mark Rothko, Barnett Newman, and Adolph Gottlieb in which they asserted their interest in the "primeval and predatory" elements in art. He argued that these artists were "too much amazed by experience, too much at a loss in the face of current events" and were "overpowered by their own feelings." Even Pollock, his favorite, at times seemed to be too preoccupied with what Greenberg characterized as "Gothic" and "morbid" sentiments.[33]

By 1955, however, Greenberg concluded that the Abstract Expres-sionists had purged these extraneous concerns from their art and had made significant advances toward pure painting. In an influential essay pub-lished in *Partisan Review* that year, entitled "American-Type Painting," Greenberg outlined the accomplishments of these modernists. As the key to their maturity, he pointed to their relationship to certain Cubist assump-tions and presuppositions. For example, these Americans, according to Greenberg, loosened up the "relatively demarcated illusion of shallow depth" in Cubism and its "canon of drawing in more or less simple lines and curves." Greenberg then divided these artists into two groups—those that continued to have strong ties to late Cubism and those that had man-aged to move substantially away from it.[34]

The late Cubists included Willem de Kooning, Franz Kline, and Jack-son Pollock. These Abstract Expressionists were no longer interested in perspective but were, like the Cubists, attracted to "value contrast," what Greenberg defined as "the opposition and modulation of dark and light." For traditional painters, value contrast was the primary means for creating the illusion of three-dimensional space. The Cubists and these Abstract Expressionists freed it from that function and used it independently from the portrayal of objects. To purify and simplify the examination of value contrast, the Abstract Expressionists eliminated color from their canvases and worked only with black and white paint. As a result, they were able to "isolate" and "exaggerate" value contrast and treat it on its own.[35]

The other group of Abstract Expressionists, Clyfford Still, Barnett Newman, and Mark Rothko, completely rejected value contrast to become even more radical painters. Their works were devoid of any traces of the shading, line, and fractured plane that were distinctive of Cubism. Rather than continuing to work with these elements, these artists turned to the works of the Impressionist Claude Monet for inspiration. Refusing to draw or design as the Cubists had, Still, Newman, and Rothko created works with Impressionist fields of color that "exhaled," "breathed," and "pulsated." Though color was a primary feature of these paintings, Greenberg believed that it was not used for symbolic purposes. Instead these painters worked in a large scale that Greenberg felt destroyed the poetic associations of their palette.[36]

When Greenberg chose Abstract Expressionism as the emblem of American cultural superiority and the practical, nonideological American sensibility, he had to overlook many important aspects of that art. The Abstract Expressionists themselves characterized their art as a modernist one. As such, it grew out of a profound disillusionment with the course of history in the contemporary world. In a search for alternative values, they settled on Freudian and utopian frameworks for their painting. Even if they were not agents in a Soviet conspiracy, Dondero was correct to suspect that their art represented much less than an endorsement of American policy during the Cold War. Greenberg also erred in his description of the intellectual and artistic community of France before the First World War. Rather than being satisfied with the nature of the society around them, the Parisian avant-garde of the early twentieth century explored absurdist and primitivist themes in art. Figures like dramatist Alfred Jarry and composer Erik Satie as well as the Cubists could never be characterized as enthusiastic supporters of the capitalist system.[37]

Whatever the failings of Greenberg's criticism, it remains one of the most important bodies of art writing in American history. Greenberg was an articulate and passionate defender of high culture and helped transform the American art world from a provincial outpost of modernist painting to a cultural center in its own right. Greenberg's experience also demonstrates the diversity of intellectual life during the Depression. Though he wrote for *Partisan Review* in the late 1930s and supported Trotsky like the rest of the staff, he had little other contact with political radicalism. He was always a cultural elitist of a particularly conservative sort and was never interested in the Freudian ideas and imagery of the Surrealists. He clung to the older modernist tradition exemplified by the Cubists. Even before the 1940s, his taste was for that art that seemed to ignore politics in favor of the questions of form, space, and color.

Greenberg's interpretation of Abstract Expressionism was based on the way in which these painters had addressed those same problems. In addition, he linked that painting with the cultural context in which it was being created. He praised those American artists who suppressed their radicalism and looked beyond temporary frustrations to more positive developments in world culture and politics. Just as the editors of and contributors to *Commentary* found more and more to admire in American society, American painters, according to Greenberg, abandoned radicalism feeling certain that they could safely neglect politics and explore the substance of painting itself. Greenberg's interest in Abstract Expressionism also drew on the cultural nationalism of the postwar era. Like other American intellectuals of the 1940s, Greenberg wanted there to be a strong and viable national high culture. Despite Dondero's campaign to make modernist painting un-American, Greenberg did help make Abstract Expressionism the first internationally successful American modernist art.

Dondero's attack on modernist art was a crude one, a kind of "cultural fundamentalism" similar to that found in Nazi propaganda. Obsessed with the threat that modernist painting seemed to present to social stability, the Congressman had no inkling of the complex relationship between modernist art and society. It goes without saying that Greenberg's art criticism was much more sophisticated. Yet Greenberg's interpretation of art and politics in the postwar period was also flawed. Using Kantian ideas about the self-reflexive nature of the arts, Greenberg evolved a history of abstract art that gave a prominent position to the canvases of the Abstract Expressionists. In the process he also argued that unique political and cultural conditions in the United States during the 1940s made the development of Abstract Expressionism possible. As part of the "cult of consensus," Abstract Expressionism, in Greenberg's hands, lost its leftist and Freudian political associations and became a reflection of the prosperity, pragmatism, and positivism of American cultural life.

9

Conclusion

In 1956 when Jackson Pollock was killed in an automobile accident on Long Island, New York, his death drew widespread public attention. *Life* magazine, which had done so much to popularize him and his art, announced his passing in an article with photographs and a headline that read "Rebel Artist's Tragic Ending." The avant-garde magazine *Evergreen Review* also marked Pollock's death by printing a tribute by Clement Greenberg and five photographs by Hans Namuth. Later that year, the Museum of Modern Art presented a retrospective exhibition of Pollock's paintings. The Museum had planned the show before the accident, but coming as it did so soon after Pollock's death, it stimulated even more interest in the artist and his art. By 1961 the painter's works were so valuable that the editors of the *New York Times Magazine* chose the headline "The Jackson Pollock Market Soars" for an article on his works.[1]

Pollock's death did make him and his art more famous, but even before 1956 the Abstract Expressionists had begun to sell their paintings for impressive sums. When asked about the market for American paintings, art dealers remembered that the mid-1950s were the crucial turning point for the sale of Abstract Expressionist works. For example, Eleanor Ward of the Stable Gallery characterized the years between 1955 and 1961 as "golden" ones for American art. This "explosion" in the New York art world originated, Ward believed, in the interest French art dealers had shown in Abstract Expressionism. Samuel Kootz, who represented Hofmann, Motherwell, and Gottlieb in the early 1950s, also recalled that 1955 was the moment when collectors "suddenly" began buying American art. John Bernard Myers of the Tibor de Nagy Gallery claimed that the market for Abstract Expressionist paintings expanded sometime after Pollock's death. He believed that prices began "to go up and up and up" in 1958 after a Pollock sold for $30,000.[2]

By the 1970s the Abstract Expressionists had gained so much fame and wealth that their deaths brought on major financial and legal problems. For example, the children of Mark Rothko, who committed suicide

in 1970, sued the executors of their father's estate charging that they had engaged in fraud and deception by undervaluing the paintings the estate sold to Marlborough Gallery. This dispute led to a long, complex legal battle because at his death Rothko left an estate valued at five million dollars, including approximately eight hundred paintings worth at least two million dollars.[3] For a painter who had once worked on the Federal Art Project, belonged to its militant Artists Union, and exhibited paintings at the Betty Parsons Gallery, this lawsuit represented a drastic departure from the "tragic and timeless" themes of his paintings.

Developments of this nature transformed Abstract Expressionism from an avant-garde art movement into something that resembled an official American art. To the next generation of artists and to the public, Abstract Expressionism was no longer radical in any way but a triumphant cultural achievement of the past. For example, to leftists of the 1960s, it seemed to be too distant and too neutral on political matters. They believed that these paintings could too easily be appropriated by the establishment for its own conservative purposes. To some of these radicals, the exhibits of Abstract Expressionist painting at the Museum of Modern Art seemed to prove that this art was no longer truly avant-garde. Since the Museum had also sent some of these shows overseas, leftists claimed that Abstract Expressionism had been transformed into a weapon of the Cold War. For example, Eva Cockcroft complained that during the 1950s the Museum of Modern Art in cooperation with the State Department had used a show of Abstract Expressionist painting (*The New American Painting*) to demonstrate to European intellectuals that American culture was superior to that of the Soviet Union.[4]

Writing about Abstract Expressionism and its relationship to the world around it in 1974, Cockcroft showed little sympathy for the painters of the 1940s. The success of the movement has tended to obscure the climate in which the art first emerged. As an art created during the 1930s and 1940s, Abstract Expressionism took much of its expressive resonance from Depression radicalism and from European Surrealism. While these painters disdained the conventional political realism that the left preferred, they did continue to define themselves and their art as hostile to the predominant political and economic system. From Surrealism they borrowed artistic techniques, images, and ideas which allowed them to use themes with visionary and apocalyptic implications. Even as they moved away from Surrealism to more and more abstract styles, they still tried to endow their works with some kind of utopian meaning. Yet at the same time that they sought utopian themes, they also broke away from the demands and standards imposed on art by leftists and by Surrealists. They pursued meaning for their paintings without sacrificing them to any one interpretation.

These artists wanted to avoid simplistic explanations for their art because by the 1940s art had a record and a history of exploitation and misuse by politics. During the Depression, Communists had insisted that it join the class struggle. American painters had also been taught that to be true to their national culture they had to depict the experience of their countrymen on farms and city streets. These scenes had to be "realistic" if they were to be truly American. In Europe, Nazi, fascist, and Soviet leaders seemed to be adept at manipulating art and architecture for savage and horrible political ends. At home during the war, there were also persistent demands from groups like the Artists for Victory that art contribute somehow to the military defeat of the Axis powers.

Insistent political demands on art and artists appeared again after the war. McCarthyite politicians like George Dondero pursued Communist sympathizers in the art world and demanded that they be denied all forms of official government recognition. Government officials were also eager to use art to illustrate the vitality of American culture. During the Cold War, paintings and other forms of art became, in the hands of the Central Intelligence Agency, weapons to win the admiration of intellectuals in Europe and the Third World.[5]

It was in this atmosphere, then, that the Abstract Expressionists worked in their studios and exhibited their canvases. A certain weariness and wariness led them to try to protect their art from the aggressive and dangerous political forces outside their control. In a world where art was readily and easily appropriated by politics, they wanted their paintings kept free from these entanglements. The Freudian elements in Surrealism were equally threatening to the independence of their art. As a result these artists and critics devised different strategies to provide some kind of meaning for this art without tying it to any one interpretation.

In order to save the content of Abstract Expressionism, Barnett Newman wrote extensively about its philosophical and political implications. Again and again, he characterized Abstract Expressionism as an art with a subject matter of the highest order and the most serious of intentions. His writing was so hyperbolic that it was an example of what Renato Poggioli called "spiritual megalomania." On the other hand, Newman would have replied that he only wanted the art to reflect the intense "fury" of its times.[6] In contrast, Pollock seldom wrote more about his art than short statements that associated it with the paintings of the Cubists and the Surrealists and with the ideas of Freud and Jung. Through photography, however, Pollock expanded and transformed the interpretation of his art to include the artist's personality and process. Ad Reinhardt offered yet another way of dealing with the issues of meaning and interpretation. A utopian abstractionist during the 1930s and 1940s, Reinhardt eventually

grew frustrated with the spiritual and political claims of the other Abstract Expressionists and began writing what he called his art-as-art dogma. In these pieces Reinhardt denied the validity of all external justifications for art and argued that it should stand alone in order to avoid the corrupting influences of philosophy, religion, and politics. Only then could art be radical and free. Reinhardt silenced meaning in art in order to save it.

In the essays of the two critics most closely associated with Abstract Expressionism, Harold Rosenberg and Clement Greenberg, the political meaning of these paintings was explained in radically different ways. Rosenberg used popularized concepts from existentialism in his essay on Action Painting. He argued that the Action Painters had retreated from political activism and had renounced European art in order to develop an independent painting. Struggling alone in isolated studios, Rosenberg's Action Painters created an anti-ideological art.

Greenberg also believed that these painters had a profound suspicion of European ideology, but he attributed that sensibility to a long-standing taste among American painters for the "facts" of painting—its formal qualities rather than its subject matter. By eliminating the spiritual and utopian elements in Abstract Expressionism, Greenberg wanted to make it part of the postwar "cult of consensus" in American culture. In contrast to Greenberg's cultural conservatism, Rosenberg interpreted the anti-ideological nature of Abstract Expressionism as a radical individualism.

These critics did agree that postwar American painting surpassed that of Europe. But again, Rosenberg considered this a victory for the radical American frontier spirit that was unfettered by any kind of tradition. Greenberg, on the other hand, sought to identify this resurgence of American creativity with the nation's international political and economic power during the Cold War. Despite these differences in political perspective, Rosenberg and Greenberg shared a passion for American culture. In the long run, their differences may not appear as great as their common interest in revitalizing American painting. As such they properly belong with those intellectuals associated with *Partisan Review* who, in its famous symposium on "Our Country and Our Culture," called for a rediscovery of American literature.

The art criticism of Rosenberg and Greenberg clearly demonstrate that Abstract Expressionism appeared and was first interpreted in a highly politicized atmosphere. In New York during the 1930s and 1940s, avant-garde life revolved around *Partisan Review* magazine, the Surrealist refugees, and the Federal Art Project. In this milieu, these painters absorbed a faith in a politicized modernism. For artists and critics interested in the ideas of the Trotskyists, the Surrealists, John Graham, and Piet Mondrian, there was no separation of modernist painting from political meaning but instead a conviction that the two should be fused.

After the Abstract Expressionists, artists approached the reconciliation of art with politics in a completely different context. There were important differences between those artists who had been through the Depression and the Project and those who had not. For example, postwar abstract painters usually did not emulate the utopian patterns established by Newman, Rothko, and Still. This new generation of abstractionists did admire the large scale and intense color used by the Abstract Expressionists, but they ignored the rhetoric about the tragedy of human history that was so often found in the writings of the color-field painters. These chromatic abstractionists led by Helen Frankenthaler, Frank Stella, Morris Louis, and Kenneth Noland also removed all remnants of Surrealism and Expressionism from their works, causing Greenberg to label this less painterly, more geometric style Post Painterly Abstraction. Minimal artists like Donald Judd also looked to Newman and Reinhardt for inspiration, but they preferred to study the formal qualities of these works rather than the essays they wrote on meaning and interpretation.[7]

On the surface, the Pop Art of the 1960s appeared to be a reaction against Abstract Expressionist imagery and brushwork because Pop Artists used subject matter from popular culture in a representational manner. On closer examination, however, these artists were committed to the same patterns of color, line, and space that had been first developed by the Cubists. In content, Pop Art proved to be even more difficult to interpret than Abstract Expressionism had been. At the heart of Andy Warhol's soup cans and Claes Oldenburg's hamburgers is an ambiguity about their subject matter that makes it impossible to define precisely. Like other painters of the 1960s and 1970s, the Pop Artists seemed inclined to reject the more personal themes adopted by the Abstract Expressionists for those that were anonymous, obscure, and impersonal.[8]

Like the Cubists and the Dadaists, the Pop Artists had borrowed materials from popular culture to incorporate into fine art. This assimilation into painting of materials normally considered non-aesthetic was also one of the fundamental concepts in the works of composer John Cage, a figure of great influence on painters during the postwar period. Building on the ideas of Dadaist Marcel Duchamp, Cage argued that art and life were inseparable and that the two had been arbitrarily separated by a culture that wanted the fine arts to be didactic and uplifting. Despite this apparent interest in the world outside the museum and the studio, Cage's ideas did not represent a resurgence of political themes in art. With no interest in pleasing a mass audience, Cage explored noise, silence, and repetition in his compositions. Their radical nature precluded any popular appreciation for his music. Cage's political sentiments represented a generalized anarchistic approach to the world outside art. The two painters

who were closest to Cage, Robert Rauschenberg and Jasper Johns, shared his aesthetic sensibility and his nihilistic view of art's place in the world.[9]

With the emergence of the civil rights movement and the war in Vietnam during the 1960s, artists once again abandoned neutrality on the questions of art and politics and placed that issue at the center of the art world. This new generation of radicals first attacked the conservatism of the offical art world. The Museum of Modern Art proved to be one popular target since its influence was widespread and its board of trustees filled with wealthy patrons of the arts. The dominant role of the Rockefeller family in that Museum also drew the wrath of leftists. The art associated with new radicalism was a diverse one. Some artists drew from Dadaism to create performance pieces, and others felt it necessary to paint large realistic murals that could be viewed from the city streets. Feminist artists of the 1970s even reverted to themes and imagery reminiscent of Surrealism to illustrate the subjugation of women.[10]

As these examples from the postwar period have shown, the fusion of art and politics is always an unstable one. Art and politics are two separate and different kinds of human behavior and can never be satisfactorily or permanently reconciled. As we have seen, the political circumstances of the 1930s and 1940s no longer seemed relevant or meaningful during the 1960s. The experience of the Abstract Expressionists with the Communist Party, the Federal Art Project, and Stalinism seemed far removed for a new generation that focused on issues like the war in Vietnam, civil rights for blacks, and equality for women.

Not only will issues and politics change, but modernist artists will also find it necessary to transcend, subvert, and evade the imperatives of politicians. Modernism means a twisting and turning of meaning and form to create ambiguity and multiplicity. Two of the primary demands of politicians on art, clarity of presentation and accessibility of meaning, do not matter to modernists. Yet the essence of modernism always is in its adversary stance. It stands against conventional artistic technique, expected meanings, and easy interpretation. It also remains outside the established powers of society. Yet it defies capture by any one organization or ideology.

As members of a generation steeped in the ideas of Marx and Freud, the Abstract Expressionists turned away from those ideas and demands and continued the modernist evasion and distortion of political ideology. By eluding the rigorous demands of Stalinism and Surrealism, these artists stayed free of the dogmatic aspects that these interpretations represented. By rejecting titles, interpretations, and names, the Abstract Expressionists did not want to deny meaning, but hoped to enhance it and protect it.

Notes

Chapter 1

1. Robert Goodnough, ed., "Artists' Sessions at Studio 35 (1950)," *Modern Artists in America* (New York: Wittenborn Schultz, 1951), pp. 21–22.

2. Clyfford Still, Statement in *15 Americans* (New York: Museum of Modern Art, 1952), p. 21. Also see, Still letters to Betty Parsons in Parsons Gallery Papers, Archives of American Art, Smithsonian Institution, Washington, D.C.

3. One of Newman's most important pieces was *The Ideographic Picture* (New York: Betty Parsons Gallery, 1947). Another piece often cited in discussions of the subject matter of Abstract Expressionism is the statement by Rothko and Gottlieb written with Newman's help that appeared in "'Globalism' Pops into View," by E. A. Jewell, *New York Times,* 13 June 1943, II, p. 9. Reinhardt's writings have been collected by Barbara Rose, *Art-As-Art: The Selected Writings of Ad Reinhardt* (New York: Viking, 1975).

4. "Open Letter to Roland L. Redmond, President of the Metropolitan Museum of Art," 20 May 1950, copy in Hedda Sterne Papers, Archives of American Art, Smithsonian Institution, Washington, D.C. See also "18 Painters Boycott Metropolitan; Charge Hostility to Advanced Art," *New York Times,* 22 May 1950, p. 1: and "The Metropolitan and Modern Art," *Life,* 15 January 1951, pp. 34–35. At the Club during the 1950's, there were a series of panel discussions on "Has the Situation Changed?" See Club records in Phillip Pavia Papers, Archives of American Art, Smithsonian Institution, Washington, D.C. Also see, P.G. Pavia, "The Unwanted Title: Abstract Expressionism," *It Is* I (Spring 1960): 8–11.

5. Newman organized "The Ideographic Picture" in 1947 at Parsons, and Motherwell assembled "The School of New York" for the Perls Gallery in Beverly Hills, California, in 1951.

6. On influence of Surrealism on Abstract Expressionism, see William Rubin, *Dada and Surrealist Art* (New York: Abrams, 1968) pp. 408–9. Rubin says of Surrealism: "it was precisely because these American painters had passed through the experience of Surrealism that it was possible for them to challenge and open up the sclerotic traditions of Cubism and Fauvism, and thus preserve what was viable in them....the spirit of their wholly abstract art retained much of Surrealism's concern with poetry." The term "gesture" was first associated with Abstract Expressionism by Harold Rosenberg in "The American Action Painters," *Art News,* December 1952, p. 23. "Color-field" grew out of the essay by Clement Greenberg, "'American-Type' Painting," *Partisan Review* XXII

(Spring 1955): 179–96. These terms form the central organization of Irving Sandler's excellent introduction to these painters, *The Triumph of American Painting: A History of Abstract Expressionism* (New York: Praeger, 1970). Dore Ashton's *The New York School: A Cultural Reckoning* (New York: Viking, 1972) provides some useful information on these artists but it is a confused and unreliable study.

7. Gottlieb, "The Ides of Art," *The Tiger's Eye I* (December 1947): 43; Newman, "The Object and the Image," *The Tiger's Eye I* (March 1948): 111; Rothko in "Personal Statement," *A Painting Prophecy—1950* (Washington, D.C.: David Porter Gallery, 1950): Still, *Clyfford Still* (Philadelphia: Institute of Contemporary Art, 1963), pp. 9–10: Pollock, in conversation with Selden Rodman in 1956, appeared in Francis V. O'Connor, *Jackson Pollock* (New York: Museum of Modern Art, 1967), p. 73; Questionnaire from *Arts and Architecture* LXI (February 1944): 14.

8. Robert Coates, "Assorted Moderns," *New Yorker,* 23 December 1944, p. 51; Anonymous, *Mark Rothko* (New York: Art of This Century Gallery, 1945); Greenberg, "Art," *Nation,* 9 June 1945, p. 657; and Janis, *Abstract and Surrealist Art in America* (New York: Reynal and Hitchcock, 1944), p. 89.

9. Coates, "Abroad and at Home," *New Yorker,* 30 March 1946, p. 75; Barr, "Foreword," *First Loan Exhibition* (New York: Museum of Modern Art, 1929), p. 15; term appeared again on the jacket diagram of *Cubism and Abstract Art* (New York: Museum of Modern Art, 1936). Kandinsky was also an important influence on the Abstract Expressionists. His works were well known to Americans through exhibits at the Guggenheim and through the interests the Surrealists had shown in him.

10. Rosenberg, "The American Action Painters," pp. 22–23, 48–50. Rosenberg's comparison of Abstract Expressionism with popularized existential concepts was a brilliant one that reflected the tone of intellectual life in the early 1950s, but it adds little to an understanding of the origins of Abstract Expressionism.

11. Barbara Rose, "A B C Art," *Art In America* in 1965, reprinted in Gregory Battcock, ed., *Minimal Art: A Critical Anthology* (New York: Dutton, 1968), p. 280; Max Kozloff, "American Painting During the Cold War," *Artforum* XI (May 1973): 45, 46.

12. Barr, *The New American Painting* (New York: Museum of Modern Art, 1959).

13. Renato Poggioli, *The Theory of the Avant-Garde,* trans. Gerald Fitzgerald (New York: Harper and Row, 1968), pp. 79–101. Originally published in Italy in 1962. Poggioli comments: "the avant-garde is condemned to conquer, through the influence of fashion, that very popularity it once disdained" (p. 82).

14. On avant-garde, see Donald D. Egbert, "The Idea of the 'Avant-Garde' in Art and Politics," *American Historical Review* LXXIII (December 1967): 339–66; Theda Shapiro, *Painters and Politics: The European Avant-Garde and Society, 1900–1925* (New York: Elsevier, 1976), pp. 3–41; Poggioli, pp. 1–15; 79–101.

15. Linda Nochlin, "The Invention of the Avant-Garde: France, 1830–1880," in *Avant-Garde Art,* ed. by Thomas B. Hess and John Ashbery (New York: Collier Books, 1967), p. 17. On Courbet, see T. J. Clark, *Image of the People: Gustave Courbet and the Second French Republic, 1848–1851* (Greenwich, Connecticut: New York Graphic Society, 1973) and *The Absolute Bourgeois: Artists and Politics in France, 1848–1851* (Greenwich, Connecticut: New York Graphic Society, 1973).

16. Poggioli, *The Theory of the Avant-Garde,* p. 181.

17. By far the best study of the social implications of modernism is Malcolm Bradbury, *The Social Context of Modern English Literature* (New York: Schocken Books, 1971). Bradbury also has edited a collection of useful essays with James McFarlane, *Modernism, 1890–1930* (New York: Penguin, 1976). Also see, Roger Shattuck, *The Banquet Years: The Origins of the Avant-Garde in France,* rev. ed. (New York: Vintage, 1968); Picasso made his remark in 1935 in an interview with Christian Zervos that was originally published in *Cahiers d'Art* and reprinted in Herschel B. Chipp, ed., *Theories of Modern Art* (Berkeley: University of California Press, 1968), p. 267. Also see, Edward Shils, *The Intellectuals and the Powers and Other Essays* (Chicago: University of Chicago Press, 1972).

18. The definitive work on Dada and Surrealism remains that of William Rubin, *Dada and Surrealist Art.* There is one other useful work on Surrealism: J. H. Matthews, *The Imagery of Surrealism* (Syracuse: Syracuse University Press, 1977).

19. Susan Sontag, *Against Interpretation and other Essays* (New York: Farrar, Straus & Giroux, 1968), p. 43; Ihab Hassan, "POSTmodernISM: A Paracritical Bibliography," *New Literary History* III (Autumn 1971): 5–30; and Gerald Graff, "The Myth of the Postmodernist Breakthrough," *Triquarterly* XXVI (Winter 1973): 383–417.

20. Newman, from unpublished letter to Clement Greenberg, 1947, reprinted in Thomas B. Hess, *Barnett Newman* (New York: Walker, 1969), p. 37; and Newman, "The Sublime Is Now," *Tiger's Eye* VI (December 1948): 51–53.

21. Newman, "The Sublime Is Now," p. 53.

Chapter 2

1. Laurance P. Hurlburt, "The Siqueiros Experimental Workshop: New York, 1936," *Art Journal* XXXV (Spring 1976): 239–40.

2. Namuth's photographs have been collected in *L'Atelier de Jackson Pollock* (Paris: Macula, 1978).

3. Daniel Bell, *The End of Ideology: On the Exhaustion of Political Ideas in the Fifties* (Glencoe, Illinois: The Free Press, 1960) and Eugene Lyons, *The Red Decade: The Stalinist Penetration of America* (Indianapolis: Bobbs-Merrill, 1941).

4. Neil Harris, *The Artist in American Society: The Formative Years 1790–1860* (New York: Simon and Schuster, 1966); Barbara Novak, *American Painting of the Nineteenth Century: Realism, Idealism, and the American Experience* (New York: Praeger, 1969); and *Nature and Culture: American Landscape and Painting, 1825–1875* (New York: Oxford, 1980).

5. Harris, *The Artist in American Society,* pp. 300–316.

6. One of the best works on the social implications of museums and philanthropy is Helen Lefkowitz Horowitz, *Culture & the City: Cultural Philanthropy in Chicago from the 1880s to 1917* (Lexington: University of Kentucky Press, 1976). Also see H. Wayne Morgan, *New Muses: Art in American Culture, 1865–1920* (Norman: University of Oklahoma Press, 1978).

7. Henri, "My People," *The Craftsman,* 1915, reprinted in *The Art Spirit* (Philadelphia: Lippincott, 1923), p. 149. Also see William Inness Homer and Violet Organ, *Robert Henri and His Circle* (Ithaca: Cornell University Press, 1969).

One of the more remarkable aspects of the emergence of Abstract Expressionism is how little these artists were influenced by earlier American modernist painters. The most important modernists in the United States before 1940 were those associated with the gallery of Alfred Stieglitz—John Marin, Arthur Dove, Georgia O'Keeffe, Marsden Hartley, and others. For the most part, the Abstract Expressionists paid little attention to them. Pollock once remarked that the only American that interested him was Albert Ryder. Stieglitz's group drew much of its inspiration from nature and then created works that reflected their exposure to Cubist and Fauvist ideas. The Abstract Expressionists, on the other hand, turned to Surrealist models.

8. Henri, *The Art Spirit*, p. 147.

9. Henry May, *The End of American Innocence: A Study of the First Years of Our Own Time, 1912–1917* (New York: Knopf, 1959), p. 393.

10. Matthew Baigell, *The American Scene: American Painting of the 1930's* (New York: Praeger, 1974), pp. 55–61, and David Shapiro, ed., *Social Realism: Art as a Weapon* (New York: Frederick Ungar, 1973).

11. Benton used the term "Literary Playboys" in his mural *Political, Business, and Intellectual Ballyhoo,* in Milton W. Brown, *American Painting from the Armory Show to the Depression* (Princeton: Princeton University Press, 1955), p. 194, and wrote of his purposes in *An Artist in America* (New York: Robert McBride, 1937), pp. 260–69.

 Also see Matthew Baigell, "The Beginnings of 'The American Wave' and the Depression," *Art Journal* XXVII (Summer 1968): 387–89; Donald Kuspit, "Regionalism Reconsidered," *Art in America* LXIV (July, August 1976): 64–69; and H. W. Janson, "Benton and Wood, Champions of Regionalism," *Magazine of Art* XXXIX (May 1946): 184 ff.

12. Stuart Davis, "American Scene," *Art Front* I (February 1935): 6. See April 1935 issue for further exchanges between Benton and the leftists.

13. Thomas Craven, *Modern Art: The Men, the Movements, the Meaning* (New York: Simon and Schuster, 1934), p. 312.

14. Matthew Baigell, *The American Scene,* pp. 55–61.

15. The Abstract Expressionists were a particularly urban group of artists. Even if born in rural areas, they moved to New York City in the early 1930s to study art. Still was the only one who renounced living in New York but he did remain there for several crucial years in the mid-1940s when his ideas were influential on Rothko and Newman. Although they never incorporated imagery that specifically recalled their chosen home, it is proper to call the Abstract Expressionists the New York School.

 Many of these artists had immigrant backgrounds. De Kooning, Rothko, and Hofmann were foreign born. Newman, Gottlieb, and Rothko came from Jewish immigrant families as did the critics Rosenberg and Greenberg. Reinhardt's family came from Eastern Europe as well.

16. Herbert Lawrence, "The Ten," *Art Front* II (February 1936): 12.

17. Rothko and Gottlieb, "'Globalism,'" *New York Times,* 13 June 1943, II, p. 9; Newman, "What About Isolationist Art," 1942, unpublished essay that appeared in Thomas B. Hess, *Barnett Newman* (New York: The Museum of Modern Art, 1971), p. 35.

18. See Jane De Hart Mathews, "Arts and the People: The New Deal Quest for a Cultural Democracy," *Journal of American History* LXII (September 1975): 316–39; Francis V.

O'Connor, ed., *Art for the Millions: Essays from the 1930's by Artists and Administrators of the WPA Federal Art Project* (New York: New York Graphic Society, 1973); and Richard McKinzie, *The New Deal for Artists* (Princeton: Princeton University Press, 1973).

Among the major Abstract Expressionist painters, Baziotes, Brooks, de Kooning, Gorky, Gottlieb, Guston, Pollock, Reinhardt, and Rothko worked for some section of the Works Progress Administration, usually the Federal Art Project, Easel Division.

19. Interview with David Smith by David Sylvester that appeared in *Living Arts* III (April 1964): 5. Smith also remarked in 1964 that he and his friends "all came from the bond of the Works Progress Administration." Reinhardt called the early years of the Project "exciting and free" in "The Artist in Search of an Academy, Part II: Who Are the Artists?" in Rose, *Art-As-Art,* p. 200. On social background of modernist painters, see Shapiro, *Painters and Politics,* pp. 20–28. The Abstract Expressionists differed from previous artists in lack of artists or artisans within their families. European modernists that Shapiro studied included a significant number who were the children of musicians, painters, or decorative artists. But the occupations of parents of Abstract Expressionists include garment factory owner, pharmacist, accountant, beverage distributor, bartender, baker, union organizer, and farmer. That is not to say that families were not interested in culture. For example, Pollock's interest in art was stimulated by his mother and older brothers. Newman's mother was also crucial for his interest in art.

20. On radical activities of American painters, see articles by Gerald Monroe, "Art Front," *Studio International* CLXXXVIII (September 1974): 66–70; "Artists as Militant: Trade Union Workers during the Great Depression," *Archives of American Art Journal* XIV (1974): 7–10; and "The 30's: Art, Ideology, and the WPA," *Art in America* LXIII (November–December 1975): 64–67. Also see *Art Front* in Archives of American Art, Smithsonian Institution, Washington, D.C.; John Opper Interview, Archives of American Art, Smithsonian Institution, New York City; and *First Annual Membership Exhibition, American Artists' Congress, Inc.,* April, 1937, pamphlet in Archives of American Art, Smithsonian Institution, Washington, D.C.

21. Balcomb Greene, "Memories of Arshile Gorky," *Arts Magazine* L (March 1976): 109–10.

22. Frederick T. Kiesler, "Murals Without Walls," *Art Front* II (December 1936), pp. 10–11; Jacob Kainen, "Our Expressionists," *Art Front* III (February 1937), pp. 14–15; and Robert Cronbach, "David Smith," *New Masses,* 19 February 1946, p. 27.

23. John Graham, *System and Dialectics of Art,* ed. by Marcia Allentuck (Baltimore: Johns Hopkins Press, 1971), pp. 136–37; Barbara Rose, "Graham and Gorky," *Arts Magazine* L (March 1976): 62–67; and Handen Herrera, "Le Feu Ardent: John Graham's Journal," *Archives of American Art Journal* XIV (1974): 6–17.

24. "Manifesto: Towards a Free Revolutionary Art," *Partisan Review* VI (Fall 1938): 51,53. Other League documents can be found in Ilya Bolotowsky Papers, Archives of American Art, Smithsonian Institution, Washington, D.C. Trotsky's comments were taken from an article he wrote in 1939 that is quoted in Isaac Deutscher, *The Prophet Outcast: Trotsky: 1929–1940,* v. 3 (New York: Random House, 1963), p. 434.

25. "War Is the Issue!" *Partisan Review* VI (Fall 1939): 125–26. On *Partisan Review,* see James Gilbert, *Writers and Partisans: A History of Literary Radicalism in America* (New York: John Wiley and Sons, 1968) and Richard Pells, *Radical Visions and American Dreams: Culture and Social Thought in the Depression Years* (New York: Harper and Row, 1973).

26. On Surrealism and politics, see Jack J. Roth, "The 'Revolution of the Mind': The Politics of Surrealism Reconsidered," *South Atlantic Quarterly* LXXVI (Spring 1977): 147–57; and Robert S. Short, "The Politics of Surrealism, 1920–1936," *Journal of Contemporary History* I (1966): 3–26.

27. On the split in the Congress, see "17 Members Bolt Artists' Congress," *New York Times,* 17 April 1940, p. 25. Also see Monroe, "Artists as Militant," pp. 7–10; Ilya Bolotowsky, Interview by Paul Cummings, March–April 1968, Archives of American Art, Smithsonian Institution, New York City, pp. 55–56.

28. "Statement of Principles," 1940, Federation of Modern Painters and Sculptors Papers, Archives of American Art, Smithsonian Institution, Washington, D.C.

29. For examples of the anti-Communist activities of the Federation, see its minutes for 3 February 1941, 7 April 1941, 25 April 1941, 30 April 1941, 7 December 1942, and 27 September 1943, in Archives of American Art, Smithsonian Institution, Washington, D.C. The Federation was particularly concerned about Communist influence in the wartime Artists Coordination Committee, a citywide alliance of art groups. One active Federation member, Edith Bry, resigned from Artists Equity in 1953 and accused its leadership of pro-Communist leanings. See letter from Bry to Ernest Fiene, President of Artists' Equity, 25 June 1953, Edith Bry Papers, Archives of American Art, Smithsonian Institution, Washington, D.C. For discussion of the new constitution, see Federation Minutes, 23 March 1953, Archives of American Art, Smithsonian Institution, Washington, D.C.

30. Letter from Sanford to Charles Pollock, 22 October 1940, in Francis V. O'Connor, *Jackson Pollock* (New York: Museum of Modern Art, 1967), p. 25.

31. Letter from Herman Baron to Jacob Kainen, 1943, in Kainen Papers, Archives of American Art, Smithsonian Institution, Washington, D.C.

32. U.S., Congress, House, Congressman Dondero speaking on How Modern Art Shackled to Communism, 81st Congress, 1st sess., 16 August 1949, *Congressional Record,* 11584.

33. Milton Brown, "After Three Years," *Magazine of Art,* April 1946, pp. 138, 166.

34. Sidney Finkelstein, "Abstract Art Today: Doodles, Dollars, and Death," *Masses and Mainstream,* September, 1952, pp. 22, 26. European leftists found Pollock's art more intriguing. After a Pollock show in Rome in 1958, the critic for the Communist newspaper *Paese Sera* wrote of one of the works, *One:* "It is the clear mirror of a temperament that unites, in a protest of anarchic origin, good and evil, harmonic and irrational forms with a universal result. This painting is a warning, a message, an irreducible and candid way of looking at the world." 13/14 March 1958, Marcello Venturoli, reprinted in O'Connor, *Jackson Pollock,* p. 76.

Chapter 3

1. The Abstract Expressionists are quite unusual in the history of American artists in that only a limited number of them traveled to Europe to study. Gottlieb, Smith, de Kooning, Hofmann, Kline, Motherwell, and Tomlin had traveled to Europe and had lived there to study and work. De Kooning and Hofmann migrated to the United States as adults after studying and working as artists. On the other hand, some of the most important of these artists did not go to Europe before late 1940s when their mature painting styles emerged. For example, Pollock, Rothko, Still, Newman, Reinhardt, Baziotes, and

Guston remained in the U.S. during the 1930s and 1940s. Before 1930, a trip to Europe for study had been a primary requirement for American artists. See William Innes Homer, *Alfred Stieglitz and the American Avant-Garde* (Boston: New York Graphic Society, 1977), pp. 85-86; and Wayne Morgan, *New Muses,* pp. 77-111.

This chapter serves as an introduction to Abstract Expressionist painting and its relation to Surrealist painting. In the course of explaining this close and significant relationship, I will discuss the major American painters of the era—Pollock, de Kooning, Kline, Still, Newman, and Rothko. Less important artists like Motherwell, Hofmann, Gottlieb, Baziotes, Guston, and others are treated less comprehensively.

2. Baziotes, quoted by Rudi Blesh, *Modern Art U.S.A.* (New York: Knopf, 1956), pp. 268-69. For more information, see Michael Preble, *William Baziotes: A Retrospective Exhibition* (Newport Beach, California: Newport Harbor Art Museum, 1978).

3. Peter Plagens, "William Baziotes: Primeval Sentiment," *Artforum* XVII (September 1978): 48-51. Plagens says of Baziotes: "at his death in 1963, Baziotes was considered a moving if minor New York School painter...whose early connections with the fertile Surrealists-in-America made up for the fact that he painted...pretty illustrations of a paleontologic subconscious" (p. 48).

4. Breton, "Genesis and Perspective of Surrealism in the Plastic Arts," in *What is Surrealism? Selected Writings,* ed. by Franklin Rosemont (New York: Monad, 1978), p. 225. First appeared in 1942 in New York in publication of Guggenheim's Art of This Century Gallery. On Miró and Masson, see Rubin, *Dada and Surrealist Art,* pp. 151-78, and Clement Greenberg, *Joan Miró* (New York: Quadrangle, 1948).

5. From interview with Baziotes by Donald Paneth, in "William Baziotes: A Literary Portrait," unpublished, copy in Archives of American Art, Smithsonian Institution, Washington, D.C.

6. Letter from Kamrowski to William Rubin, 10 April 1975, printed in Jeffrey Wechsler, *Surrealism and American Painting, 1931-1947* (New Brunswick: Rutgers University Art Gallery, 1977), p. 55. On Baziotes' interest in Surrealism, see also Barbara Cavaliere and Robert C. Hobbs, "Against a Newer Laocoon," *Arts Magazine* LI (April 1977): 110-17; Barbara Cavaliere, "An Introduction to the Method of William Baziotes," *Arts Magazine* LI (April 1977): 124-31. On Pollock and automatism, see David S. Rubin, "A Case for Content: Jackson Pollock's Subject Was the Automatic Gesture," *Arts Magazine* LIII (March 1979): 103-9.

7. David Rubin, "A Case for Content," p. 105; "Concerning the Beginnings of the New York School: 1939-1943," "Interview with Robert Motherwell Conducted by Sidney Simon," *Art International* XI (Summer 1967): 22-23.

8. From "The Portrait and the Modern Artist" on *Art in New York* Program, WNYC, New York, copy of broadcast, 13 October 1943, reprinted in Maurice Tuchman, ed., *New York School: The First Generation* (Greenwich, Connecticut: New York Graphic Society, 1965), p. 139.

9. Stephen Jay Gould, *Ontogeny and Phylogeny* (Cambridge: Harvard University Press, 1977), p. 156. For influence of Jung, see Adolph Gottlieb interview with Dorothy Seckler, 25 October 1967, in Archives of American Art, Smithsonian Institute, New York, p. 17.

On Pollock and Jung, see Elizabeth L. Langhorne, "Jackson Pollock's 'The Moon Woman Cuts the Circle,'" *Arts Magazine* LIII (March 1979): 128-37; and Stephen

Polcari, "The Intellectual Roots of Abstract Expressionism: Mark Rothko," *Arts Magazine* LIV (September 1979): 124-34.

10. On myth in New York and its effect on Pollock, see William Rubin, "Pollock as Jungian Illustrator: The Limits of Psychological Criticism," *Art in America* LXVII (November, December 1979): 104-23, 72-91. Lacanian art critics like Marcelin Pleynet and Flavio Caroli have also shown interest in Freudian aspects of Pollock's art.

11. "Concerning the Present Day Relative Attractions of Various Creatures in Mythology & Legend," *VVV* I (June 1942): 62-63: Harold Rosenberg, "Notes on Identity: With Special Reference to the Mixed Philosopher, Soren Kierkegaard," *View* VI (May 1946): 7.

12. Harold Rosenberg, "Breton—A Dialogue," *View* II (May 1942).

13. Andrea Caffi, "On Mythology," trans. by Lionel Abel, *Possibilities* I (Winter 1947/8): 92.

14. Lionel Abel, "It Is Time to Pick the Iron Rose," *VVV* I (June 1942): 2.

15. André Breton, "Interview with René Bélance," in Rosemont, ed., *What Is Surrealism?* p. 256. This interview with a young Haitian poet appeared in the *Haiti-Journal* in 1945. Also see Wolfgang Paalen, *Form and Sense* (New York: Wittenborn and Company, 1945), pp. 51-57; John D. Graham, "Primitive Art and Picasso," *Magazine of Art* XXX (April 1937): 236 ff; and Barnett Newman, *Northwest Coast Indian Painting* (New York: Betty Parsons, 1946).

16. Rothko and Gottlieb, "'Globalism' Pops into View," *New York Times,* 13 June 1943, II, p. 9.

17. Lawrence Alloway, "The Biomorphic '40s," in *Topics in American Art Since 1945* (New York: Norton, 1975), pp. 17-24.

18. André Breton, "Arshile Gorky," in *Surrealism and Painting,* trans. by Simon Watson Taylor (New York: Harper and Row, 1972), p. 200. Originally written in 1945 for exhibition catalog for Gorky show at Julien Levy Gallery, New York City. The best study of Gorky is Harry Rand, *Arshile Gorky: The Implications of Symbols* (Montclair: Allanheld and Schram, 1981).

19. Rubin, "A Case for Content," pp. 103-9.

20. Greenberg, "'American-Type' Painting," p. 189. On Kline, see Frank O'Hara, "Franz Kline Talking," *Evergreen Review* II (Autumn 1958): 58-65; Harry F. Gaugh, "Franz Kline's Romantic Abstraction," *Artforum* XIII (Summer, 1975): 28-37; Budd Hopkins, "Franz Kline's Color Abstractions: Remembering and Looking Afresh," *Artforum* XVII (Summer 1979): 37-41; and "Franz Kline: An Interview with David Sylvester," *Living Arts* I (Spring 1963): 2-13.

21. Pollock's statement appeared in Selden Rodman's *Conversations With Artists* (New York: Devin-Adair, 1957), pp. 76-87.

22. de Kooning, "Content Is a Glimpse..." *Location* I (Spring 1963), reprinted in Thomas B. Hess, *Willem de Kooning* (New York: Museum of Modern Art, 1968), pp. 148-49; "The Renaissance and Order," *transformation* I (1951), reprinted in Ibid., p. 142. Also see, Lawrence Alloway, "De Kooning: Criticism and Art History," *Artforum* XIII (January 1975): 46-50.

23. Whitney Chadwick, "Eros or Thanatos—The Surrealist Cult of Love Reexamined,"

Artforum XIV (November 1975): 46–56; for a more formal approach, see Sally Yard, "Willem de Kooning's Women," *Arts Magazine* LIII (November 1978): 96–99; André Masson was particularly drawn to erotic themes. See William Rubin, *André Masson* (New York: Museum of Modern Art, 1976), pp. 11–77.

24. Newman, Letter to the Editor, *Art News,* May 1968, p. 8; Still, Letter to Gordon Smith, 1 January 1959, published in *Paintings by Clyfford Still* (Buffalo: Albright Art Gallery, 1959).

25. On Still, see Donald Kuspit, "Clyfford Still: The Ethics of Art," *Artforum* XV (May 1977): 32–40; Greenberg, "'American-Type' Painting," pp. 190–92.

26. Letter from Still to his dealer Betty Parsons, 29 December 1949, "As before the pictures are to be without titles of any kind. I want no allusions to interfere with or assist the spectator. Before them I want him to be on his own, and if he finds in them an imagery unkind or unpleasant or evil, let him look to the state of his own soul." In Betty Parsons Gallery Papers, Archives of American Art, Smithsonian Institution, Washington, D.C.

27. Rothko, "The Romantics Were Prompted," *Possibilities* I (Winter 1947/48): 84; also see, statement in *Interiors* CX (May 1951): 104; and letter from Rothko to Lloyd Goodrich of Whitney Museum, 20 December 1952, on Rothko's refusal to allow his paintings to be exhibited at Whitney, Betty Parsons Gallery Papers, Archives of American Art, Smithsonian Institution, Washington, D.C.

28. Newman, *The Ideographic Picture* (New York: Betty Parsons Gallery, 1947); Still, "An Open Letter to an Art Critic," *Artforum* II (December 1963): 32 (letter originally written in 1959).

29. Rothko, "The Romantics Were Prompted," p. 84. On affinities between Abstract Expressionism and Surrealism, see Robert Carleton Hobbs and Gail Levin, *Abstract Expressionism: The Formative Years* (Ithaca: Cornell University Press, 1978).

Chapter 4

1. Donald Judd, "Barnett Newman," *Studio International* CLXXIX (February 1970): 67–69. Also see Elizabeth Baker, "Barnett Newman in a New Light," *Art News,* February 1969, pp. 38 ff.

2. Greenberg, "'American-Type' Painting," *Art and Culture,* p. 226.

3. Newman, *The Ideographic Picture;* "Frontiers of Space," Interview with Dorothy Gees Seckler, *Art in America* L (Summer 1962): 86; and Robert Goodnough, ed., "Artists' Sessions at Studio 35 (1950)," p. 18.

4. Newman, "The Plasmic Image, Part I," unpublished essay in Hess, *Barnett Newman,* (1971), p. 38; *The Stations of the Cross: lema sabachthani* (New York: Solomon Guggenheim Museum, 1966), p. 9.

5. Newman, "The Ides of Art: What Is Sublime in Art?" *Tiger's Eye* VI (December 1948): 53; "The First Man was an Artist," *Tiger's Eye* I (October 1947): 59.

6. Newman, *Stamos* (New York: Betty Parsons Gallery, 1947). That attitude toward nature and culture should be compared to Barbara Novak's study of nineteenth century American landscape painters who were also influenced by the Transcendentalists. See *Nature and Culture,* pp. 3–44.

7. Hess, *Barnett Newman* (1971), p. 52.

8. Ibid., p. 61; Gershom G. Scholem, *Major Trends in Jewish Mysticism,* rev. ed., (New York: Schocken Books, 1954), pp. 7-10, 34-35.

9. Hess, *Barnett Newman* (1971), pp. 70-73; also see Barbara Cavaliere, "Barnett Newman's 'Vir Heroicus Sublimis': Building the 'Idea Complex,'" *Arts Magazine* LV (January 1981): 144-52.

10. Donald Kuspit, "Utopian Protest in Early Abstract Art," *Art Journal* XXIX (Summer 1970): 430-36.

11. On Newman's life, see Hess, *Barnett Newman* (1971), pp. 19-31, also see "Barnett Newman," *Current Biography* (New York: H. W. Wilson, 1969), pp. 300-303.

12. Newman, "The True Revolution Is Anarchist!" Foreward to *Memoirs of a Revolutionist* by P. Kropotkin (New York: Horizon Press, 1968), p. ix.

13. A. J. Liebling, "Two Aesthetes Offer Selves as Candidates To Provide Own Ticket for Intellectuals," *New York World-Telegram,* 4 November 1933. Also in Hess, *Barnett Newman* (1971), pp. 24-25.

14. Newman, "What About Isolationist Art?" unpublished essay in Hess, *Barnett Newman* (1971), p. 35.

15. "Artists Boycott Chicago," *New York Times,* 5 September 1968, p. 41; and Donald Janson, "Anti-Daley Art Put in Show in Chicago," *New York Times,* 24 October 1968, p. 40.

16. Letter to the Editor, *Art News,* May 1968, p. 8.

17. On Newman's Surrealist drawings, see Brenda Richardson, *Barnett Newman: The Complete Drawings, 1944-1969* (Baltimore: Baltimore Museum of Art, 1979), pp. 34-89.

18. "Art of the South Seas," *Studio International* CLXXIX (February 1970): 70-71. Originally appeared in Spanish as "Las formas artisticas del Pacifico," *Ambos Mundos* I (June 1946): 51-55. Also see Wilhelm Worringer, *Abstraction and Empathy: A Contribution to the Psychology of Style,* trans. by Michael Bullock (New York: International Universities Press, 1953).

19. From Newman's catalogs for Parsons Gallery, *Ideographic Picture* and *Stamos.*

20. Seckler, "Frontiers of Space," p. 87.

21. Newman, "The True Revolution Is Anarchist!" Forward to Kropotkin, *Memoirs,* p. xix.

22. Ibid., p. x.

23. Ian Dunlop, "Edvard Munch, Barnett Newman, and Mark Rothko: The Search for the Sublime," *Arts Magazine* LIII (February 1979): 128-30.

Chapter 5

1. "The Wild Ones," *Time,* 20 February 1956, p. 75. For a description of Pollock's art, see William Rubin, "Jackson Pollock and the Modern Tradition," *Artforum* V (February, March, April, and May, 1967): Greenberg, "'American-Type' Painting," pp. 186-88; and Rubin, "Pollock as Jungian Illustrator: The Limits of Psychological Criticism," pp. 104-23, 72-91.

2. Ibid.; and Pollock, Questionnaire that appeared in *Arts and Architecture* in 1944, reprinted in O'Connor, *Jackson Pollock,* p. 32.

3. From an interview with Pollock taped by William Wright in 1950 in Sag Harbor, New York, reprinted in O'Connor, *Jackson Pollock,* p. 81.

4. The catalog is one by O'Connor, *Jackson Pollock;* Barbara Rose, "Hans Namuth's Photographs and the Jackson Pollock Myth: Part One: Media Impact and the Failure of Criticism," *Arts Magazine* LIII (March 1979): 115; and "Jackson Pollock: An Artists' Symposium," *Art News,* April and May 1967; pp. 29-33 ff.; pp. 27-29 ff.

5. Benton, *An Artist in America,* pp. 44-45.

6. Stephen Polcari, "Jackson Pollock and Thomas Hart Benton," *Arts Magazine* LIII (March 1979): 120-24.

7. Letter from Pollock to brothers Charles and Frank, 22 October 1929, described Pollock's trouble in school and his interest in Rivera's work through meetings with Communists. Reprinted in O'Connor, *Jackson Pollock,* p. 14.

8. Hurlburt, "The Siqueiros Experimental Workshop," pp. 239-40.

9. On Pollock and Surrealism, see Rubin, "Pollock as Jungian Illustrator," pp. 104-23, 72-91; and Rubin, *André Masson,* pp. 68-74.

10. Greenberg, "'American-Type' Painting," p. 186; Breton, "Surrealism and Painting," in *Surrealism and Painting,* p. 5 (written in 1928).

11. Elizabeth L. Langhorne, "Jackson Pollock's 'Moon Woman Cuts the Circle,'" pp. 128-37.

12. Walter Benjamin, "The Work of Art in the Age of Mechanical Reproduction," *Illuminations,* trans. by Harry Zohn (New York: Harcourt, Brace & World, 1968), p. 231. The essay was originally written in 1936.

13. See C. L. Wysuph, *Jackson Pollock: Psychoanalytic Drawings* (New York: Horizon Press, 1970), pp. 9-19.

14. "Jackson Pollock: Is He the Greatest Living Painter in the United States?" *Life,* 8 August 1949, pp. 42-43, 45; Greenberg, "The Present Prospects of American Painting and Sculpture," *Horizon* LXCIII (October 1947): 26; and "Rebel Artist's Tragic Ending," *Life,* 27 August 1956, p. 58.

15. Namuth's photographs have been collected in *L'Atelier de Jackson Pollock;* Robert Goodnough, "Pollock Paints a Picture," *Art News,* May 1951, pp. 38-39.

16. Dorothy Seiberling, "Baffling U.S. Art: What It Is About," *Life,* 9 November 1959, pp. 68-80.

17. Biographical information from Francis V. O'Connor, "The Genesis of Jackson Pollock: 1912 to 1943," *Artforum* V (May 1967): 16-23; *Jackson Pollock;* and with Eugene Thaw, eds., *Jackson Pollock: A Catalog Raisonné of Paintings, Drawings and Other Works,* 4 vol. (New Haven: Yale University Press, 1978).

18. Jackson Pollock: "Is He the Greatest Living Painter in the United States?" p. 45.
 On importance of captions for photographs in popular press, see Benjamin's essay, op.cit., and Roland Barthes, "The Photographic Message," in *Image/Music/Text,* trans. by Stephen Heath (New York: Hill and Wang, 1977), pp. 15-31.

19. George Segal, "Jackson Pollock: An Artists' Symposium, Part 2," *Art News,* May 1967, p. 29; and R. Meltzer, *The Aesthetics of Rock* (New York: Something Else Press, 1970), p. 32.

 For other evaluations of Pollock's impact on subsequent artists, see Donald Judd, "Jackson Pollock," *Arts Magazine* XLI (April, 1967): 34; Frank O'Hara, *Jackson Pollock* (New York: George Braziller, 1959); and Sam Hunter, "Jackson Pollock," *Bulletin of the Museum of Modern Art* XXIV (1956–1957): 5. Claes Oldenburg, *Art News,* May 1967, p. 27, says this of Pollock: "Following his call to directness got me out of art school and unlocked the use of paint." As recently as 1975 Jackson Pollock still represented the avant-garde in painting. When *Artforum* held a symposium on new painting in 1975, the editors put a Namuth photograph of Pollock on the cover (September, 1975).

20. Robert Goldwater, *Primitivism in Modern Art,* rev. ed. (New York: Random House, 1966).

 On primitivism of Pollock, also see Robert Creeley, "The Art of Poetry," *Paris Review* XI (Fall, 1968): 185; and Willem de Kooning, "An Interview by James T. Valliere," in *Partisan Review* XXXIV (Fall 1967): 605.

21. Namuth, "Photographier Pollock," in *L'Atelier de Jackson Pollock,* pp. 7–11; and Rose, "Hans Namuth's Photographs," p. 113. Kaprow included Namuth's photographs of Pollock in his *Assemblage, Environments, and Happenings* (New York: Abrams, 1966), pp. 8, 111, with the caption "Environmental Painting." Also see Allan Kaprow, "The Legacy of Jackson Pollock," *Art News,* October 1958, pp. 24–26, 55–57.

22. Benjamin, "The Work of Art in the Age of Mechanical Reproduction," pp. 220–26.

Chapter 6

1. The best description of Reinhardt's painting is found in Lucy Lippard, "Ad Reinhardt: One Art," *Art In America* LXII (September/October and November/December 1974): 65–75, 95–101. Also see her recent book *Ad Reinhardt* (New York: Abrams, 1981): and Irving Sandler, *Triumph of American Painting,* pp. 225–32; quote is from unpublished notes, 1965, in Ad Reinhardt Papers, Archives of American Art, Smithsonian Institution, Washington, D.C., reprinted in Rose, *Art-As-Art,* p. 10.

 Reinhardt composed a satiric "Chronology" of his own life in 1967 for a catalog for his Jewish Museum show. On Reinhardt, also see Priscilla Colt, "Notes on Ad Reinhardt," *Art International* VIII (20 October 1964): 32–34, and Lawrence Alloway, "Systemic Painting," in *Topics in American Art Since 1945* (New York: Norton, 1975), pp. 76–91.

2. "The Fine Artist and the War Effort," Unpublished notes, ca.1943, in Rose, *Art-As-Art,* p. 177. This piece may have been a report Reinhardt prepared as a delegate to the Artists for Victory. A similar statement appeared in "Abstraction vs. Illustration," Unpublished lecture, 1943, in Rose, *Art-As-Art,* p. 49. The same essay demonstrates Reinhardt's interest in Cubism as an art movement displaying "an order that implies man can not only control and create his world, but ultimately free himself completely from a brutal, barbaric existence" (p. 48). Reinhardt criticized Surrealism because it only reflected the disorder of the world.

 "How To Look at Space," *P.M.,* 28 April 1946, in Thomas B. Hess, *The Art Comics and Satires of Ad Reinhardt* (Rome: Marlborough, 1975), unpaged.

3. "25 Lines of Words on Art Statement," *It Is* (Spring 1958), in Rose, *Art-As-Art,* p. 51; and "Art-As-Art," *Art International* (December 1962), in Rose, *Art-As-Art,* p. 53.

4. Sontag, *Against Interpretation,* p. 43; and Roland Barthes, *Writing Degree Zero,* trans. by Annette Lavers and Colin Smith (New York: Hill and Wang, 1967), pp. 74–78.

5. "Chronology," in Rose, *Art-As-Art,* pp. 5–6. Also see Thomas B. Hess, *The Art Comics and Satires of Ad Reinhardt,* pp. 15–16.

6. Ad Reinhardt Papers, Archives of American Art, Smithsonian Institution, Washington, D.C., contain materials on organizations the painter joined.

7. See cover of *New Masses,* 27 December 1938; anti-fascist cartoons appeared 3 January 1939, p. 15; 17 January 1939, pp. 6–7; 30 May 1939, p. 3. Cartoons attacking the leaders of Great Britain and France appeared in the *New Masses* on 10 October 1939, p. 15, and 6 February 1940, p. 7. Cartoon on Hitler and Franco appeared in *P.M.* on 11 May 1943, reprinted in James H. Beck, "Ad Reinhardt in Retrospect," *Arts Magazine* LIV (June 1980): 149.

8. Reinhardt, "Stuart Davis," *New Masses,* 27 November 1945, p. 15; Irving Flamm, "The USA and USSR can and MUST get along," *Soviet Russia Today,* February 1947, pp. 10–11.

9. Material in Reinhardt Papers, Archives of American Art, Smithsonian Institution, Washington, D.C., indicates that Reinhardt was vice chairman of the Artist's Committee for Student Nonviolent Coordinating Committee in 1963, donated a painting to be auctioned at a Congress for Racial Equality benefit in 1964, and gave another painting to the First African Methodist Church in Los Angeles in 1964. He was involved in numerous protests against the war in Vietnam, served on the executive committee of Artists for SANE, and supported the Bertrand Russell Peace Foundation.

10. Piet Mondrian, "Plastic Art & Pure Plastic Art," in *Modern Artists on Art,* ed. by Robert L. Herbert (Englewood Cliffs, N.J.: Prentice-Hall, 1964), pp. 115–130. Originally appeared in *Circle* (London 1937).

11. *General Prospectus,* American Abstract Artists Papers, Archives of American Art, Smithsonian Institution, Washington, D.C., probably printed in January 1937. See also Susan C. Larsen, "The AAA: A Documentary History, 1936–1941," *Archives of American Journal* XIV (1974): 2–7. See also Sandler, *Triumph of American Painting,* pp. 15–20.

12. "Introduction," *American Abstract Artists 1938,* unpaged; and *American Abstract Artists 1942* (New York: Fine Arts Galleries, March 9–23, 1943), unpaged.
 Balcomb Greene, "American Perspective," *Plastique* III (Spring 1938): 12; and Balcomb Greene, "Expression as Production," *American Abstract Artists 1938,* unpaged.

13. "The Fine Artist and the War Effort," in Rose, *Art-As-Art,* pp. 175–77.

14. "Abstraction vs. Illustration," in Rose, *Art-As-Art,* pp. 48–49.

15. See Hess, *The Art Comics,* pp. 25–28. The cartoons described in the text were "How to Look at a Cubist Painting," *P.M.,* 27 January 1946; "How to Look at Looking," *P.M.,* 21 July 1946; and "How to Look at a Mural," *P.M.,* 5 January 1947. All are reproduced in the Hess volume.
 Marion Summers, "Art Today: Lessons in Utter Confusion," *Daily Worker,* 19 May 1946, p. 14.

16. Budd Hopkins, "An Ad for Ad As Ad," *Artforum* XIV (Summer 1976): 62–63.

17. "Abstract Art Refuses," *Contemporary American Painting* (Urbana, Illinois: University of Illinois, 1952), reprinted in Rose, *Art-As-Art*, pp. 50–51.

18. "The Artist in Search of an Academy, Part II: Who Are the Artists?" *College Art Journal* (Summer 1954), in Rose, *Art-As-Art*, pp. 201–2. Reinhardt first read this paper at a symposium on the Reality group in August 1954, at Woodstock, New York.

19. Hess, *The Art Comics*, pp. 50–51. On effect of Reinhardt on his fellow artists, see Harold Rosenberg, "Purifying Art," *New Yorker*, 23 February 1976, p. 98. Also see Max Kozloff, "Andy Warhol and Ad Reinhardt: The Great Accepter and the Great Demurrer," *Studio International* CLXXXI (March 1971): 113–17.

20. "25 Lines of Words on Art Statement," in Rose, *Art-As-Art*, pp. 51–52.

21. Hopkins, "An Ad for Ad As Ad," pp. 62–63.

22. "Cycles Through the Chinese Landscape," *Art News*, (December 1954), in Rose, *Art-as-Art*, pp. 214–15; "Timeless in Asia," *Art News* (January 1960), in Rose, *Art-as-Art*, p. 217; "Angkor and Art," *Art News* (December 1961), in Rose, *Art-as-Art*, pp. 218–23.

23. "Art-As-Art," *Art International* (December 1962) in Rose, *Art-As-Art*, p. 54.

24. "The Next Revolution in Art," *Art News* (February 1964), in Rose, *Art-As-Art*, p. 61. "Art vs. History," *Art News* (January, 1966), in Rose, *Art-As-Art*, p. 226.

25. This cartoon is reproduced in the Hess collection, *The Art Comics* and is discussed by him on pp. 49–52. It originally appeared in *Art News* in April 1954.

26. On the relationship between Abstract Expressionists and art dealers, see Betty Parsons interview with Paul Cummings, 4 June 1969, p. 25; Aline Louchheim, "Parsons," *Vogue*, 1 October 1951, p. 141; Robert Motherwell interview with Paul Cummings, 21 February 1972, pp. 62–63. Also see Samuel Kootz interviews, 2 March 1960 and 13 April 1964. All interviews in Archives of American Art, Smithsonian Institution, New York.

27. Postcard, 24 January 1962, from Reinhardt to Bernard Karpel, Chief Librarian, Museum of Modern Art, New York City, in Reinhardt Papers, Archives of American Art, Smithsonian Institution, Washington, D.C.

28. "The Next Revolution in Art," in Rose, *Art-As-Art*, pp. 59, 61; "Abstract Painting, Sixty by Sixty Inches Square, 1960," *Artforum* (March 1966), in Rose, *Art-As-Art*, p. 85.

29. On Reinhardt and de Kooning, see Hess, *The Art Comics*, pp. 10–11; "Chronology," in Rose, *Art-As-Art*, p. 8; "Monologue," From an interview with Mary Fuller, taped April 27, 1966, and published in *Artforum* (October 1970), in Rose, *Art-As-Art*, p. 27; and "Religious Strength Through Market-Place Joy," Unpublished, undated notes, in Rose, *Art-As-Art*, p. 190.

30. On Pepsi-Cola contest, see Hess, *The Art Comics*, pp. 29–30; Clement Greenberg, "Art," *The Nation*, 1 December 1945, pp. 605, 606; and Ad Reinhardt, "How to Look at Art and Industry," *P.M.*, 6 October 1946, in Hess, *The Art Comics*, unpaged.

Chapter 7

1. Harold Rosenberg, "The Search for Jackson Pollock," *Art News*, February 1961, p. 35.

Here Rosenberg borrowed terms from Constance Rourke's *American Humor* to compare Pollock with Daniel Boone.

2. Editorial, *Possibilities* I (Winter 1947/1948): 1.

3. Jerry Mangione, *The Dream and the Deal: The Federal Writers' Project, 1935–1943* (Boston: Little, Brown, 1972), p. 226; Rosenberg, "For a Poet's Insurrection," *Trance Above the Streets* (New York: Gotham Bookmart Press, 1942), p. 45; "A Spectre Haunts Mr. Krutch," *Partisan Review* II (1935): 83; and "The American Writers' Congress," *Poetry: A Magazine of Verse* XLVI (1935): 222–27.

4. See Mangione, *The Dream and the Deal*, pp. 244–52; and Gerald M. Monroe, "Art Front," p. 69.

5. "Manifesto," League for Cultural Freedom and Socialism, 1939, copy in Ilya Bolotowsky Papers, Archives of American Art, Smithsonian Institution, Washington, D.C. On appeal of Trotskyism, see Richard H. Pells, *Radical Visions and American Dreams*, pp. 131–32.
 For description of *Commentary's* politics, see Norman Podhoretz, *Making It* (New York: Knopf, 1967), pp. 220–36, 294–98. Rosenberg, "The Communist: His Mentality and His Morals," *Commentary* VIII (July 1949): 1–9.

6. Irving Howe and Lewis Coser, "A Word to Our Readers," *Dissent* I (Winter 1954): 3–7.

7. Rosenberg, "Couch Liberalism and the Guilty Past," *Dissent* II (1955): 321; and in *The Tradition of the New* (New York: Horizon Press, 1959), p. 229.

8. Howe, "Introduction," *Echoes of Revolt: The Masses, 1911–1917,* ed. by William O'Neill (Chicago: Quadrangle, 1966), p. 5.

9. Rosenberg, "Death in the Wilderness," *The Tradition of the New*, pp. 250–51.

10. Rosenberg, "The American Action Painters," p. 23, 48.

11. Rosenberg, "Art of Bad Conscience," *New Yorker,* 12 December 1967, pp. 142–43. Also in *Artworks and Packages* (New York: Horizon, 1969), p. 161.

12. Rose, "Hans Namuth's Photographs and the Jackson Pollock Myth," p. 113; and Goodnough, "Pollock Paints a Picture," pp. 38–39.

13. Editorial, *Possibilities* I (1947/1948): 1. On avant-garde magazines, also see Poggioli, *The Theory of the Avant-Garde*, pp. 27–40.

14. Richard Huelsenbeck, "En Avant Dada," *Possibilities* I (1947/1948): 42.

15. Editorial, *Possibilities* I (1947/1948): 1.

16. Rosenberg, "Young Masters, New Critics: Frank Stella," *The De-Definition of Art* (New York: Horizon Press, 1972), pp. 121, 123, 127.

17. Rosenberg, "The Game of Illusion: Pop and Gag," *The Anxious Object: Art Today and Its Audience* (New York: Horizon Press, 1964), p. 75; and "Marilyn Mondrian: Roy Lichtenstein and Claes Oldenburg," *The De-Definition of Art*, p. 112.

18. Rosenberg, "The Herd of Independent Minds," *Commentary* V (September 1948): 244–47; and "Jewish Identity in a Free Society," *Commentary* IX (June 1950): 513.

19. Rosenberg, "Is There a Jewish Art?" *Commentary* XL (1966): 58–60; and "Jews in Art," *New Yorker,* 22 December 1975, pp. 64–68.

20. Rosenberg, "Jewish Identity in a Free Society," p. 512.

21. Rosenberg, "The Fall of Paris," *Partisan Review* VII (1940): 440. Also in *The Tradition of the New,* p. 209.

22. Matthiessen's book appeared in 1941; Kazin's in 1942; and Rahv's essay in *Partisan Review* and later in *Image and Idea* (New York: New Directions, 1949). All of them of course owed a debt to the works of Van Wyck Brooks.

23. Rosenberg, "Parable of American Painting," *The Tradition of the New,* pp. 13-22.

24. Rosenberg, "French Silence and American Poetry," *The Tradition of the New,* p. 91.

25. Rosenberg, "Style and the American Scene," *The Anxious Object,* p. 83.

Chapter 8

1. Richard Hofstadter, *The Paranoid Style in American Politics and Other Essays* (New York: Knopf, 1965), pp. 3-40. On Dondero, see Jane D. Mathews, "Art and Politics in Cold War America," *American Historical Review* LXXXI (October 1976): 762-87. Also see, Meyer Schapiro, "Rebellion in Art," in *America in Crisis,* ed. by Daniel Aaron (New York: Knopf, 1952), pp. 202-42.

2. Dondero's remarks taken from Modert Art Shackled to Communism, 16 August 1949, *Congressional Record,* 11584.

3. U.S. Congress, House, Congressman Dondero speaking on How the Magazine the *Nation* is Serving Communism, 82nd Cong., 1st sess., 4 May 1951, *Congressional Record,* 4920-25.

4. Greenberg, "The Present Prospects of American Painting and Sculpture," *Horizon* No. 93-94 (October 1947): 20-29; "The Best?" *Time,* 1 December 1947, p. 55; Barbara Rose, "Wolfeburg," *New York Review of Books,* XXIV (26 June 1975): 26. The last article includes the Levine drawing and is a review of Tom Wolfe's book, *The Painted Word* (New York: Farrar, Straus & Giroux, 1975). Wolfe is correct to point to the power that critics like Greenberg have in the art world but his assessment of Greenberg's criticism is almost wholly inaccurate. Wolfe claims that Greenberg elevates the words or the concepts behind art over the actual works themselves. Greenberg's criticism is conceptual, relying as it does on Kantian aesthetics, but the critic stresses the visual experience offered by art. For a serious, sophisticated and philosophical treatment of Greenberg's criticism, see Donald Kuspit, *Clement Greenberg: Art Critic* (Madison: University of Wisconsin Press, 1979).

5. "Clement Greenberg," *Twentieth Century Authors: A Biographical Dictionary of Modern Literature,* First Supplement, ed. by Stanley Kunitz (New York: H. W. Wilson, 1955), pp. 386-87. Part of the entry was written by Greenberg himself.

6. The best works on Trotskyism and *Partisan Review* remain James Gilbert, *Writers and Partisans*; Richard Pells, *Radical Visions and American Dreams: Culture and Social Thought in the Depression Years*; and David Hollinger, "Ethnic Diversity, Cosmopolitanism, and the Emergence of the American Liberal Intelligentsia," *American Quarterly* XXVII (May 1975): 133-51.

7. Greenberg, "Art," *Nation,* 16 March 1946, p. 327.

8. Ibid., 9 January 1943, p. 680; and 1 November 1947, pp. 481-82.

9. Greenberg, "Art Chronicle: Irrelevance versus Irresponsibility," *Partisan Review* XV (May 1948): 579; and "Anna Seghers," *Nation,* 17 October 1942, pp. 388–90. The first article was part of an exchange with British art critic Geoffrey Grigson and the second was a review of a novel about the relationship between Nazis and Communists during an escape from a German concentration camp.

10. Greenberg, "Avant-Garde and Kitsch," *Partisan Review* VI (Fall 1939): 34–49. This essay also appeared in *Art and Culture: Critical Essays* (Boston: Beacon Press, 1961). Also see Casey Blake, "Aesthetic Engineering," *democracy* I (October 1981): 37–50.

11. Greenberg and Macdonald, "10 Propositions on the War," *Partisan Review* VIII (July/August 1941): 271–78.

12. Macdonald, "Politics Past," in *Memoirs of a Revolutionist: Essays in Political Criticism* (New York: Farrar, Straus, Giroux, & Cudahy, 1957), pp. 27–28; Gilbert, *Writers and Partisans,* pp. 244–52; and on Macdonald's career, see Christopher Lasch, *The New Radicalism in America, 1889–1963: The Intellectual as a Social Type* (New York: Knopf, 1965), pp. 322–34.

13. Irving Howe, *World of Our Fathers* (New York: Harcourt Brace Jovanovich, 1976), p. 412; Norman Podhoretz, *Making It,* pp. 127–36; and Oscar Handlin, "The American Jewish Committee: A Half-Century View," *Commentary* XXIII (January 1957): 1–10. For Cohen's interpretation of political role of Jews, see "What Do thé Germans Propose to do?" *Commentary* X (September 1950): 225–28.

14. Greenberg, "The Jewishness of Franz Kafka: Some Sources of His Particular Vision," *Commentary* XIX (April 1955): 320–24; "The Jewish Dickens," *Nation,* 16 October 1943, pp. 450–452; "Art," *Nation,* 1 June 1946, p. 672; "The Sculpture of Jacques Lipchitz: Strengths and Weaknesses of a Modern Master," *Commentary* XVIII (September 1954): 257–59; and "The Pound Award," *Partisan Review* XVI (May 1949): 515–16.

15. Greenberg, "Under Forty," *Contemporary Jewish Record* VII (February 1944): 32–33.

16. Greenberg, "Self-Hatred and Jewish Chauvinism: Some Reflections on 'Positive Jewishness,'" *Commentary* X (November 1950): 432.

17. Cohen, *Commentary* I (November 1945): 1–2. Also see Podhoretz, *Making It,* p. 294.

18. Christopher Lasch, "The Cultural Cold War: A Short History of the Congress for Cultural Freedom," in *Towards a New Past: Dissenting Essays in American History,* ed. by Barton J. Bernstein, (New York: Knopf, 1967), pp. 322–59; and Francois Bondy, "Berlin Congress for Freedom," *Commentary* X (September 1950): 245–51. The manifesto of the Congress appeared in "The Berlin Manifesto," *New Leader,* 8 July 1950, p. 8. One of the leading moderate participants at the 1950 Berlin Congress was the Italian anti-Communist writer Ignazio Silone. Greenberg had known him since the late 1930s. His interview with Silone had appeared in the fall, 1939, issue of *Partisan Review.* There are two letters in the Greenberg Papers, Archives of American Art, Smithsonian Institution, Washington, D.C., from Silone (12 June 1940 and 14 July 1940) on the European war and the refugee situation.

19. Greenberg, "American Stereotypes," *Commentary* XXII (October 1956): 380–81.

20. Nicholas Calas, Letter to Editor, *View* I (October 1940): 1. Greenberg wrote a book on one of the leading abstract Surrealists, Joan Miró. Yet the critic's interpretation of Miró

rested on the painter's affinities with the Cubists rather than the Surrealists. In that work, Greenberg again associated Cubism with "the end of ideology." As he wrote, the original impulses of Cubism were "its optimistic positivism, its trusting and self-confident indifference to politics and ideology, its faith in the powers of reason and its certainty of the ultimate comfort of existence." *Joan Miró,* p. 41.

21. The attack on the *New Statesman and Nation* was by Richard L. Strout in *New Republic,* 5 March 1951, pp. 13-15. Its editor Kingsley Martin answered the charges in the issue of 19 March 1951, pp. 15-16. On Kirchwey, see June Sochen, *Movers and Shakers: American Women Thinkers and Activists, 1900-1970* (New York: Quadrangle, 1973), pp. 213-18. Frank Warren in *Liberals and Communism: The 'Red Decade' Revisited* (Bloomington: Indiana University Press, 1966), finds that Kirchwey was sympathetic to the Communist Party and to the Soviet Union but never followed any kind of Party line. According to Warren, she judged each event on its own merit and was often critical of the Party. She was, however, not on good terms with the Trotskyist intellectuals. She resigned from the Trotsky Defense Committee run by Sidney Hook and was less critical of the Moscow Trials afterwards. See Warren, pp. 45-48, 171-79. After the war, Kirchwey was an outspoken foe of McCarthyism and a critic of American foreign policy. For examples, see the *Nation,* 22 March 1947, pp. 317-19; 22 July 1950, p. 72; and 13 December 1947, pp. 666-67.

22. See del Vayo's memoir, *Give Me Combat: The Memoirs of Julio Alvarez del Vayo* (Boston: Little Brown, 1973). Barbara Tuchman in a foreword to the book calls del Vayo a "happy warrior" for radical causes (p. x). Also see del Vayo's obituary in *New York Times,* 6 May 1975, p. 42. In that article, *Times* reporter Herbert Matthews is quoted as characterizing del Vayo as a fellow traveler.

23. "*The Nation* Censors a Letter of Criticism," *New Leader,* 19 March 1951, p. 17. Another attack appeared in Peter Viereck, "Sermons of Self-Destruction," *Saturday Review of Literature,* 18 August 1951, pp. 6-7, 39-41.

 On controversy between *Nation* and Greenberg, also see Mary Sperling McAuliffe, *Crisis on the Left: Cold War Politics and American Liberals, 1947-1954* (Amherst: University of Massachusetts Press, 1978).

24. Granville Hicks, "The Liberals Who Haven't Learned," *Commentary* XII (April 1951): 319. Also see Kirchwey, "Why the *Nation* Sued," *Nation,* 2 June 1951, pp. 504-5.

25. Schlesinger's letter appeared in *New Leader,* 30 April 1951, p. 27; Hook's in *Time,* 23 April 1951, pp. 8-9. Reinhold Niebuhr and Robert Bendiner were contributing editors of the *Nation* who pulled their names from the masthead after Greenberg's letter. Notice was given of Marshall's departure from the staff on 17 January 1953, p. 40. A letter from Marshall appeared on 7 February 1953, p. 135, charging that the firing was political. See also *Time,* 19 January 1953, p. 62. In 1961 when Greenberg published his collected essays, *Art and Culture,* he dedicated the volume to Marshall. The suit was settled and discontinued in 1955 without cost to either party. See *New Leader,* 19 September 1955, p. 20. For Communist Party reaction to these attacks on the *Nation,* see Samuel Sillen, "The McCarthy Intellectuals," *Masses & Mainstream* IV (October 1951): 25-26.

26. Greenberg, "Art," *Nation,* 28 November 1942, p. 590; "Art," *Nation,* 1 July 1944, p. 24; "Art," *Nation,* 28 October 1944, p. 541; "Art," *Nation,* 27 November 1943, p. 621.

 On the history written during the Cold War, see John Diggins, "Consciousness and Ideology in American History: The Burden of Daniel J. Boorstin," *American Historical Review* LXXVI (February 1971): 99-118; also see Daniel Bell, *The End of Ideology: On the Exhaustion of Political Ideas in the Fifties,* pp. 286-99, 369-75.

27. Greenberg, "Some Advantages of Provincialism," *Art Digest,* 1 January 1954, p. 8; "Art," *Nation,* 22 February 1947, pp. 228–29; "Symposium: Is the French Avant-Garde Overrated?" *Art Digest,* 15 September 1953, pp. 12, 27; and "A Symposium: The State of American Art," *Magazine of Art,* March 1949, p. 92. F. O. Matthiessen in *American Renaissance: Art and Expression in the Age of Emerson and Whitman,* pp. 602–25, drew comparisons among Whitman, Eakins and other writers and painters. This book was of inestimable influence in reviving interest in American literature and is one of the crucial works that stimulated interest in American studies.

28. Louis Hartz, *The Liberal Tradition in America* (New York: Harvest, 1955); Greenberg, "Art," *Nation,* 11 April 1942, p. 441; "Art," *Nation,* 10 October 1942, p. 350; "Art," *Nation,* 27 November 1943, p. 621.

29. Greenberg, "Art Chronicle: The Decline of Cubism," *Partisan Review* XV (March 1948): 367–68; "Art," *Nation,* 27 November 1948, pp. 612–13.

30. Greenberg, "Avant-Garde and Kitsch," *Partisan Review:* 34–39; "Towards a Newer Laocoon," *Partisan Review* VII (1940): 302. On the influence of Greenberg's ideas, see Barbara M. Reise, "Greenberg and the Group: A Retrospective View," *Studio International* CLXXV (May/June 1968), 254–57, 314–16; Andrew Higgins, "Clement Greenberg and the Idea of the Avant-Garde," *Studio International* CLXXXIII (October 1971): 144–47; Stephen C. Foster, "Clement Greenberg: Formalism in the '40s and '50s," *Art Journal* XXXV (Fall 1975): 20–24; Carter Ratcliff, "Art Criticism: Other Eyes, Other Minds," *Art International* XVIII (15 December 1974): 53–57; Barbara Cavaliere and Robert C. Hobbs, "Against a New Laocoon," pp. 114–17; Max Kozloff, "Critical Reception of Abstract Expressionism," *Arts Magazine* XL (December 1965): 27–33. and Serge Guilbaut, "The New Adventures of the Avant-Garde in America," trans. by Thomas Repensek, *October* XV (October 1981): 61–78.

31. Greenberg, "Towards a Newer Laocoon," 298–307.

32. Greenberg, "Present Prospects of American Painting and Sculpture," *Horizon* (1947): 26–27.

33. Ibid., pp. 26,28; "Art," *Nation,* 6 December 1947, p. 630.

34. "American-Type Painting," *Partisan Review* XXII (Spring 1955): 181. Essay also appeared in *Art and Culture* (1961), p. 211.

35. Ibid., pp. 220–21.

36. Ibid., p. 226.

37. For general description of Parisian avant-garde, see Roger Shattuck, *The Banquet Years: The Origins of the Avant-Garde in France,* and Theda Shapiro, *Painters and Politics: The European Avant-Garde and Society, 1900–1925.*

Chapter 9

1. "Rebel Artist's Tragic Ending," *Life,* 27 August 1956, p. 58; Greenberg and Namuth, "Jackson Pollock," *Evergreen Review* III (1956): 95–96; and Greenberg, "The Jackson Pollock Market Soars," *New York Times Magazine,* 16 April 1961, pp. 42 ff.

2. Les Levine, "The Golden Years: A Portrait of Eleanor Ward," *Arts Magazine* XLVIII (April 1974): 42–43; "The Spring of '55: A Portrait of Sam Kootz," *Arts Magazine* XLVIII (April 1974): 34–35; and "Suffer, Suffer, Suffer: A Portrait of John Bernard Myers," *Arts Magazine* XLVIII (April 1974): 38–39.

3. Lee Seldes, *The Legacy of Mark Rothko* (New York: Holt, Rinehart, and Winston, 1978), p. 115.

4. Eva Cockcroft, "Abstract Expressionism, Weapon of the Cold War," *Artforum* XII (June 1974): 39–41; also see Kozloff, "American Painting During the Cold War," pp. 43–54; for another analysis of politics and Abstract Expressionism, see David and Cecile Shapiro, "Abstract Expressionism: The Politics of Apolitical Painting," *Prospects* III (1977): 175–214.

5. Lasch, "The Cultural Cold War," in *Towards a New Past,* pp. 322–59.

6. Poggioli, *The Theory of the Avant-Garde,* p. 182.

7. Greenberg, "Post-Painterly Abstraction," *Art International* VIII (Summer 1964): 63–64; on Minimal art, see essays in Gregory Battcock, *Minimal Art: A Critical Anthology.*

8. Kozloff, "Andy Warhol and Ad Reinhardt," pp. 113–17; Lucy Lippard, *Pop Art* (New York: Oxford, 1966), pp. 69–138.

9. John Cage, *Silence* (Middletown, Connecticut: Wesleyan University Press, 1961); and Richard Kostelanetz, ed., *John Cage* (New York: Praeger, 1970).

10. Therese Schwartz, "The Politization of the Avant-Garde," *Art In America* LVIX (November/December 1971): 96–105, and LX (March/April 1972): 70–79, and LXI (March/April 1973): 67–71.

Bibliography

I. Archival Collections

Washington, D.C.: Smithsonian Institution. Archives of American Art. The following collections were consulted:

American Abstract Artists
Artists for Victory
Ilya Bolotowsky
James Brooks
Edith Bry
The Club
George Constant
Federation of Modern Painters and Sculptors
Adolph Gottlieb
Clement Greenberg
Peggy Guggenheim
Jacob Kainen
Ibram Lassaw
Seymour Lipton
William Littlefield
Alice Trumbull Mason
George L. K. Morris
New York Public Library—Art Division Pamphlet File
Barnett Newman
Betty Parsons Gallery
Patricia Passlof
Phillip Pavia
Ad Reinhardt
Mark Rothko
Louis Shanker
Harris Steinberg
Hedda Sterne
Bradley Walker Tomlin
Whitney Museum Papers—Franz Kline File
 William Baziotes File

II. Interviews

New York, New York: Smithsonian Institution. Archives of American Art. The following interviews were consulted in Oral History Program of the Archives:

Bolotowsky, Ilya. Interview by Paul Cummings. 1968. Interview by Ruth Gurin. 1963.
Busa, Peter. Interview by Dorothy Seckler. 1965.
Castelli, Leo. Interview by Paul Cummings. 1969. Interview by Barbara Rose. 1969.
Ferber, Herbert. Interview by Dorothy Seckler. 1962. Interview by Irving Sandler. 1968–69.
Frankenthaler, Helen. Interview by Barbara Rose. 1968.
Gottlieb, Adolph. Interview by John Jones. 1965. Interview by Dorothy Seckler. 1967.
Kootz, Samuel. Interview by John Morse. 1960. Interview by Dorothy Seckler. 1964.
Krasner, Lee. Interview by Dorothy Seckler. 1964. Interview by Barbara Rose. 1966.
Lassaw, Ibram. Interview by Ruth Gurin. 1962. Interview by Dorothy Seckler. 1964. Interview by Irving Sandler. 1968.
Miller, Dorothy. Interview by Paul Cummings. 1970-71.
Motherwell, Robert. Interview by Paul Cummings. 1971–74.
Opper, John. Interview by Irving Sandler. 1968.
Parsons, Betty. Interview by Paul Cummings. 1969.
Pavia, Phillip. Interview by Bruce Hooton. 1965.
Rosati, James. Interview by Sevim Fesci. 1968.
Vicente, Esteban. Interview by Irving Sandler. 1968.

III. Magazines

Art Front, November 1934–December 1937.
Possibilities I. An Occasional Review, Winter 1947–1948.
The Tiger's Eye, 1947–1949.

IV. Newspapers

"Alvarez del Vayo Dead." *New York Times,* 6 May 1975, p. 42.
"Artists Boycott Chicago." *New York Times,* 5 September 1968, p. 41.
"Artists Denounce Modern Museum." *New York Times,* 17 April 1940, p. 25.
"18 Painters Boycott Metropolitan: Charge 'Hostility to Advanced Art.'" *New York Times,* 22 May 1950, p. 1.
"Evolution Theory Called Obsolete." *New York Times,* 13 October 1946, p. 25.
Janson, Donald. "Anti-Daley Art Put in Show in Chicago." *New York Times,* 24 October 1968, p. 40.
Jewell, Edward Alden. "'Globalism' Pops Into View." *New York Times,* 13 June 1943, sec. 2, p. 9.
Knox, Sandra. "21 Artists Assail Museum Interior." *New York Times,* 12 December 1956, p. 46.
Lelyveld, Joseph. "Modern U.S. Art Stirs New Delhi." *New York Times,* 10 April 1967, p. 32.
"17 Members Bolt Artists' Congress." *New York Times,* 17 April 1940, p. 25.
"Was This First Man." *New York Times,* 10 February 1946, sec. 4, p. 9.

V. Exhibition Catalogs

Alloway, Lawrence. *The Stations of the Cross.* New York: Solomon R. Guggenheim Museum, 1966.

American Abstract Artists 1938. New York: 1938.

American Abstract Artists 1942. New York: Fine Arts Galleries, March 9–23, 1942.

Barr, Alfred H., Jr. *Cubism and Abstract Art.* New York: Museum of Modern Art, 1936.

————. *First Loan Exhibition.* New York: Museum of Modern Art, 1929.

————. *The New American Painting.* New York: Museum of Modern Art, 1959.

First Annual Membership Exhibition. New York: American Artists' Congress, Inc., 1937.

Greenberg, Clement. *Post Painterly Abstraction.* Los Angeles: Los Angeles County Museum of Art, 1964.

Hess, Thomas B. *Barnett Newman.* New York: Walker and Company, 1969.

————. *Barnett Newman.* New York: Museum of Modern Art, 1971.

————. *Willem de Kooning.* New York: Museum of Modern Art, 1968.

Hobbs, Robert Carleton, and Levin, Gail. *Abstract Expressionism: The Formative Years.* Ithaca: Cornell University Press, 1978.

Mark Rothko. New York: Art of This Century Gallery, 1945.

Miller, Dorothy. *15 Americans.* New York: Museum of Modern Art, 1952.

Newman, Barnett. *The Ideographic Picture.* New York: Betty Parsons Gallery, January 20–February 8, 1947.

————. *Northwest Coast Indian Painting.* New York: Betty Parsons Gallery, September 30–October 19, 1946.

————. *Stamos.* New York: Betty Parsons Gallery, February 10–March 1, 1947.

O'Connor, Francis V. *Jackson Pollock.* New York: Museum of Modern Art, 1967.

Paintings by Clyfford Still. Buffalo: Albright Art Gallery, 1959.

Porter, David, ed. *A Painting Prophecy—1950.* Washington, D.C.: David Porter Gallery, 1950.

Preble, Michael. *William Baziotes: A Retrospective Exhibition.* Newport Beach, California: Newport Harbor Art Museum, 1978.

Reinhardt, Ad. *Recent Abstract Paintings by Ad Reinhardt.* New York: Betty Parsons Gallery, October 18–November 6, 1948.

Richardson, Brenda. *Barnett Newman: The Complete Drawings, 1944–1969.* Baltimore: Baltimore Museum of Art, 1979.

Rosenberg, Harold, and Kootz, Samuel. *The Intrasubjectives.* New York: Samuel Kootz Gallery, September 14–October 3, 1949.

Tuchman, Maurice. *New York School, The First Generation: Paintings of the 1940s and 1950s.* Revised edition. Greenwich, Connecticut: New York Graphic Society, 1969.

Wechsler, Jeffrey. *Surrealism and American Painting, 1931–1947.* New Brunswick: Rutgers University Art Gallery, 1977.

VI. Writings of the Artists, the Critics, and Their Associates

Abel, Lionel. "It Is Time to Pick the Iron Rose." *VVV* I (June 1942): 2.

Alvarez del Vayo, Julio. *Give Me Combat: The Memoirs of Julio Alvarez del Vayo.* Translated by Donald D. Walsh. Boston: Little, Brown, 1973.

Beaudoin, Kenneth Lawrence. "This Is the Spring of 1946." *Iconograph,* Spring 1946, pp. 3–4.

Benton, Thomas Hart. *An Artist in America.* New York: Robert McBride and Company, 1937.

"The Berlin Manifesto." *New Leader,* 8 July 1950, p. 8.

Bondy, Francois. "Berlin Congress for Freedom." *Commentary* X (September 1950): 245–51.

Breton, André. *Surrealism and Painting.* Translated by Simon Watson Taylor. New York: Harper and Row, 1972.

————. *What Is Surrealism? Selected Writings.* Edited by Franklin Rosemont. New York: Monad, 1978.

Breton, André, and Trotsky, Leon. "Manifesto: Towards a Free Revolutionary Art," *Partisan Review* VI (Fall 1938): 51–53.

Cage, John. *Silence.* Middletown, Connecticut: Wesleyan University Press, 1961.

Calas, Nicholas. "Letter to Editor." *View* I (October 1940): 1.

Cannon, James P. *History of American Trotskyism.* New York: Pioneer Press, 1944.

Chipp, Herschel B., ed. *Theories of Modern Art.* Berkeley: University of California Press, 1968.

Coates, Robert. "Abroad and at Home." *New Yorker,* 30 March 1946, p. 75.

———. "Assorted Moderns." *New Yorker,* 23 December 1944, p. 51.

———. "Art." *Nation,* 9 June 1945, p. 657.

Cohen, Elliot. "Editorial." *Commentary* I (November 1945): 1–2.

———. "What Do the Germans Propose to Do?" *Commentary* X (September 1950): 225–28.

"Concerning the Present Day Relative Attractions of Various Creatures in Mythology & Legend." *VVV* I (June 1942): 62–63.

Creeley, Robert. "The Art of Poetry." *Paris Review* XI (Fall 1968): 155–87.

Cronbach, Robert. "David Smith." *New Masses,* 19 February 1946, p. 27.

de Kooning, Willem. "An Interview by James T. Valliere." *Partisan Review* XXXIV (Fall 1967): 603–5.

"Editorial." *Art News,* February 1949, p. 13.

Federation of Modern Painters and Sculptors. "Letter to the Editor." *Nation,* 20 March 1943, p. 431.

Finkelstein, Sidney. "Abstract Art Today: Doodles, Dollars, and Death." *Masses and Mainstream,* September 1952, pp. 22–26.

Flamm, Irving. "The USA and USSR can and MUST get along." *Soviet Russia Today,* February 1947, pp. 10–11.

Fried, Michael. "Art and Objecthood." *Artforum* V (June 1967): 12–23.

Glazer, Nathan. "An Answer to Lillian Hellman." *Commentary* LXI (June 1976): 36–39.

Golub, Leon. "A Critique of Abstract Expressionism." *College Art Journal* XIV (Winter 1955): 142–47.

Gottlieb, Adolph. "Artist and Society: A Brief Case History." *College Art Journal* XIV (Winter 1955): 96–101.

Graham, John. "Primitive Art and Picasso." *Magazine of Art,* April 1937, pp. 236–39, 260.

———. *System and Dialectics of Art.* Edited by Marcia Allentuck. Baltimore: Johns Hopkins Press, 1971.

Greenberg, Clement. "American Stereotypes." *Commentary* XXII (October 1956): 379–81.

———. "'American-Type' Painting." *Partisan Review* XXII (Spring 1955): 179–96.

———. "Anna Seghers." *Nation,* 17 October 1942, pp. 388–90.

———. "Art." *Nation,* 11 April 1942, p. 441.

———. "Art." *Nation,* 10 October 1942, p. 350.

———. "Art." *Nation,* 29 November 1942, p. 590.

———. "Art." *Nation,* 9 January 1943, pp. 68–69.

———. "Art." *Nation,* 27 November 1943, p. 621.

———. "Art." *Nation,* 1 January 1944, pp. 24–25.

———. "Art." *Nation,* 12 February 1944, pp. 195–96.

———. "Art." *Nation,* 1 July 1944, pp. 24–25.

———. "Art." *Nation,* 28 October 1944, p. 541.

———. "Art." *Nation,* 21 April 1945, p. 469.

———. "Art." *Nation,* 1 December 1945, pp. 605–6.

———. "Art." *Nation,* 23 February 1946, p. 241.

———. "Art." *Nation,* 16 March 1946, p. 327.

———. "Art." *Nation,* 13 April 1946, pp. 444–45.

———. "Art." *Nation,* 4 May 1946, pp. 552–53.

———. "Art." *Nation,* 1 June 1946, p. 672.

———. "Art." *Nation,* 28 December 1946, pp. 767–68.

———. "Art." *Nation,* 22 February 1947, pp. 228–29.

———. "Art." *Nation,* 8 March 1947, p. 284.

———. "Art." *Nation,* 19 April 1947, pp. 459–60.

———. "Art." *Nation,* 1 November 1947, pp. 481–82.

———. "Art." *Nation,* 6 December 1947, pp. 629–30.

———. "Art." *Nation,* 24 April 1948, p. 448.

———. "Art." *Nation,* 29 May 1948, pp. 612–13.

———. "Art." *Nation,* 27 November 1948, pp. 612–13.

———. *Art and Culture: Critical Essays.* Boston: Beacon Press, 1961.

———. "Art Chronicle: The Decline of Cubism." *Partisan Review* XV (March 1948): 366–69.

———. "Art Chronicle: Irrelevance versus Irresponsibility." *Partisan Review* XV (May 1948): 573–79.

———. "Avant-Garde and Kitsch." *Partisan Review* VI (Fall 1939): 34–49.

———. "How Art Writing Earns Its Bad Name." *Second Coming* I (March 1962): 58–62.

———. "The Jackson Pollock Market Soars." *New York Times Magazine,* 16 April 1961, pp. 42 ff.

———. "The Jewish Dickens." *Nation,* 16 October 1943, pp. 450–52.

———. "The Jewishness of Franz Kafka: Some Sources of His Particular Vision." *Commentary* XIX (April 1955): 320–24.

———. *Joan Miró.* New York: Quadrangle, 1948.

———. "The Plight of Our Culture." *Commentary* XV (June 1953): 558–66.

———. "Post Painterly Abstraction." *Art International* VIII (Summer 1964): 63–64.

———. "The Pound Award." *Partisan Review* XVI (May 1949): 515–16.

———. "The Present Prospects of American Painting and Sculpture." *Horizon* LXCIII (October 1947): 20–29.

———. "The Renaissance of the Little Magazine." *Partisan Review* VIII (January–February 1941): 72–76.

———. "The Sculpture of Jacques Lipchitz: Strengths and Weaknesses of a Modern Master." *Commentary* XVIII (September 1954): 257–59.

———. "Self-Hatred and Jewish Chauvinism." *Commentary* X (November 1950): 426–33.

———. "Some Advantages of Provincialism," *Art Digest,* 1 January 1954, pp. 6–8.

———. "Symposium: Is the French Avant-Garde Overrated?" *Art Digest,* 15 September 1953, pp. 12,27.

———. "A Symposium: The State of American Art." *Magazine of Art,* March 1949, p. 92.

———. "Towards a Newer Laocoon." *Partisan Review* VII (1940): 296–310.

———. "Under Forty." *Contemporary Jewish Record* VII (February 1944): 32–34.

Greenberg, Clement, and Macdonald, Dwight. "10 Propositions on the War." *Partisan Review* VIII (July/August 1941): 271–78.

Greenberg, Clement, and Namuth, Hans. "Jackson Pollock." *Evergreen Review* III (1956): 95–96.

Greene, Balcomb. "American Perspective." *Plastique* III (Spring 1938): 12–14.

———. "Memories of Arshile Gorky." *Arts Magazine* L (March 1976): 108–10.

Hartz, Louis. *The Liberal Tradition in America.* New York: Harvest, 1955.

Henri, Robert. *The Art Spirit.* Philadelphia: Lippincott, 1923.

Herbert, Robert L., ed. *Modern Artists on Art.* Englewood Cliffs, New Jersey: Prentice-Hall, 1964.

Heron, Patrick. "The Ascendency of London in the Sixties." *Studio International* CLXXII (December 1966): 280–81.

Hess, Thomas B., editor. *The Art Comics and Satires of Ad Reinhardt.* Rome: Marlborough, 1975.

Hicks, Granville, "The Liberals Who Haven't Learned." *Commentary* XII (April 1951): 319–29.

Hofmann, Hans. *Search for the Real and Other Essays.* Edited by Sarah T. Weeks and Bartlett Hayes, Jr. Cambridge, Massachusetts: MIT Press, 1967.

Hook, Sidney. "The Berlin Congress for Cultural Freedom." *Partisan Review* XVII (May-June 1950): 715–22.

———. "Letter to Editor." *Time,* 23 April 1951, pp. 8–9.

Howe, Irving, and Coser, Lewis. "A Word to Our Readers." *Dissent* I (Winter 1954): 3–7.

Hudson, G. F. "Who is Guilty of the Katyn Massacre?" *Commentary* XIII (March 1952): 203–8.

"Inquiry on Dialectical Materialism." *Dyn* II (July–August 1942): 49–59.

"Jackson Pollock: An Artists' Symposium." *Art News,* April 1967, pp. 29–33 ff.; and May 1967, pp. 27–29 ff.

Janis, Sidney. *Abstract and Surrealist Art in America.* New York: Reynal and Hitchcock, 1944.

Judd, Donald. "Barnett Newman." *Studio International* CLXXIX (February 1970): 67–69.

———. "Jackson Pollock." *Arts Magazine* XLI (April 1967): 34.

Kaprow, Allan. *Assemblage, Environments, and Happenings.* New York: Abrams, 1966.

———. "The Legacy of Jackson Pollock." *Art News,* October 1958, pp. 24–26, 55–57.

Kazin, Alfred. *On Native Grounds: An Interpretation of Modern American Prose Literature.* New York: Harcourt Brace, 1942.

Kiesler, F. J. "Frank Lloyd Wright." *It Is* IV (Autumn 1959): 27.

Kirchwey, Freda. "Why *The Nation* Sued." *Nation,* 2 June 1951, pp. 504–5.

Kostelanetz, Richard, ed. *John Cage.* New York: Praeger, 1970.

Krauss, Rosalind. "Changing the Work of David Smith." *Art In America* LXII (September-October 1974): 30–34.

———. *Terminal Iron Works: The Sculpture of David Smith.* Cambridge, Massachusetts: MIT Press, 1971.

Kristol, Irving. "'Civil Liberties,' 1952 — A Study in Confusion." *Commentary* XIII (March 1952): 228–36.

League for Cultural Freedom and Socialism. "War is the Issue!" *Partisan Review* VI (Fall 1939): 125–26.

Louchheim, Aline B. "Parsons." *Vogue,* 1 October 1951, pp. 141–42, 194–96.

Levine, Les. "The Golden Years: A Portrait of Eleanor Ward." *Arts Magazine* XLVIII (April 1974): 42–43.

———. "The Spring of '55: A Portrait of Sam Kootz." *Arts Magazine,* XLVIII (April 1974): 34–35.

———. "Suffer, Suffer, Suffer: A Portrait of John Bernard Myers." *Arts Magazine* XLVIII (April 1974): 38–39.

Levy, Julien. *Surrealism.* New York: Black Sun Press, 1936.

Macdonald, Dwight. *Memoirs of a Revolutionist: Essays in Political Criticism.* New York: Farrar, Straus, and Cudahy, 1957.

———. "Soviet Society and Its Cinema." *Partisan Review* VI (July 1938): 37–50; (August-September 1938): 35–62; (Winter 1939): 80–95.

————. "A Theory of Mass Culture." *Diogenes* III (Summer 1953): 1–17.

Marshall, Margaret. "Letter to the Editor." *Nation,* 7 February 1953, p. 135.

Matthiessen, F. O. *American Renaissance: Art and Expression in the Age of Emerson and Whitman.* New York: Oxford, 1941.

"The Metropolitan and Modern Art." *Life,* 15 January 1951, pp. 34–37.

Meyer, Peter. "The Driving Force Behind Soviet Imperialism: Is It a New Menace or the Old Bear Reawakened?" *Commentary* XIII (March 1952): 209–17.

Motherwell, Robert. "The Modern Painter's World." *Dyn* VI (1944): 9–14.

Motherwell, Robert, and Reinhardt, Ad, eds. *Modern Artists in America.* New York: Wittenborn, Schultz, 1952.

"*The Nation* Censors a Letter of Criticism." *New Leader,* 19 March 1951, pp. 16–18.

Newman, Barnett. "Art of the South Seas." *Studio International* CLXXIX (February 1970): 70–71.

————. "Letter to the Editor." *Art News,* November 1965, p. 6.

————. "Letter to the Editor." *Art News,* May 1968, p. 8.

————. "The True Revolution Is Anarchist!" Foreword to *Memoirs of a Revolutionist,* by Peter Kropotkin. New York: Horizon Press, 1968.

O'Connor, Francis V., and Thaw, Eugene, eds. *Jackson Pollock: A Catalog Raisonné of Paintings, Drawings and Other Works.* 4 vols. New Haven: Yale University Press, 1978.

O'Hara, Frank. "Franz Kline Talking." *Evergreen Review* II (Autumn 1958): 58–65.

O'Neill, William, ed. *Echoes of Revolt: The Masses, 1911–1917.* Chicago: Quadrangle, 1966.

"Our Country and Our Culture." *Partisan Review* XIX (May–June 1952): 282–86.

Paalen, Wolfgang. *Form and Sense.* New York: Wittenborn, 1945.

Pavia, Phillip. "The Unwanted Title: Abstract Expressionism." *It Is* I (Spring 1960): 8–11.

Phillips, William. "What Happened in the 1930's." *Commentary* XXXIV (September 1962): 204–12.

Podhoretz, Norman. *Making It.* New York: Random House, 1967.

Pollock, Jackson. "Statement." *Arts and Architecture* CLXI (February 1944): 14.

Rahv, Philip. *Image and Idea.* New York: New Directions, 1949.

Reinhardt, Ad. "Stuart Davis." *New Masses,* 27 November 1945, p. 15.

Rose, Barbara, ed. *Art-As-Art: The Selected Writings of Ad Reinhardt.* New York: Viking Press, 1975.

Rosenberg, Bernard, and White, David Manning, eds. *Mass Culture: The Popular Arts in America.* New York: The Free Press, 1957.

Rosenberg, Harold. *Act and the Actor: Making the Self.* Perspectives in Humanities Series. New York: New American Library, 1970.

————. "Action Painting: A Decade of Distortion." *Art News,* December 1962, pp. 42–44.

————. "The American Action Painters." *Art News,* December 1952, pp. 22–23, 48–50.

————. "The American Writers' Congress." *Poetry: A Magazine of Verse* XLVI (July 1935): 222–27.

————. *The Anxious Object: Art Today and Its Audience.* New York: Horizon Press, 1966.

————. *Arshile Gorky: The Man, The Time, The Idea.* New York: Horizon Press, 1962.

————. "Art of Bad Conscience." *New Yorker,* 16 December 1967, pp. 138–49.

————. *Art Works and Packages.* New York: Horizon Press, 1969.

————. "Breton — A Dialogue," *View* II (1942): unpaged.

————. "Character Change and the Drama." *The Symposium* III (July 1932): 348–69.

————. "Cold War and the West." *Partisan Review* XXIX (Winter 1962): 74–77.

————. "The Communist: His Mentality and His Morals." *Commentary* VIII (July 1949): 1–9.

————. "The Concept of Action in Painting." *New Yorker,* 25 May 1968, pp. 116–28.

————. "Couch Liberalism and the Guilty Past." *Dissent* II (Autumn 1955): 317-28.

————. *The De-Definition of Art: Action Art to Pop to Earthworks.* New York: Horizon Press, 1972.

————. *Discovering the Present: Three Decades In Art, Culture, and Politics.* Chicago: University of Chicago Press, 1973.

————. "Does the Jew Exist?: Sartre's Morality Play About Anti-Semitism." *Commentary* VII (January 1949): 8-18.

————. "Du Jeu au Je." *Les Temps Modernes* III (April 1948): 1729-53.

————. "The Fall of Paris." *Partisan Review* VII (1940): 44-54.

————. "The Front." *Partisan Review* II (January–February 1935): 74.

————. "The God in the Car." *Poetry: A Magazine of Verse* LII (September 1938): 334-42.

————. "The Herd of Independent Minds." *Commentary* V (September 1948): 244-52.

————. "The Intellectuals and the American Idea." *Commentary* XI (April 1951): 508-9.

————. "Is There a Jewish Art?" *Commentary* XL (1966): 58-60.

————. "Jewish Identity in a Free Society." *Commentary* IX (June 1950): 508-14.

————. "Jews in Art," *New Yorker,* 22 December 1975, pp. 64-68.

————. "Literature Without Money." *Direction: American Stuff* I (1938): 6-10.

————. "The Mythic Art." *New Yorker,* 6 May 1967, pp. 162-71.

————. "Notes on Identity: With Special Reference to the Mixed Philosopher, Soren Kierke-gaard." *View* VI (May 1946): 7-10, 24-30.

————. "On the Fall of Paris." *Partisan Review* VII (1940): 440-48.

————. "On Vietnam." *Partisan Review* XXXII (Fall 1965): 651-55.

————. "Painting Is a Way of Living." *New Yorker,* 16 February 1963, pp. 126-37.

————. "Parable of American Painting." *Art News,* January 1954, pp. 60-63.

————. "The Pathos of the Proletariat." *Kenyon Review* XI (1949): 595-629.

————. "Pledged to the Marvelous." *Commentary* III (February 1947): 145-51.

————. "Poets of the People." *Partisan Review* III (October 1936): 21-26.

————. "Purifying Art." *New Yorker,* 23 February 1976, pp. 94-98.

————. "The Resurrected Romans." *Kenyon Review* X (Autumn 1948): 602-20.

————. "Revolution and the Idea of Beauty." *Encounter* I (December 1953): 65-68.

————. "Roadside Arcadia." *Partisan Review* XXV (Fall 1958): 568-75.

————. "The Search for Jackson Pollock." *Art News,* February 1961, p. 35 ff.

————. "Seven Questions." *Partisan Review* VI (Summer 1939): 47-49.

————. "A Spectre Haunts Mr. Krutch." *Partisan Review* II (April–May 1935): 82-84.

————. "Thugs Adrift." *Partisan Review* XL (1973): 341-48.

————. *The Tradition of the New.* New York: Horizon Press, 1959.

————. *Trance Above the Streets.* New York: Gotham Bookmart Press, 1942.

————. "The Trial and Eichmann." *Commentary* XXXII (November 1961): 369-81.

————. "Truth and the Academic Style." *Poetry: A Magazine of Verse* XLIX (October 1936): 49-51.

————. "What's Happening to America." *Partisan Review* XXXIV (Winter 1967): 44-47.

Rothko, Mark. "Statement." *Interiors* CX (May 1951): 104.

Schlesinger, Arthur, Jr. "Letter to the Editor." *New Leader,* 30 April 1951, p. 27.

Sillen, Samuel. "The McCarthy Intellectuals." *Masses & Mainstream,* October 1951, pp. 25-26.

Simon, Sidney. "Interview with Robert Motherwell." *Art International* XI (Summer 1967): 22-23.

Still, Clyfford. "An Open Letter to an Art Critic." *Artforum* II (December 1963): 32.

Summers, Marion. "Art Today: Lessons in Utter Confusion." *Daily Worker,* 19 May 1946, p. 14.

Sylvester, David. "An Interview with Franz Kline." *Living Arts* I (Spring 1963): 2-13.

————. "An Interview with David Smith." *Living Arts* III (April 1964): 5–14.

Taylor, Francis Henry Taylor. "Modern Art and the Dignity of Man." *Atlantic* CLXXXII (December 1948): 30–36.

Trilling, Lionel. "George Orwell and the Politics of Truth." *Commentary* XIII (March 1952): 218–27.

Viereck, Peter. "Sermons of Self-Destruction." *Saturday Review of Literature,* 18 August 1951, pp. 6–7.

Warshow, Robert. "The Legacy of the 1930's: Middle-Class Mass Culture and the Intellectuals' Problem." *Commentary* IV (December 1947): 538–45.

Wiedenreich, Franz. *Apes, Giants and Man.* Chicago: University of Chicago Press, 1946.

Wolfe, Bertram. "Stalinism Versus Stalin." *Commentary* XXI (June 1956): 522–31.

Wolfe, Tom. *The Painted Word.* New York: Farrar, Straus, and Giroux, 1975.

VII. Secondary Sources

Aaron, Daniel. *Writers on the Left.* New York: Harcourt, Brace, and World, 1961.

Alloway, Lawrence. "The American Sublime." *Living Arts* II (1963): 11–22.

————. "De Kooning: Criticism and Art History." *Artforum* XIII (January 1975): 46–50.

————. Melpomene and Graffiti: Adolph Gottlieb's Early Work." *Art International* XII (20 April 1968): 21–24.

————. "Residual Sign Systems in Abstract Expressionism." *Artforum* XII (November 1973): 36–42.

————. *Topics in American Art Since 1945.* New York: Nortón, 1975.

Ashton, Dore. *The New York School: A Cultural Reckoning.* New York: Viking Press, 1972.

Baigell, Matthew. *The American Scene: American Painting of the 1930's.* New York: Praeger, 1974.

————. "The Beginnings of 'The American Wave' and the Depression." *Art Journal* XXVII (Summer 1968): 387–98.

Baker, Elizabeth. "Barnett Newman in a New Light." *Art News,* February 1969, pp. 38–41 ff.

Barthes, Roland. *Image/Music/Text.* Translated by Stephen Heath. New York: Hill and Wang, 1977.

————. *Writing Degree Zero.* Translated by Annette Lavers and Colin Smith. New York: Hill and Wang, 1967.

Battcock, Gregory, ed. *Minimal Art: A Critical Anthology.* New York: Dutton, 1968.

Baur, John I. H. *Revolution and Tradition in Modern American Art.* Cambridge, Massachusetts: Harvard University Press, 1951.

Baxandall, Lee, editor. *Radical Perspectives in the Arts.* Middlesex, England: Penguin, 1972.

Beck, James H. "Ad Reinhardt in Retrospect." *Arts Magazine* LIV (June 1980): 148–49.

Bell, Daniel. *The End of Ideology: On the Exhaustion of Political Ideas in the Fifties.* Glencoe, Illinois: The Free Press, 1960.

Benjamin, Walter. *Illuminations.* Translated by Harry Zohn. New York: Harcourt, Brace, and World, 1968.

Berman, Ronald. *America in the Sixties: An Intellectual History.* New York: The Free Press, 1968.

"The Best?" *Time,* 1 December 1947, p. 55.

Blake, Casey. "Aesthetic Engineering." *democracy* I (October 1981): 37–50.

Blesh, Rudi. *Modern Art U.S.A.* New York: Knopf, 1956.

Bradbury, Malcolm. *The Social Context of Modern English Literature.* New York: Schocken Books, 1971.

Bradbury, Malcolm, and McFarlane, James, eds. *Modernism, 1890–1930.* New York: Penguin, 1976.

Brown, Milton Wolf. *American Painting From the Armory Show to the Depression*. Princeton: Princeton University Press, 1955.

———. "After Three Years." *Magazine of Art*, April 1946, pp. 138, 166.

Buettner, Stewart. "John Dewey and the Visual Arts in America." *Journal of Aesthetics and Art Criticism* XXXIII (Summer 1975): 383–91.

Cavaliere, Barbara. "Barnett Newman's 'Vir Heroicus Sublimis': Building the 'Idea Complex.'" *Arts Magazine* LV (January 1981): 144–52.

———. "An Introduction to the Method of William Baziotes." *Arts Magazine* LI (April 1977): 124–31.

Cavaliere, Barbara, and Hobbs, Robert C. "Against a Newer Laocoon." *Arts Magazine* LI (April 1977): 110–17.

Chadwick, Whitney. "Eros or Thanatos—The Surrealist Cult of Love Reexamined." *Artforum* XIV (November 1975): 46–56.

Clark, T. J. *The Absolute Bourgeois: Artists and Politics in France, 1848–1851*. Greenwich, Connecticut: New York Graphic Society, 1973.

———. *Image of the People: Gustave Courbet and the Second French Republic, 1848–1851*. Greenwich, Connecticut: New York Graphic Society, 1973.

Clecak, Peter. *Radical Paradoxes: Dilemmas of the American Left, 1945–1970*. New York: Harper and Row, 1973.

Cockcroft, Eva. "Abstract Expressionism, Weapon of the Cold War." *Artforum* XII (June 1974): 39–41.

Colt, Priscilla. "Notes on Ad Reinhardt." *Art International* VIII (20 October 1964): 32–34.

Cowley, Malcolm. *Exile's Return: A Literary Odyssey of the 1920s*. New York: Viking Press, 1951.

Craven, Thomas. *Modern Art; The Men, the Movements, the Meaning*. New York: Simon and Schuster, 1934.

Deleon, David. "The American as Anarchist: Social Criticism in the 1960s." *American Quarterly* XXV (December 1973): 517–37.

Deutscher, Isaac. *The Prophet Outcast: Trotsky: 1929–1940*. New York: Oxford, 1963.

Diggins, John. "Consciousness and Ideology in American History: The Burden of Daniel J. Boorstin." *American Historical Review* LXXVI (February 1971): 99–118.

Dunlop, Ian. "Edvard Munch, Barnett Newman, and Mark Rothko: The Search for the Sublime." *Arts Magazine* LIII (February 1979): 128–30.

Egbert, Donald D. "The Idea of the 'Avant-Garde' in Art and Politics." *American Historical Review* LXXIII (December 1967): 339–66.

———. *Socialism and American Art*. Princeton: Princeton University Press, 1967.

Elderfield, John. "American Geometric Abstraction in the Late Thirties." *Artforum* XI (December 1972): 35–42.

Fingesten, Peter. "Spirituality, Mysticism, and Non-Objective Art." *Art Journal* XXI (Fall 1961): 2–6.

Foster, Stephen C. "The Avant-Garde and the Privacy of Mind." *Art International* XII (20 November 1975): 71–78.

———. "Clement Greenberg: Formalism in the '40s and '50s." *Art Journal* XXXV (Fall 1975): 20–24.

Fredrickson, George. *The Inner Civil War: Northern Intellectuals and the Crisis of the Union*. New York: Harper and Row, 1965.

Friedman, B. H. *Jackson Pollock: Energy Made Visible*. New York: McGraw-Hill, 1972.

Gaugh, Harry F. "Franz Kline's Romantic Abstraction." *Artforum* XIII (Summer 1975): 28–37.

Gay, Peter. *Art and Act: Manet, Gropius, Mondrian*. New York: Harper and Row, 1976.

Gershman, Herbert. *The Surrealist Revolution in France.* Ann Arbor: University of Michigan Press, 1969.

Gilbert, James Burkhart. *Writers and Partisans: A History of Literary Radicalism in America.* New York: John Wiley and Sons, 1968.

Glazer, Penina Migdal. "From the Old Left to the New: Radical Criticism in the 1940's." *American Quarterly* XXIV (December 1972): 584–603.

Goldwater, Robert. *Primitivism in Modern Art.* Revised edition. New York: Harper and Brothers, 1966.

———. "Reflections on the New York School." *Quadrum* VIII (1960): 17–36.

Goodnough, Robert. "Pollock Paints a Picture." *Art News,* May 1951, pp. 38–39 ff.

Gould, Stephen Jay. *Ontogeny and Phylogeny.* Cambridge: Harvard University Press, 1977.

Graff, Gerald. "The Myth of the Postmodernist Breakthrough." *Triquarterly* XXVI (Winter 1973): 383–417.

Guilbaut, Serge. "New Adventures of the Avant-Garde in America." Translated by Thomas Repensek. *October* XV (October 1981): 61–78.

Haftmann, Werner. *Painting in the Twentieth Century.* New York: Praeger, 1961.

Handlin, Oscar. "The American Jewish Committee: A Half Century View." *Commentary* XXIII (January 1957): 1–10.

Harris, Neil. *The Artist in American Society: The Formative Years 1790–1860.* New York: Braziller, 1966.

Hassan, Ihab. "POSTmodernISM: A Paracritical Bibliography." *New Literary History* III (Autumn 1971): 5–30.

Herbert, Eugenia. *The Artist and Social Reform, France and Belgium, 1885–1889.* New Haven: Yale University Press, 1961.

Hess, Thomas B. and Ashbery, John, eds. *Avant-Garde Art.* New York: Collier Books, 1967. 1967.

Higgins, Andrew. "Clement Greenberg and the Idea of the Avant-Garde." *Studio International* CLXXXIII (October 1971): 144–47.

Hofstadter, Richard. *The Paranoid Style in American Politics and Other Essays.* New York: Knopf, 1965.

Hollinger, David. "Ethnic Diversity, Cosmopolitanism, and the Emergence of the American Liberal Intelligentsia." *American Quarterly* XXVII (May 1975): 133–51.

Homer, William Innes. *Alfred Stieglitz and the American Avant-Garde.* Boston: New York Graphic Society, 1977.

Homer, William Innes, and Organ, Violet. *Robert Henri and His Circle.* Ithaca: Cornell University Press, 1969.

Hopkins, Budd. "An Ad for Ad As Ad." *Artforum* XIV (Summer 1976): 62–63.

———. "Franz Kline's Color Abstractions: Remembering and Looking Afresh." *Artforum* XVII (Summer 1979): 37–41.

Horowitz, Helen Lefkowitz. *Culture & the City: Cultural Philanthropy in Chicago from the 1880s to 1917.* Lexington: University of Kentucky Press, 1976.

Howe, Irving. *World of Our Fathers: The Journey of the East European Jews and the Life They Found and Made.* New York: Harcourt, Brace, Jovanovich, 1976.

Hunter, Sam. "Jackson Pollock." *Bulletin of the Museum of Modern Art* XXIV (1956–1957): 1–36.

Hurlburt, Laurance P. "The Siqueiros Experimental Workshop: New York, 1936." *Art Journal* XXXV (Spring 1976): 237–46.

"Jackson Pollock: Is He the Greatest Living Painter in the United States?" *Life,* 8 August 1949, pp. 42–43, 45.

Janson, H. W. "Benton and Wood, Champions of Regionalism." *Magazine of Art* XXXIX

(May 1946): 184 ff.

Kozloff, Max. "American Painting During the Cold War." *Artforum* XI (May 1973): 43–54.

———. "Andy Warhol and Ad Reinhardt: The Great Acceptor and the Great Demurrer." *Studio International* CLXXXI (March 1971): 113–17.

———. "The Critical Reception of Abstract Expressionism." *Arts Magazine* XL (December 1965): 27–33.

Kuspit, Donald. *Clement Greenberg: Art Critic.* Madison: University of Wisconsin Press, 1979.

———. "Clyfford Still: The Ethics of Art." *Artforum* XV (May 1977): 32–40.

———. "Regionalism Reconsidered." *Art In America* LXIV (July/August 1976): 64–69.

———. "Utopian Protest in Abstract Art." *Art Journal* XXIX (Summer 1970): 430–37.

Langhorne, Elizabeth L. "Jackson Pollock's 'The Moon Woman Cuts the Circle'," *Arts Magazine* LIII (March 1979): 128–37.

Larsen, Susan. "The AAA: A Documentary History 1936–1941." *Archives of American Art Journal* XIV (1974): 2–7.

Lasch, Christopher. "The Cultural Cold War: A Short History of the Congress for Cultural Freedom." In *Towards a New Past: Dissenting Essays in American History,* 322–59. Edited by Barton J. Bernstein. New York: Knopf, 1967.

———. *The New Radicalism in America: The Intellectual as a Social Type.* New York: Knopf, 1965.

Lehmann-Haupt, Helmut. *Art Under a Dictatorship.* New York: Oxford University Press, 1954.

Levine, Edward M. "Abstract Expressionism: The Mystical Experience." *Art Journal* XXXI (Fall 1971): 22–25.

Lippard, Lucy. "Ad Reinhardt." *Art In America* LXII (September/October and November/December 1974): 65–75, 95–101.

———. *Ad Reinhardt.* New York: Abrams, 1981.

———. *Pop Art.* New York: Oxford, 1966.

Loevgren, Sven. *The Genesis of Modernism: Seurat, Gauguin, Van Gogh, and French Symbolism in the 1880's.* Revised edition. Bloomington, Indiana: Indiana University Press, 1971.

Lynes, Russell. *Good Old Modern: An Intimate Portrait of the Museum of Modern Art.* New York: Atheneum, 1973.

Lyons, Eugene. *The Red Decade: The Stalinist Penetration of America.* Indianapolis: Bobbs-Merrill, 1941.

McAuliffe, Mary Sperling. *Crisis on the Left: Cold War Politics and American Liberals, 1947–1954.* Amherst: University of Massachusetts Press, 1978.

McKinzie, Richard. *The New Deal for Artists.* Princeton: Princeton University Press, 1973.

Mangione, Jerry. *The Dream and the Deal: The Federal Writers' Project, 1935–1943.* Boston: Little, Brown, 1972.

Mathews, Jane DeHart. "Art and Politics in Cold War America." *American Historical Review* LXXXI (October 1976): 762–87.

———. "Arts and the People: The New Deal Quest for a Cultural Democracy." *Journal of American History* LXII (September 1975): 316–39.

Matthews, J. H. *The Imagery of Surrealism.* Syracuse: Syracuse University Press, 1977.

May, Henry F. *The End of American Innocence: A Study of the First Years of Our Own Time 1912–1917.* New York: Knopf, 1959.

Meltzer, R. *The Aesthetics of Rock.* New York: Something Else Press, 1970.

"The Metropolitan and Modern Art," *Life,* 15 January 1951, pp. 34–35.

Monroe, Gerald. "Art Front." *Studio International* CLXXXVIII (September 1974): 66–70.

———. "Artists as Militant: Trade Union Workers during the Great Depression." *Archives of American Art Journal* XIV (1974): 7–10.

———. "The 30s: Art, Ideology, and the WPA." *Art in America* LXIII (November-December 1975): 64–67.

Morgan, H. Wayne. *New Muses: Art in American Culture, 1865–1920.* Norman: University of Oklahoma Press, 1978.

Namuth, Hans. *L'Atelier de Jackson Pollock.* Paris: Macula, 1978.

Novak, Barbara. *American Painting of the Nineteenth Century: Realism, Idealism, and the American Experience.* New York: Praeger, 1969.

———. *Nature and Culture: American Landscape and Painting, 1825–1875.* New York: Oxford, 1980.

Oestereicher, Emil. "Fascism and the Intellectuals: The Case of Italian Futurism." *Social Research* XLI (Autumn 1974): 515–33.

O'Connor, Francis. "The Genesis of Jackson Pollock: 1912 to 1943." *Artforum* V (May 1967): 16–23.

O'Connor, Francis, ed. *Art for the Millions: Essays from the 1930s by Artists and Administrators of the WPA Federal Art Project.* New York: New York Graphic Society, 1973.

O'Hara, Frank. *Jackson Pollock.* New York: George Braziller, 1959.

Pells, Richard H. *Radical Visions and American Dreams: Culture and Social Thought in the Depression Years.* New York: Harper and Row, 1973.

Plagens, Peter. "William Baziotes: Primeval Sentiment." *Artforum* XVII (September 1978): 48–51.

Poggioli, Renato. *The Theory of the Avant-Garde.* Translated by Gerald Fitzgerald. Cambridge, Massachusetts: Harvard University Press, 1968.

Polcari, Stephen. "The Intellectual Roots of Abstract Expressionism: Mark Rothko." *Arts Magazine* LIV (September 1979): 124–34.

———. "Jackson Pollock and Thomas Hart Benton," *Arts Magazine* LIII (March 1979): 120–24.

Rand, Harry. *Arshile Gorky: The Implications of Symbols* (Montclair: Allanheld and Schram, 1981).

Ratcliff, Carter. "Art Criticism: Other Minds, Other Eyes, Part V." *Art International* XVIII (15 December 1974): 53–57.

"Rebel Artist's Tragic Ending." *Life,* 27 August 1956, p. 58.

Reise, Barbara M. "Greenberg and the Group: A Retrospective View." *Studio International* CLXXV (May/June 1968): 254–57, 314–16.

———. "The Stance of Barnett Newman." *Studio International* CLXXIX (February 1970): 49–63.

Rodman, Selden. *Conversations With Artists.* New York: Devin-Adair, 1957.

Rose, Barbara. *American Art Since 1900: A Critical History.* Revised edition. New York: Praeger, 1975.

———. "Arshile Gorky and John Graham: Eastern Exiles in a Western World." *Arts Magazine,* March 1976, pp. 62–69.

———. "Hans Namuth's Photographs and the Jackson Pollock Myth: Part One: Media Impact and the Failure of Criticism." *Arts Magazine* LIII (March 1979): 112–16.

———. "How to Murder an Avant-Garde." *Artforum* IV (November 1965): 30–34.

———. "Wolfeburg." *New York Review of Books* XXII (26 June 1975): 26–28.

Rosenblum, Robert. "The Abstract Sublime." *Art News,* February 1961, pp. 38–41, 56–58.

Roth, Jack J. "The 'Revolution of the Mind': The Politics of Surrealism Reconsidered." *South Atlantic Quarterly* LXXVI (Spring 1977): 147–57.

Rubin, David S. "A Case for Content: Jackson Pollock's Subject Was the Automatic Gesture." *Arts Magazine* LIII (March 1979): 103–9.

Rubin, William. *André Masson.* New York: Museum of Modern Art, 1976.

———. *Dada and Surrealist Art.* New York: Abrams, 1968.

———. "Jackson Pollock and the Modern Tradition." *Artforum* V (February, March, April, and May 1967).

———. "Pollock as Jungian Illustrator: The Limits of Psychological Criticism." *Art in America* LXVII (November 1979): 104–23, and (December 1979): 72–91.

Sandler, Irving. *Triumph of American Painting: A History of Abstract Expressionism.* New York: Praeger, 1970.

Schapiro, Meyer. "Rebellion in Art." In *America In Crisis,* pp. 202–42. Edited by Daniel Aaron. New York: Knopf, 1952.

Scholem, Gershom G. *Major Trends in Jewish Mysticism.* Revised edition. New York: Schocken Books, 1954.

Schwartz, Sanford. "Typecasting the Modern Artist." *Art In America* LXIV (November-December 1976): 37–41.

Schwartz, Therese. "The Politization of the Avant-Garde." *Art In America* LVIX (November/December 1971): 95–105; LX (March/April 1972): 70–79; and LXI (March/April 1973): 67–71.

Seiberling, Dorothy. "Baffling U.S. Art: What It Is About." *Life,* 9 November 1959, pp. 68–80.

Seitz, William. *Hans Hofmann.* New York: Doubleday for Museum of Modern Art, 1963.

Seldes, Lee. *The Legacy of Mark Rothko.* New York: Holt, Rinehart, and Winston, 1978.

Shapiro, David, ed. *Social Realism: Art as a Weapon.* New York: Frederick Ungar, 1973.

Shapiro, David, and Shapiro, Cecile. "Abstract Expressionism: The Politics of Apolitical Painting." *Prospects* III (1977): 175–214.

Shapiro, Theda. *Painters and Politics: The European Avant-Garde and Society, 1900–1925.* New York: Elsevier, 1976.

Shattuck, Roger. *The Banquet Years: The Origins of the Avant-Garde in France.* Revised edition. New York: Knopf, 1968.

Shils, Edward. *The Intellectuals and the Powers and Other Essays.* Chicago: University of Chicago Press, 1972.

Short, Robert S. "The Politics of Surrealism, 1920–1936." *Journal of Contemporary History* I (1966): 3–26.

Skotheim, Robert. *Totalitarianism and American Social Thought.* New York: Holt Rinehart and Winston, 1971.

Sochen, June. *Movers and Shakers: American Women Thinkers and Activists, 1900–1970.* New York: Quadrangle Press, 1973.

Sontag, Susan. *Against Interpretation and Other Essays.* New York: Farrar, Straus & Giroux, 1968.

Stott, William. *Documentary Expression and Thirties America.* New York: Oxford University Press, 1973.

Susman, Warren, ed. *Culture and Commitment: 1929–1945.* American Culture Series. New York: Braziller, 1970.

Tashjian, Dickran. *Skyscraper Primitives: Dada and the American Avant-Garde, 1910–1925.* Middleton, Connecticut: Wesleyan University Press, 1975.

Warren, Frank. *Liberals and Communism: The 'Red Decade' Revisited.* Bloomington, Indiana: Indiana University Press, 1966.

"The Wild Ones." *Time,* 20 February 1956, p. 75.

Woodcock, George. *Anarchism: A History of Libertarian Ideas and Movements.* Cleveland: World Publishing Company, 1962.

Worringer, Wilhelm. *Abstraction and Empathy: A Contribution to the Psychology of Style.* Translated by Michael Bullock. Third edition. New York: International Universities Press, 1953.

Wysuph, C. L. *Jackson Pollock: Psychoanalytic Drawings.* New York: Horizon Press, 1970.

Yard, Sally. "Willem de Kooning's Women." *Arts Magazine* LIII (November 1978): 96–99.

VIII. Miscellaneous Materials

Current Biography, 1969 edition. S.v. "Barnett Newman."

Hays, H. R. Review of *Trance Above the Streets,* by Harold Rosenberg. *Poetry: A Magazine of Verse* LX (September 1943): 342–44.

Kozloff, Max. "An Interview with Robert Motherwell." *Artforum* IV (September 1965): 33–37.

Kuspit, Donald. Review of *Discovering the Present: Three Decades in Art, Culture, and Politics,* by Harold Rosenberg. *Artforum* XIII (March 1975): 58–60.

Monroe, Gerald M. "The Artists Union of New York." Ed.D. Dissertation, New York University, 1971.

Reinhardt, Ad. "Millennium," *New Masses* XXXIV (6 February 1940): 7.

――――. "Returned, No Thanks," *New Masses* XXX (3 January 1939): 15.

――――. "The Unhappy Warriors." *New Masses* XXXIII (10 October 1939): 15.

Seckler, Dorothy Gees. "Frontiers of Space." *Art In America* L (Summer 1962): 82–87.

Twentieth Century Authors: A Biographical Dictionary of Modern Literature, First Supplement, 1955, S.v. "Clement Greenberg."

United States Congress. House. Congressman Dondero speaking on How the Magazine *The Nation* Is Serving Communism. 82nd Congress, 1st session, 4 May 1951. *Congressional Record,* volume 97.

――――. Congressman Dondero speaking on How Modern Art Is Shackled to Communism. 81st Congress, 1st session, 16 Aug. 1949. *Congressional Record,* volume 96.

Index

Page numbers in italics indicate illustrations.